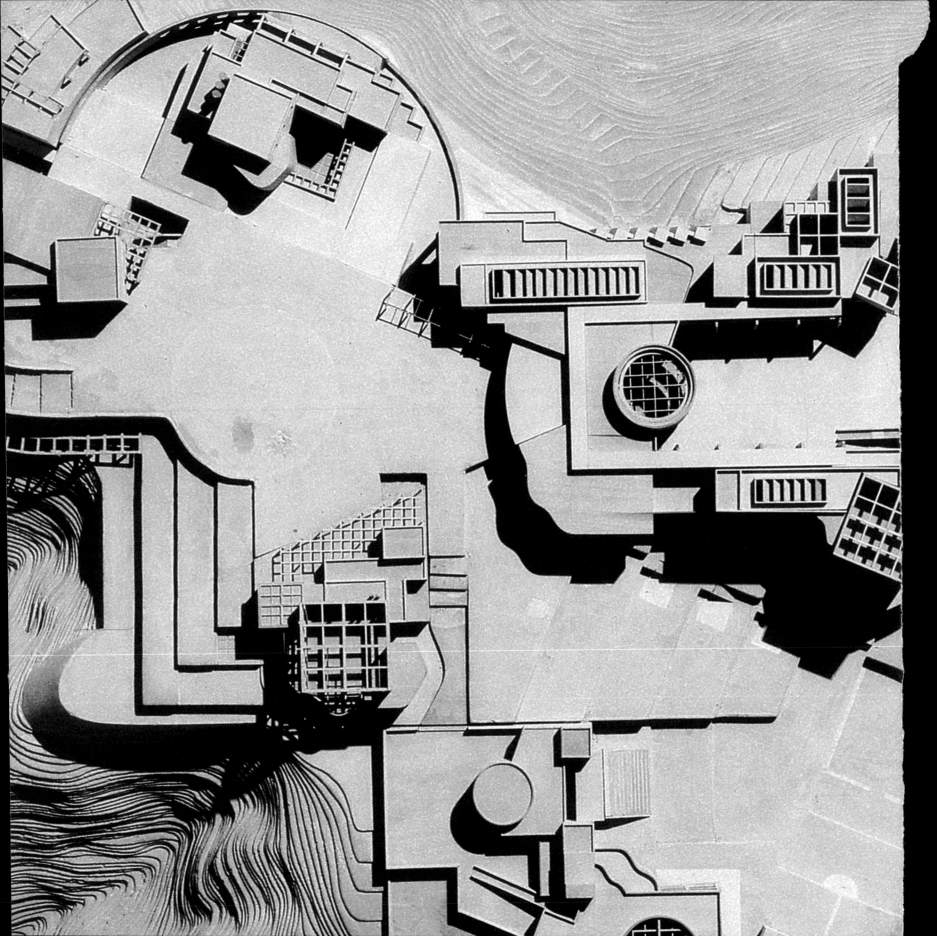

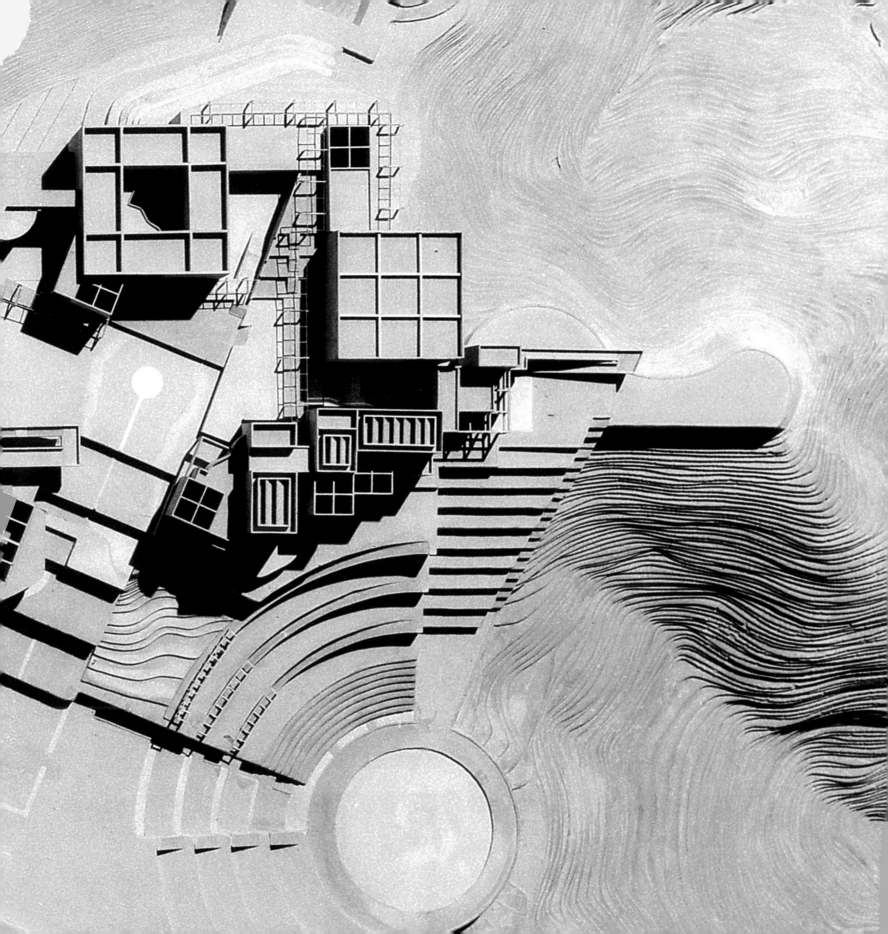

THE GETTY CENTER
DESIGN PROCESS

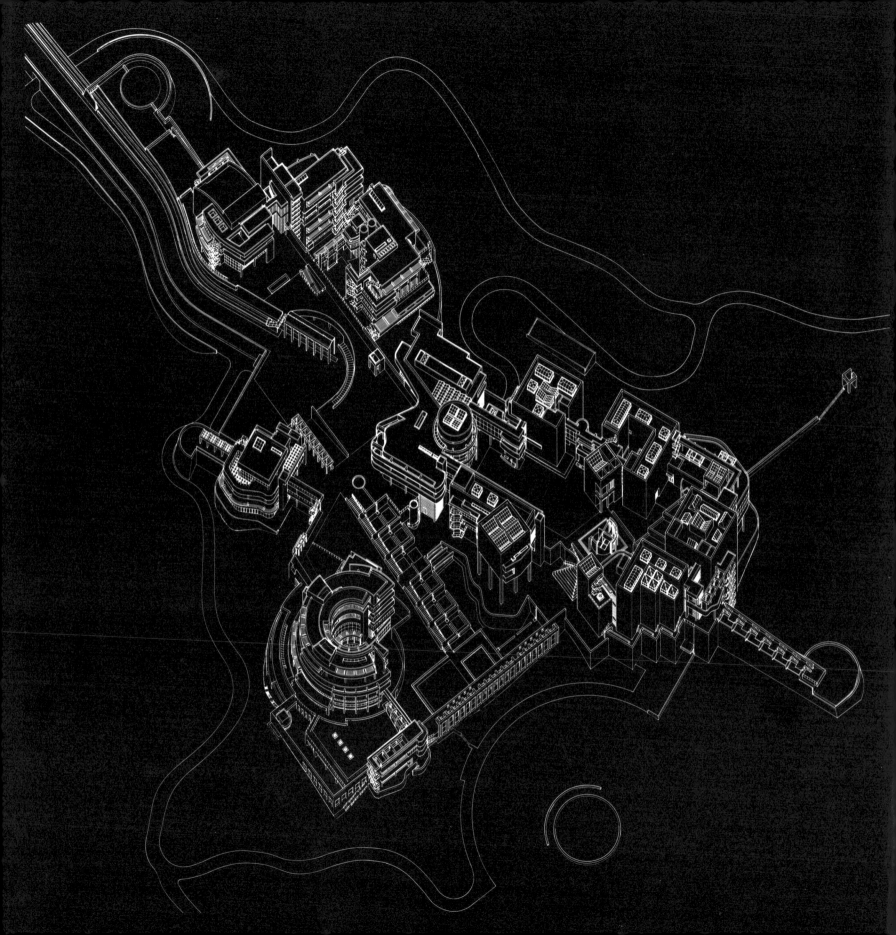

⌐The Getty Center ˙
Design Process
 ⌐

Harold M. Williams
Bill Lacy
Stephen D. Rountree
Richard Meier

The J. Paul Getty Trust
Los Angeles, 1991

©1991 The J. Paul Getty Trust
1875 Century Park East, Suite 2300
Los Angeles, California 90067

Gloria Gerace, *Editor*
Andrea P.A. Belloli, *Manuscript Editor*
Lorraine Wild, *Designer*
Karen Schmidt, *Production Manager*
Typography by CCI Typographers, *Torrance, California*
Printed by Meriden-Stinehour Press, *Lunenburg, Vermont*

The Getty Center: design process/Harold Williams…[et al.].
p. cm.
ISBN 0-89236-210-3 (paper)
1. Getty Center (Los Angeles, Calif.) 2. Art centers — California —
Los Angeles — Designs and plans. 3. Richard Meier & Partners.
4. Los Angeles (Calif.) — Buildings, structures, etc. I. Williams,
Harold Marvin, 1928 –
NA6813.U6L674 1991
727 — dc20 91-25981
 CIP

Contents

1983

September	Purchase of site for Getty Center is announced.
October	Thirty-three architects are invited to submit qualifications.
November	Architect Selection Committee chooses seven semifinalists.

1984

January–April	Members of Architect Selection Committee and Trustees Site Committee visit sites in United States, Europe, and Japan; Architect Selection Committee interviews seven semifinalists and submits names of three finalists to Trustees.
August	Application is submitted to Los Angeles Planning Commission for Conditional Use Permit. Stephen D. Rountree is named director of Building Program.
October	Richard Meier is named project architect.
November	Getty planning committee has first meeting.

1985

March	Conditional Use Permit is issued.
February–June	Getty planning committees visit sites in United States, Canada, and Europe.

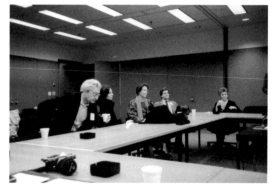

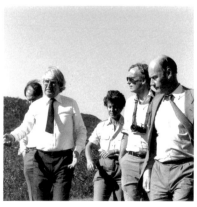

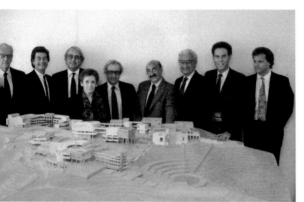

1986	
January	Trustees meet Richard Meier on site; approve Architectural Program.
March	Architectural Program is distributed.
April	Design Advisory Committee has first meeting.
September	Richard Meier & Partners opens Los Angeles office.

1987	
August	Los Angeles Planning Commission approves site master plan.

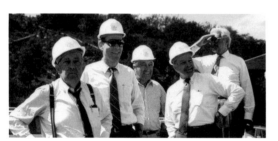

1988	
September	Getty Trust approves schematic design.

1989	
November	Construction begins at North Entry Parking.

1990	
May	Grading for main complex commences.

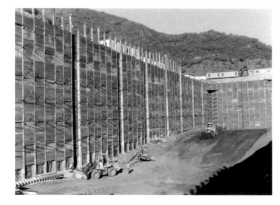

1991	
March	Los Angeles Planning Commission grants final design approval for Getty Center.
April	Getty Trust approves Getty Center design.
October	Getty Center design is unveiled to public.

In 1982, during the earliest days of the J. Paul Getty Trust, we had just begun to explore what we might become. At that time only the J. Paul Getty Museum existed. Our explorations ultimately led to the creation of a group of independent but closely related programs dedicated to making significant contributions to the visual arts internationally. These programs now include, in addition to the Museum, the Center for the History of Art and the Humanities, the Conservation Institute, the Center for Education in the Arts, the Art History Information Program, and the Grant Program. The commitment to all of these entities, along with a new museum to house the post-antique collections (antiquities will remain at the original Museum in Malibu), led to the undertaking that is the subject of this volume.

While the various activities of the Getty organization were taking shape in rented facilities scattered around Los Angeles, we began the process of selecting a permanent site at which they all could be housed, one large enough to foster the potential synergy among them that was fundamental to their conceptualization. It was clear that carefully designed, well-located buildings were essential. The Malibu Museum could not be expanded; it had severe limitations in terms of public access, and growth on the grounds was impossible. Leased commercial space was only viable in the short term for the Conservation Institute and Center for the History of Art and the Humanities. Such space is comparatively very expensive (prohibitive over the long term) as well as functionally inadequate and inflexible.

We thus began to seek a property of at least twenty-five acres to meet our needs. In addition to the practical considerations to which we were committed — a reasonable cost and a location that would be both accessible to the general public and close to the existing scholarly resources of the University of California, Los Angeles — we hoped to find a natural setting that would enhance the programs and their activities. When we were shown a hilltop property at the southern edge of the Santa Monica Mountains, above the intersection of Sunset Boulevard and Interstate 405, we knew we had something special. Not only did it meet cost and location requirements; it was dramatically beautiful, with commanding views of the city, sea, and mountains. In mid-1983 we were able to acquire the property, a twenty-four-acre building site protected by nearly a hundred surrounding acres: a suitable setting for the new Getty Center.

It is important to an understanding of the Getty Center's design to visualize its geographical context in Los Angeles. The coastal range of the Santa Monica Mountains runs west–east across the city, defining the Los Angeles coastal basin to the south and the San Fernando Valley to the north. It is not a tall range; elevations typically are between eight and fourteen hundred feet. A network of highways and major streets encircles the mountains and traverses its passes, and the hills are, for the most part, covered with homes. The San Fernando Valley and Los Angeles basin are dense urban areas with millions of residents and every type of commercial, educational, and cultural facility and activity. The Getty Center site occupies a promontory at the southernmost extension of the Santa Monica Mountains. Interstate 405 — part of the major north–south artery for the entire state of California — cuts through the mountains here by way of the Sepulveda Pass at the eastern edge of the Getty Center property. Sunset Boulevard, a major thoroughfare that runs east–west from downtown Los Angeles to the Pacific Ocean, intersects Interstate 405 approximately a mile from the entrance to the site and will connect the Getty Center with the University of California, Los Angeles, two miles to the east, and with the Getty Museum in Malibu, ten miles to the west.

By mid-1983 the three program components that will occupy most of the building space at the Getty Center were established and growing. First was the Museum, which needed new quarters to house its growing collections of paintings, drawings, sculpture, illuminated manuscripts, decorative arts, and photographs. Second was the Center for the History of Art and the Humanities, with a library, archives, and research facilities for the study of art history, broadly conceived as encompassing other humanistic and social science disciplines. In contrast to the Museum's public focus, the Center had a predominantly scholarly and research-oriented character. Third was the Conservation Institute, a center for both training and scientific research. The Center for Education in the Arts, also underway in 1983, was externally focused and had a small staff with modest space requirements. The Art History Information and Grant programs were both established a few years later.

To house these programs we required sound buildings that would serve and enhance the purposes of the Getty programs and their interrelationships as well as capture the uniqueness of the site. We believed that our responsibility extended beyond the Getty's programs to their architectural embodiments and that the project offered an opportunity to make a significant architectural statement suited to the character, climate, history, and dynamics of Los Angeles.

As of this writing, work is well underway at the site. Between its challenges and the requirements of the programs, this has been a far more complex project than any of us could have imagined. Its elaboration has been characterized by an unprecedented degree of interaction between architect and client. The completed design is a tribute not only to Richard Meier's extraordinary talent but also to the creativity, flexibility, determination, and perseverance of a team of people from his office and the Trust who are working together to realize a special vision.

My involvement with the J. Paul Getty Trust began in July 1983, when I met with Harold Williams and Nancy Englander (then Director, Program Planning and Analysis). Williams and Englander described the main components of a building project that would embody the Getty Trustees' vision for their organization and asked my opinion on the best way to proceed in selecting a project architect. A building design competition was inappropriate; it seemed wrong to deny the architect the opportunity to develop a program and conceptual designs in collaboration with this client. I therefore suggested that the Getty appoint an architect and only then begin to develop a program and design with that individual as a participant in the planning effort. In order to achieve this goal, I recommended that the Getty identify a panel of individuals who would provide the Trustees with a short list of candidates for project architect.

In the fall of 1983 the Getty Trust empaneled a group chosen to cover as wide a spectrum of relevant interests and knowledge as possible. The committee included the late Reyner P. Banham, Chair, Department of Art History, University of California, Santa Cruz; Richard Bender, Chair, College of Environmental Design, University of California, Berkeley; Kenneth Dayton, Chair, Executive Committee, Dayton-Hudson Corporation, and former member, National Council on the Arts; Anne d'Harnoncourt, Director, Philadelphia Museum of Art; Ada Louise Huxtable, MacArthur Fellow, and former Editorial Board member and architecture critic, *New York Times;* and Craig Hugh Smyth, Director, I Tatti, Florence, and former Director, Institute of Fine Arts, New York University. Williams and Englander served as ex-officio members; the directors of the Getty Museum (John Walsh) and Center for the History of Art and the Humanities (Kurt W. Forster) participated as nonvoting observers, and I served as chair.

The Architect Selection Committee's initial task was to establish a list of individuals who would be invited to submit their credentials for consideration. A selection of thirty-three architects was compiled from various lists made by committee members, Trustees, and other advisers. All of the architects, whose firms ranged in size and location, had produced consistent and distinguished bodies of work. The roster (as of 1983) was the following:

Agrest and Gandelsonas
Luis Barragan
Edward Larabee Barnes Associates
Batey & Mack
Welton Becket Associates
Ricardo Bofill
Daniel, Mann, Johnson and Mendenhall (DMJM)
Eisenman/Robertson Architects
Foster Associates
Frank O. Gehry & Associates
Michael Graves
Gwathmey/Siegel
Hardy Holzman Pfeiffer Associates
Herman Hertzberger
Hans Hollein
Arata Isozaki and Associates
Kallman, McKinnell and Woods
Josef Kleihues
Rem Koolhaas
Charles Luckman
Fumihiko Maki and Associates
Albert C. Martin and Associates
Richard Meier & Partners
Mitchell/Giurgola
Charles Moore
I. M. Pei & Partners (Henry N. Cobb, Jr.)
Cesar Pelli & Associates
William Pereira and Associates
Renzo Piano
Kevin Roche John Dinkeloo and Associates

Moshe Safdie and Associates
James Stirling, Michael Wilford and Associates
Venturi, Rauch and Scott Brown

Since there was as yet no program on paper, I worked with the Getty to put together a small brochure describing the objectives of the institutions that would be the core of the Getty Center and the essential qualities of the architecture that would serve them. The invitation, which included a site map, described the Trust's requirements as follows: "The buildings must be technically sound in construction. They must serve and enhance the programmatic purposes of the institutions and their relationship to each other. They must be appropriate to the site and responsive to its uniqueness. They must achieve the above three qualities in a manner that brings aesthetic pleasure to the building's occupants, visitors, and neighboring community." Throughout the selection process, the importance of human scale and the intention to avoid monumentality were stressed.

On October 1, 1983, the committee dispatched its invitation with the request that the recipients each submit twenty slides of work, a statement of qualifications, a list of clients for projects over $5 million (with references if possible), a firm brochure, and a short essay describing how they might approach the commission if chosen. Responses were reviewed by the committee in November 1983, and seven semifinalists were chosen: Batey & Mack; Fumihiko Maki; Richard Meier & Partners; Mitchell/Giurgola; I. M. Pei & Partners (Henry N. Cobb, Jr.); James Stirling, Michael Wilford and Associates; and Venturi, Rauch and Scott Brown.

Since architecture is a three-dimensional art, not a photographic one, and since the reality of a building can never be realized from pictures and drawings alone, it was felt that the Architect Selection Committee should visit at least two buildings by each of the seven semifinalists. At each site we were met by the architect and, sometimes, the client. Not every member of the committee visited all of the sites, and some were also visited by the Trustees Site Committee. The projects and their locations included:

Batey & Mack
Holt Residence, Corpus Christi, Texas
Napa Valley Houses, California
Pasadena Condominiums, California

Fumihiko Maki and Associates
Iwasaki Art Museum, Ibusuki, Japan
Toyota Kuragaike Memorial Hall, Toyota City, Japan
Main Library, Keio University, Tokyo, Japan
Fujisawa Municipal Gymnasium, Japan
YKK Guest House, Kurobe, Japan
Hillside Terrace Apartment Complex, Tokyo, Japan
Royal Danish Embassy, Tokyo, Japan

Richard Meier & Partners
Atheneum, New Harmony, Indiana
Hartford Seminary, Connecticut
High Museum, Atlanta, Georgia
Museum für Kunsthandwerk, Frankfurt, Germany
 (then under construction)

Mitchell/Giurgola
American College, Bryn Mawr, Pennsylvania
MIT Health Services Building, Cambridge, Massachusetts

I. M. Pei & Partners (Henry N. Cobb, Jr.)
Mobil Exploration and Production Research Laboratory,
 Dallas, Texas
Portland Museum of Art, Maine

James Stirling, Michael Wilford and Associates
Arthur M. Sackler Museum, Cambridge, Massachusetts
Neue Staatsgalerie, Stuttgart, Germany
School of Architecture, Rice University, Houston, Texas

Venturi, Rauch and Scott Brown
Allen Memorial Art Museum, Oberlin College, Ohio
Wu College, Princeton University, New Jersey

In April 1984 the semifinalists were interviewed by the Architect Selection Committee. Only one member of each firm could attend the interview, which lasted about an hour. These informal discussions covered such topics as the degree of commitment each architect could give; the manner in which he would address the programmatic and design stages; his thoughts and attitudes regarding appropriate building materials; his philosophy regarding the site and landscape design; his reaction to the site; his attitudes toward such design elements as lighting, display of art, pedestrian and automobile circulation, and parking accommodations; the organization of his office and plans for association with others; and his personal philosophical and aesthetic vision for the Getty Center. The interviews crackled with excitement and tension.

In the end the committee submitted three names to the Getty Trustees: Maki, Meier, and Stirling. Part of the review process then repeated itself with different players, members of the Trustees Site Committee — John T. Fey, Jon B. Lovelace, Rocco Siciliano, J. Patrick Whaley, and Harold Williams — with Nancy Englander and myself as advisers. In October 1984, eighteen months after the process had begun, the Trustees announced their selection of Richard Meier & Partners.

But this was just the beginning of a long and complex process: developing a design for the new Getty Center. Although architects are accustomed to peer review

and regularly submit their designs for critical review in competitions, a design advisory committee of the sort Harold Williams put in place in 1986 is rare. I was asked to chair the committee. Ada Louise Huxtable and I, both members of the Architect Selection Committee, were joined by designer Saul Bass, architects Frank Gehry and Ricardo Legorreta, and arts patron J. Irwin Miller. After our initial meeting with Richard Meier, in which our role was firmly stated to be advisory, not dictatorial, a cordial and productive partnership developed. One cannot say with certainty how much the committee's dialogue with Meier influenced his thinking or whether he made changes based on his own conclusions. However, we saw a steady evolution of models and drawings from our first meeting to our last.

The Design Advisory Committee held six meetings over a three-and-a-half-year period commencing in September 1986. We were joined by Harold Williams, Trustee Rocco Siciliano, and Stephen Rountree, director of the Building Program. Having received a briefing from Williams, Meier, and Rountree, we visited the site to become acquainted with its challenges and potential.

At one of the early meetings we were introduced to the first of many site models that would become more refined with each iteration. Among Meier's concerns at this early moment were level changes dictated by the site's rugged and beautiful promontories and the difficulty in dealing with the transition from natural terrain to man-made landscape. The committee supported Meier's opinion at the outset that gardens should be an integral part of the visitor's experience and that they should be natural, inviting, and informal in character, in keeping with Southern California tradition. On more than one occasion we reminded ourselves of the need to give the natural landscape, gardens, terraces, and fountains consideration equal to that accorded

the buildings. We tried to think of the outdoor spaces as outside architecture rather than landscape and stressed the importance of discovery and incident to visitors' experience of the garden environment.

An ever-present challenge was presented by the Conditional Use Permit restrictions—in particular, the building height limitation. At several meetings we discussed the fact that this "imposed horizontality" required some sort of vertical focus, such as a campanile, to give unity to the site. Our wide-ranging discussions often dealt with pragmatic aspects of the project, such as the selection of the stone cladding and its color and texture, but just as frequently were devoted to theoretical and poetic considerations. One in particular focused on the massing of the buildings on the site and the historical "hill town" imagery this type of massing recalled. We made frequent visits to the site at different times of the year and simulated the experience of visitors who would park their cars in the garage at its foot and ride an automated tram to the arrival point in the entry courtyard at the top. We noted that visitors would glimpse the complex now and again as they approached the site. It seemed essential that they be able to understand the building concept and entire site plan at the Museum's entrance in order to feel at ease.

In the meantime a steady procession of ever larger and more detailed architectural models emanated from a small shop equipped and staffed to produce generations of simulations of the Getty Center. Gradually, the immensity and complexity of the project reached our consciousness. By our final meeting the site had come alive for us, and its unity was balanced by the distinct character of each element on it and the revelation of intimate scale despite the complex's large size. And the

committee was able to see tangible evidence of the design: a road carved from the base of the site to its summit, with a retaining wall of concrete masonry — to be faced with stone later — and excavation work at the base of the property.

It is a credit to Richard Meier's intelligence that he was somewhat cautious about, and more than a little skeptical of, the value of such an oversight group, particularly one with credentials accompanied, more often than not, by strong biases. And it is a credit to his generosity of spirit that at our final meeting, he acknowledged the value of his dialogue with the committee during the development of his design.

The Architectural Program

Stephen D. Rountree

In looking back over the seven years devoted to the planning and design of the Getty Center, it seems to me that three principal factors combined to shape both the process and the product: the unusual breadth and complexity of the Trust's programmatic objectives, our determination to have an intensive and thoughtful collaboration with the architect, and the site, which is extraordinary in terms of its prospects but demanding as well. It was some time before the cumulative effect of these factors was fully understood by us. Even now, with Richard Meier's accomplished design in front of us, it is easy to lose sight of them.

The Trust requires a wide range of specialized building types. While there are certainly campuses that contain similar facilities, it is unusual for any institution to undertake the detailed design and construction of such a varied array of buildings in a single effort. The Museum will require display space for diverse works of art — European paintings of all periods; French seventeenth- and eighteenth-century decorative arts, including restored period rooms; photographs; drawings; sculpture; and illuminated manuscripts — and for temporary exhibitions. The same facility will present educational programming for a diverse regional audience. It will also house extensive laboratories and workshops for conserving the collections. The Getty Conservation Institute will house sophisticated scientific research laboratories, specialized training facilities, a conservation library, and various information and publication services. The Getty Center for the History of Art and the Humanities will provide research facilities and seminar space and house staff together with a unique collection of resources, including a library with over a million volumes, five million photographs, and various special collections of primary research materials. Offices will be needed for other programs and activities, including the Center for Education in the Arts, the Art History Information Program, the Getty Grant Program, and Trust operations. Serving all of

these activities will be a multipurpose auditorium for public events originated by the programs, extensive restaurant facilities for staff and visitors, underground parking facilities for nearly sixteen hundred cars and a dozen buses, an automated electric tram to transport people up and down the hill, and sophisticated central building systems for environmental control, security, and telecommunications.

Each of these components was carefully described in the Architectural Program given to Richard Meier in March 1986, and each presented him with a difficult challenge. The overriding objective was to see that each piece of the whole worked on its own terms while also serving the larger purpose: to balance the diversity of programmatic needs within the framework of a single institution.

While the full extent of the Trust's programs was not made apparent to Meier until the Architectural Program was completed, that was only one milestone in a process of planning and exploration which is ongoing. Following Meier's appointment as project architect, we initiated a series of collaborative discussions intended to engage those principally involved in the planning, including Nancy Englander, Kurt W. Forster, Luis Monreal (then director of the Conservation Institute), John Walsh, Harold Williams, and myself. We had several objectives. First, we wanted to establish a basic level of rapport between the architect and his clients. This included developing a common framework and vocabulary for discussing architectural and programmatic issues. Second, in 1985 the planning process presented one of the first opportunities for three of the program directors — Forster, Monreal, and Walsh — to share their thoughts on the future of their programs and the nature of the interaction between them. The particulars of the broad vision enunciated by Harold Williams were forged during these discussions. Finally,

we wanted an opportunity to listen to Meier and to each other as the architectural ideas that might come to characterize the Getty Center were developed.

On three occasions during this exploratory process, members of the planning committee visited buildings and sites we felt might teach us something or spark our imaginations. At that juncture we were particularly interested in the character and spirit of places, not in their technical aspects. (That would come later in numerous site visits made to study particular issues.) Ultimately, Italian examples provided both a historical context and a point of departure for developing answers that fit Los Angeles. The gardens and hill towns of Italy engendered a variety of inspirational experiences in settings similar to our own. The specifics were not the point. Obviously, Richard Meier was not going to recreate the Villa Lante or Certosa del Galuzzo. But these places and many others caused us to think and talk about the scale and texture of outdoor spaces, the sensory impact of moving water, the relationship between intimate alcoves and open plazas, and the entire dialogue between buildings and their surrounding garden spaces.

To experience the differences in the way museum buildings accompany the works of art they house, we visited dozens of museums in the United States, Canada, and Europe. The nature of the light in the galleries, the color and texture of wall surfaces, the proportions of rooms, the relationships between the buildings' structural vocabularies and the works of art, and the nature of circulation were all of primary concern to us. The virtues and faults of each building were debated. Walsh and Meier came to understand each other and started to lay the framework for the new Getty Museum's design. In the summer of 1985, during a lively discussion in Orvieto, Italy, they began to articulate the

basic scheme that remains central to the Museum's conception. The collections would be displayed in several intimately scaled, two-story gallery pavilions linked around a garden. The upper galleries, housing paintings and some sculpture, would be illuminated from above with lively daylight.

In an effort to better understand the character of the Center for the History of Art and the Humanities, we visited both venerable and new study centers and libraries. In the process we came to realize that this facility would represent a unique amalgam, drawing upon traditional building types — library, college, archive, and monastery — to create a very different sort of enclave dedicated to interdisciplinary research. The first design schemes tended to reflect the more traditional library models we had seen. But over time, Meier's architecture realized the possibilities for a fresh physical setting for scholarly work. This proved to be valuable to Kurt Forster and his staff as they worked to refocus the functional organization of the Center for the History of Art and the Humanities.

All of this took time. But it was an essential process by means of which our programmatic vision was established. My staff and I then began to assemble the specifics needed to prepare a full program. We had created expectations and a model for collaboration that was unusually intense.

Aspects of the collaborative process were probably daunting to Richard Meier. By 1986 the Trust's objectives had grown to encompass six distinct programs as well as the central administrative operations. At least a dozen senior staff members had important input to the design process. In addition there were over forty key users who were, at some point, actively involved in the detailed planning effort and design review. While my staff and I represented the Trust and orchestrated

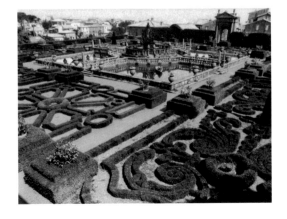

planning and design review activity, the nature of the Trust's commitment to a collaborative effort meant that Meier and his associates were asked to listen and respond to an unusually large number of relatively independent, determined clients. While this suffused the entire enterprise with creativity and a variety of perspectives, it also led to a tendency to compartmentalize the planning and design, to deal with each component on its own terms, apart from the rest. This was probably inevitable. However, Meier did not let the design of the pieces become more compelling than that of the whole. While he continued to work with us pragmatically and carefully to fill out each program, that very process seemed to convince him of the need to impose unifying and integrating elements upon the architecture. As time passed he devoted more and more of his energy to the effort to bring unity and clarity to the overall complex of buildings and gardens.

In the course of these explorations, the hilltop site was both an inspiring and a controlling factor. When Meier first described his concept for the site plan in 1986, it was clear that he saw the site itself and the buildings on it as an integral part of the urban fabric of west Los Angeles. The setting, while natural, is not remote or bucolic. It is riveted to the city. One of its greatest advantages is accessibility. At the same time it benefits from its relative elevation, which gives it definition, permits the creation of a garden setting, and provides a perspective on the city and the ocean beyond. Its urban situation gives added purpose and perspective to the place. The Getty Center will be an urban park or garden, one of the few in the city and certainly one of the most available and compelling.

Home owners who lived adjacent to the site supported the notion of a new art museum, public gardens, auditorium, and other programs, but they were understandably concerned about the impact of such a place on their community. Our ability to develop the site — which had been zoned for residences — depended on securing the approval of local residents as well as the Los Angeles Planning Commission. In 1984 we had decided that we must have at least tentative approval before asking the architect to begin any serious planning or design work. During 1984 and 1985 we worked closely with elected officials and home owner representatives to establish a basic framework for the design and operations of the proposed Getty Center. Their concerns related principally to such matters as traffic, privacy, noise, night lighting, landscaping, and the scale and appearance of the buildings.

By March 1985 we had achieved a general accord on all of these matters. A Conditional Use Permit created a set of written conditions and a rough envelope that defined the limits of mass and height for the buildings. Meier, who was hardly involved at this point, was asked to develop the site plan in conformity with the terms of this permit. Many of the conditions limited the scale of the project. The height limits were important to the community but were difficult to interpret and frustrating to design around. The master plan for the site was approved by the city in 1987, subject to further conditions regarding landscaping (for protection of privacy) and the exterior treatment of the buildings. The key to the 1987 master plan was the recognition of the need to interpret height limits within the topographical context. In early 1991 the final design was confirmed. In effect the zoning process established several community groups as essential participants in the site plan approval process. In the end not a single critical architectural element was diminished, and we were able to move ahead with a large construction project with an extraordinary degree of community approval and support.

The Getty Center project design is compelling because these elements have conjoined to make it *possible* to create a place of distinction and quality. The site combines beauty, prominence, and accessibility while affording the opportunity to bring disparate programs together. The range of building requirements has presented a unique set of challenges. Our determination to meet the objectives by means of an unusually close collaboration with the architect and his associates has enriched the process and, I believe, the resulting design.

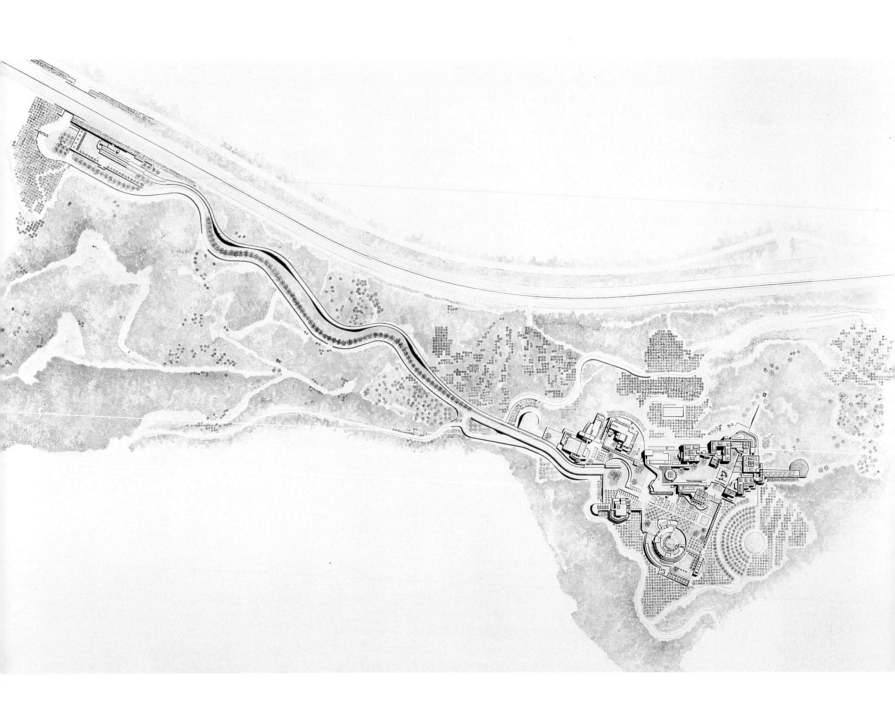

When Richard Meier & Partners received an invitation from the J. Paul Getty Trust in October 1983 announcing its intention to choose an architect for the Getty Center and soliciting submissions for review, I was immediately fascinated by the complexity, scope, and opportunity the project promised. On November 1 we responded with a letter that included the following statement:

Design Philosophy
Through design we seek to organize the environment aesthetically and to invest space with a coherent and meaningful set of values. We believe we share the attitude of those who have conceived and are guiding the J. Paul Getty Trust Art Complex project: a commitment to the highest standard of artistic quality, something inseparable from the highest quality of life. The new buildings of the Art Complex should contribute to the Trust's cultural mission in the broadest sense. Through their architecture — the shaping of space, the control of light, the organization of program, the pattern of circulation — they should create an ambience congenial to contemplative and creative use and the reinforcement of aesthetic values. In this way those who come to the complex will benefit from their experience not only of the art displayed and conserved but of the architecture as well. If the complex's purpose is to pursue cultural "enlightenment," this metaphor can also inform the architectural conception: the building can be both literally and metaphysically "radiant," a beacon of the cultural life of Los Angeles and the art community at large.

The new complex must respond to functional and internal concerns, but it must also be sensitive to the natural context of its site and the architectural patrimony of its region. Indeed the parti *must be largely determined by the terrain. A site like the one chosen by the Trust, with its great natural beauty and double orientation to downtown Los Angeles and the Pacific*

Ocean, offers an inspiring source of conception. It evokes the combination of urbane and contemplative aspects which characterize the complex's purpose.

Upon learning that Richard Meier & Partners was one of the seven semifinalists, I was of course delighted, and I went to Los Angeles to understand more about the Getty. I visited the Museum in Malibu and spent a good deal of time on the site.

In April 1984 I attended my first interview with the Architect Selection Committee. The committee subsequently spoke with me in my New York offices and in conjunction with several site visits to projects I had designed. When the Trustees reviewed the work of the three finalists, the Trust asked me to describe the materials I envisioned for the project. In August 1984 I wrote:

Architecture is an art of substance, of materialized ideas about space. Between the demands of program, site, locale, and building technology the architect has to find a means of making the buildings communicate in the language of materials and textures. Buildings are for the contemplation of the eyes and the mind but also, no less importantly, to be experienced and savored by all the human senses. You cannot have form in architecture which is unrelated to human experience; and you cannot approach an understanding of experience, in terms of architecture, without a strongly sensuous and tactile attitude toward form and space. The spectacular site of the Getty Complex invites the architect to search out a precise and exquisitely reciprocal relationship between built architecture and natural topography. This implies a harmony of parts; a rational procedure; concern for qualities of proportion, rhythm, and repose; precision of detail, constructional integrity, programmatic appropriateness; and, not least, a respect for human scale.

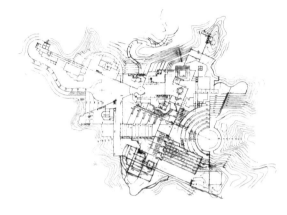

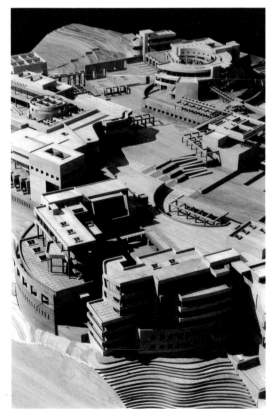

All of these issues relate intimately to the choice of materials.

The material elements of the complex — the composition and character of masses, textures, volumes — must in fact be determined by specific, sensitive reactions to the site and by typological responses derived from the programmatic requirements. At the same time the unity of the whole complex must also be ensured by a governing conceptual idea regarding the usage of materials. This concept may be derived from a basic idea of the complementary relationship between built form and natural form, something which may be seen in all of my previous work. This relationship of complementarity does not so much imply opposition as it does harmony and balance.

Besides its topography, the most powerful aspect of the Getty site is the quality of the light that is natural to it, which is astonishingly beautiful. That clear, golden California light is, I must say, intoxicating to an Easterner. I long to make walls that have openings for the glorious light to flood through, casting crisp, delicious shadows. I am eager to see built structures set against that brilliant blue sky of southern California. I can envisage a complex based on a horizontal layering of spaces that relate both to the site and to the nature of the collection.

Besides this American attitude of openness, warmth, flexibility, and invention, my vision of the building also has to do with a more European-derived ideal of permanence, specificity, and history. The materials used should reaffirm this image of solidity, of permanent presence in the landscape. Architecture at its best is simplicity with material richness, an interest in technical innovation with respect for historical precedent.

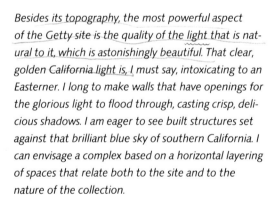

Thus I can envision a complex made up of larger volumetric pieces counterpointed by smaller elements made of materials that lend themselves to light, delicate frame-like structures. The volumetric pieces would probably be constructed of materials that are massive, made for permanent anchoring, and solid and rock-like in appearance, stable, long-lived. One thinks of various cut stones, such as granite (smooth and rough textured), travertine, marble, sandstone, limestone. Stone could be used both in large-scale and small-scale blocks, on both vertical and horizontal surfaces, its sizes and textures juxtaposed in order to play off intimate surfaces against more massive ones.

The counterpoint to the stone elements in the complex would be likely to include materials such as aluminum, bronze, nickel-plated, or stainless steel surface treatments or structural components, as well as many kinds of glazing. All of these would, of course, have to be compatible with the Southern California climate. Thus we imagine a dialogue: a massive enclosure, but also open, lightweight, transparent glazed areas.

But once again, it's not just a matter of opposites — there must be a balance that is related to the site, to the contours and history of the land, to the program, as well as to the plasticity of the whole composition. I am also thinking about the beautiful effect of long, massive expanses of whitewashed stucco wall such as one sees in many Spanish Colonial buildings. This may be something we would also like to strive to capture here, whether in stucco itself or in some more refined material with analogous properties of texture and density. We can envision using a material of this kind in some of the more domestically scaled, intimate spaces that have an informal character but still demand a classic material expression.

Naturally, the scope of the materials selected and the colors integrally implied by those materials have

to be determined by that relationship between all finishes and components. This means that one must look at the whole while also remaining sensitive to even the smallest-scale building elements, from copings, roofing materials, skylights, hardware, mechanical and electrical devices to landscape elements and outdoor furniture.

When we address the issue of interior materials (and we are thinking now specifically of the museum component of the program), the most important aspect is that the objects within the collections should emerge as the major protagonists of the space. Therefore the choice of wall, floor, and ceiling surfaces will have to vary according to the contents of rooms. This means that all backdrops need not necessarily be painted plaster walls but may be materials derived more carefully from scale considerations, the "ambience" or atmosphere one wishes to create, and the comfort and appeal to the museum goer of a variety of different surface treatments. These could include such hard and soft materials as wood and fabric. Naturally, the treatment of the interior is related to that of the exterior and integral to the architectural conception as a whole; in both there must be a paramount concern for materials that age well and function well. Finally, I should emphasize my belief that all materials ought to be studied on the site and under natural conditions of light and coloration. Extensive sample and test panels should be erected and full-scale models of room interiors built. Nothing should be finalized until such on-site experiments have been studied and discussed.

In my mind's eye I see a classic structure, elegant and timeless, emerging, serene and ideal, from the rough hillside, a kind of Aristotelian structure within the landscape. Sometimes I think that the landscape overtakes it, and sometimes I see the structure as standing out, dominating the landscape. The two are entwined in a dialogue, a perpetual embrace in which building and site are one. In my mind I keep returning to the Romans — to Hadrian's Villa, to Caprarola — for their sequences of spaces, their thick-walled presence, their sense of order, the way in which building and landscape belong to each other. The material substance of the Getty Complex must come out of the history and regional tradition of California, out of its colors and textures, its openness, warmth, and ease, as well as out of a timeless tradition of architecture itself. Sensitive to the natural tactilities of materials and solidly, precisely constructed, the place will have beauty and elegance and be a classic expression of contemporary California, a fresh and eternal building.

Seven years have passed since the Trust chose Richard Meier & Partners to design the Getty Center. The complexity, scope, and opportunity I anticipated from the 1983 invitation have all materialized; the design process has been both a challenge and a source of exhilaration. Although some of my ideas about the project have changed in the intervening time, the basic principles that underlie our final design have remained largely consistent.

The Getty Center will occupy a narrow, hilly site that stretches along Interstate 405. With its native chaparral and breathtaking views of the city, mountains, and Pacific Ocean, the site has had a powerful influence on my thinking throughout the design process. Most of the buildings will rise on two ridges that form the southern end of the Getty's 110-acre parcel, meeting at an angle of 22.5 degrees. To the east the freeway precisely supplements this angle as it bends from its north–south alignment with the Los Angeles street grid in order to traverse Sepulveda Pass. The 22.5-degree shift suggested two axes for our building grid.

The Getty Center will establish a dialogue between this grid and curvilinear forms derived from site contours. Taking its cues from the freeway and street grid, the geometry of the ridges, and smaller topographical features, our design establishes the project's place in the city of Los Angeles and the Santa Monica Mountains, as well as each building's relationship with its more immediate surroundings.

Three-quarters of a mile to the north of the main complex and below it, a parking garage and tram station will mark the public entrance to the Getty Center. Museum visitors will drive under a freeway overpass, park in the garage, and board an automated tram for a four-minute trip to the top of the hill. Along the winding route the site will gradually unfold before their eyes. Scholars, business visitors, and some Getty employees will bypass the tram, driving instead up an access road that will run parallel to the tramway and parking in a garage underground at the top of the hill.

At the end of the tramway and access road, the Getty Center will spread out from a hilltop arrival plaza. To the northeast the 450-seat Auditorium, Art History Information Program, Center for Education in the Arts, Grant Program, Conservation Institute, and Trust offices will occupy one group of buildings. The Museum, five buildings in all, will extend southward along one of the diverging ridges. The Restaurant/Café building and the Center for the History of Art and the Humanities will stand along the other ridge to the southwest. Much of the complex will be built at several levels below the hilltop grade of 896 feet. All buildings on the site will be connected underground at the 876-foot level.

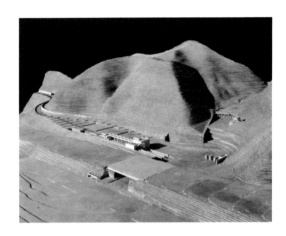

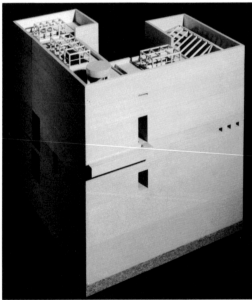

Upon ascending the steps from the Entrance Plaza, visitors will be presented with an array of choices: enter any of the buildings at once or explore the gardens first.

Visitors to the Museum will enter the lobby from beneath a top-lit overhang. The lobby itself will focus on a tall cylindrical space, and it will be extensively glazed in order to provide views through a courtyard to the gallery pavilions. The small pavilions themselves will serve to break down the scale of the whole. They will permit glimpses of the world outside as well as a steady interplay between interior and exterior spaces.

Exhibition spaces will be organized by both period and medium. A clockwise horizontal progression around the main courtyard will allow visitors to experience the collections chronologically, and different media will be split between the two levels of galleries. Paintings will occupy the upper floor of every gallery pavilion in order to take advantage of the top light that suits them best. Decorative arts and works on paper will be housed in lower-level galleries shielded from the sunlight that is so destructive to such pieces. Sculpture will be displayed on both levels.

The Museum scheme will offer choices at every turn. By switching floors within the same pavilion, visitors will be able to experience different media within the same period. Or, if they prefer, they will be able to look at a single medium through time by exploring only one level. Several special exhibition spaces — including one for mid-size exhibitions — will offer relief from a purely chronological tour through the gallery pavilions. Visitors who want to see only part of the collections will be able to take a secondary route, bypassing certain galleries.

Since most visitors will come to the Getty Center for a half day or more, it is expected that the Restaurant/Café building will be a major attraction. In addition to private rooms for meetings, this building will provide the complex's dining facilities. Its location on the arrival plaza will make the building convenient to the entire site, and its windows and terraces will afford outstanding views to the north and west. Across the arrival plaza, the Auditorium — the other major public building — will seat 450 people for lectures, concerts, and other cultural events. It will stand to the west of the Art History Information Program and Trust offices, which will mark one end of the complex's long east elevation. Between the former and the first Museum pavilion, the Conservation Institute, Grant Program, and Center for Education in the Arts will occupy the most open, California-influenced building on the site. Because the offices of these three programs have somewhat more relaxed climate control requirements, their building will take full advantage of the beautiful local weather with generous glazing and open walkways.

Along the more private western ridge, the Getty Center for the History of Art and the Humanities will complete the complex. The program comprises a million-volume library, reading rooms, study carrels, a small exhibition space, and offices for staff and scholars. The building's curvature will evoke the essentially introspective nature of scholarly activity. The program's commitment to accommodate a variety of scholarly itineraries and to stimulate interaction among researchers and staff suggested a radial scheme. Research material will not be centralized but will be organized around a central core in small libraries. The plan will encourage scholars to explore other areas in the open stacks as they look for their own materials. Staff members will retrieve materials from the closed stacks, which will be housed below grade. Employees,

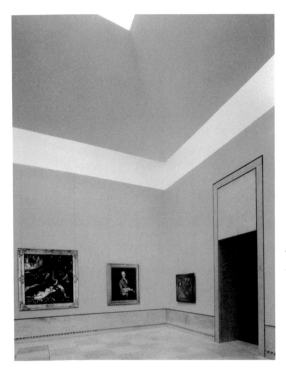

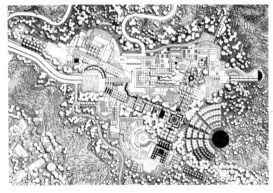

visitors, and scholars will then be able to use the materials in the reading room, carrels, and offices. Some of the offices for scholars will be arrayed around the top floors; the rest will be located in the Scholars' Wing, a smaller, secluded element at the ridge's southern end.

Throughout the hilltop complex and at the North Entry, landscaping will unite built forms with the existing topography. Garden extensions — architectural features that reach beyond the building envelope — will punctuate the entire composition with prominent site features. Water will also play an important role in uniting the man-made structures with the natural site. A series of small fountains and waterways will run among the buildings and through the central gardens between the two ridges.

The exterior cladding materials for the Getty Center will reinforce the balance we envision between buildings and site. The cladding will also be appropriate to the several programs and to the scheme we have created for each building.

All of the Museum buildings will be clad in rich, textured stone. The Museum is the Getty's most public program, and stone can be thought of as a traditional material for public architecture. But the Getty Museum also celebrates certain qualities that especially suggest a stone exterior: permanence, solidity, simplicity, warmth, and craftsmanship. Finally, a good stone — a stone that *looks like* stone — offers a connection with the landscape that no other material can provide. For this reason we will also use stone to clad most retaining walls throughout the site.

The Center for the History of Art and the Humanities, Conservation Institute/Center for Education/Grant Program, Art History Information Program/Trust, Auditorium, and Restaurant/Café facilities will be more curvilinear in their exterior forms than the Museum's solid orthogonal pavilions. They will also be more fluid and open in architectural expression. With the exception of the Auditorium, all of these buildings demand liberal glazing — both to admit light and to provide views from within. We will use clear glass for all windows and also plan to use glass block in some areas.

I had several criteria for the cladding on these buildings. The opaque surfaces require a material that is simple, pliable, panelized, and relatively light — one that will complement both the glazing and the stone-clad site walls below. In answer to these demands, we expect to use porcelain-enameled paneling. Like stone, this material is permanent, and it will lend a uniform scale to the buildings it will cover. Such panels have a particular advantage in that they can easily be molded to fit the structures' fluid, sculptural forms. The panels will provide an elegant surface. The enameled finish will emphasize the light, transparent qualities of the buildings without being highly reflective — without being shiny. At the same time this material will offer both a contrast and a complement to the Museum's stone surfaces. And it will be a subtle reminder of the landscape with which I have become so familiar; I see these buildings absorbing the greens and blues of the surrounding hills and sky.

The entire built project, then, will embody an essential, classic drive: the drive to find enlightenment and inspiration in the highest achievements of humankind. The Getty Center's regular rhythms and axial organization will accentuate the rational, the human. At the same time the buildings will take shape on a wild hilltop — or, more accurately, *around* and *within* the hilltop. Their alternately fluid and massive forms — and the materials we will use to express these forms — will strike a balance between classic human concerns and the natural substances of the rugged setting.

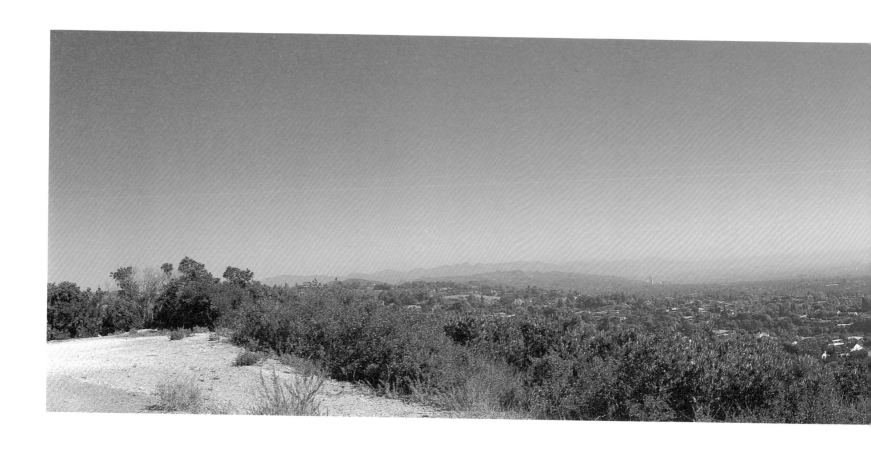

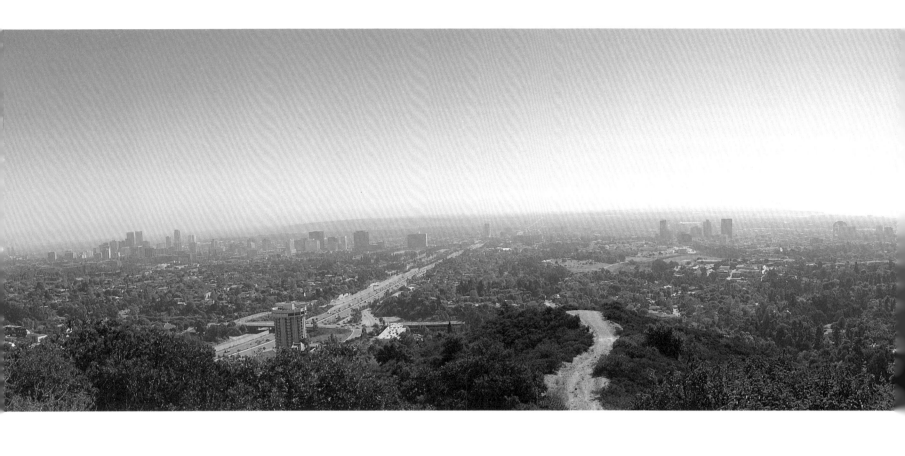

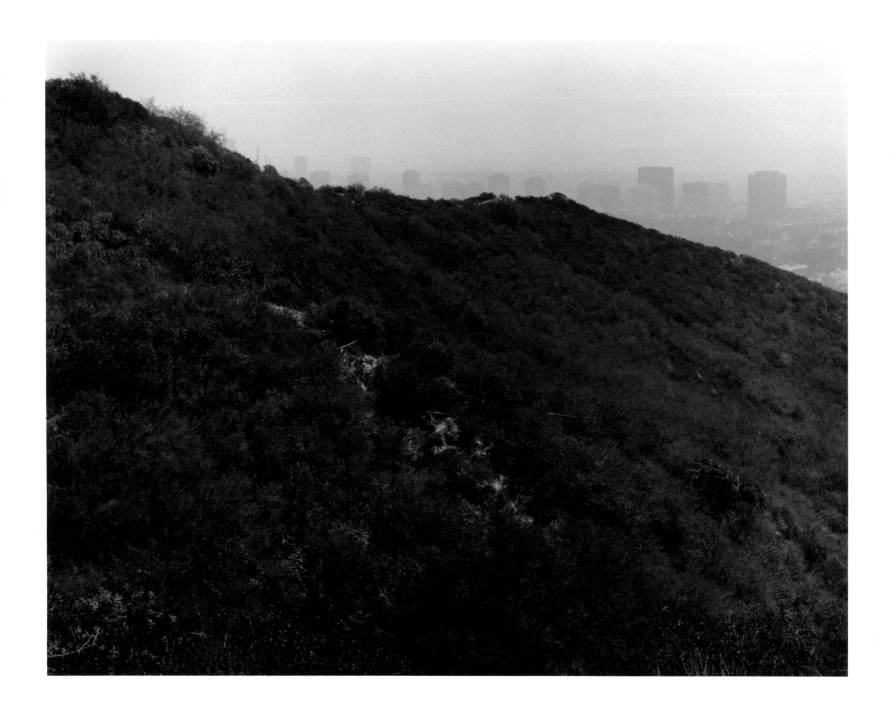

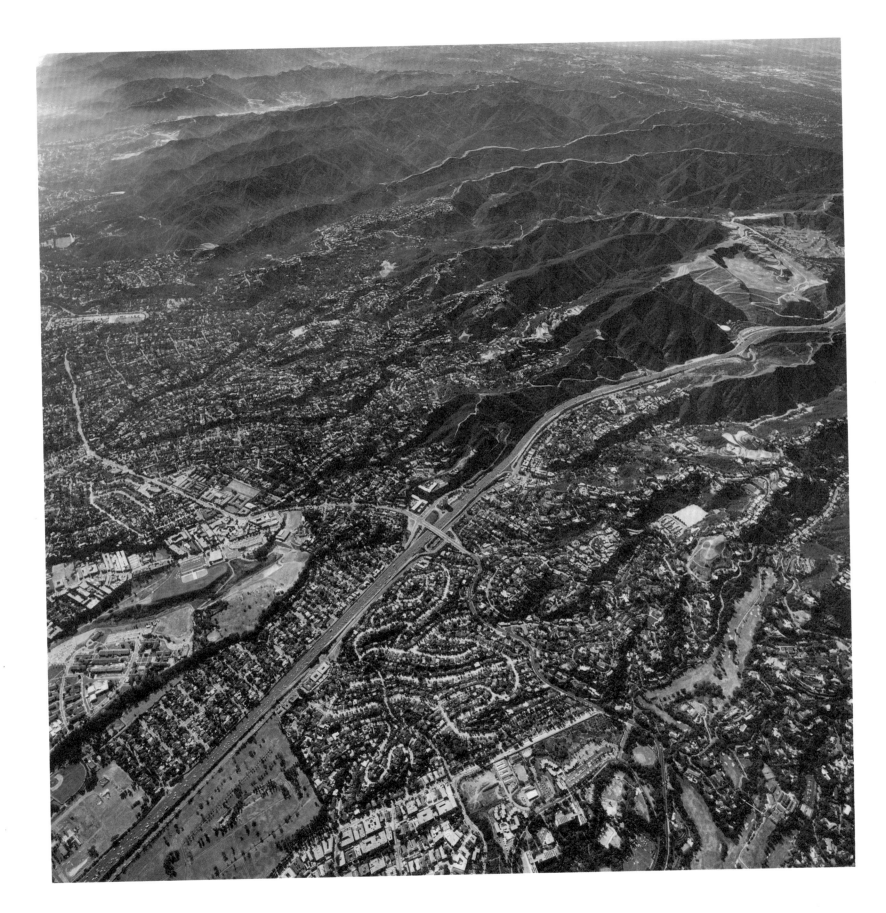

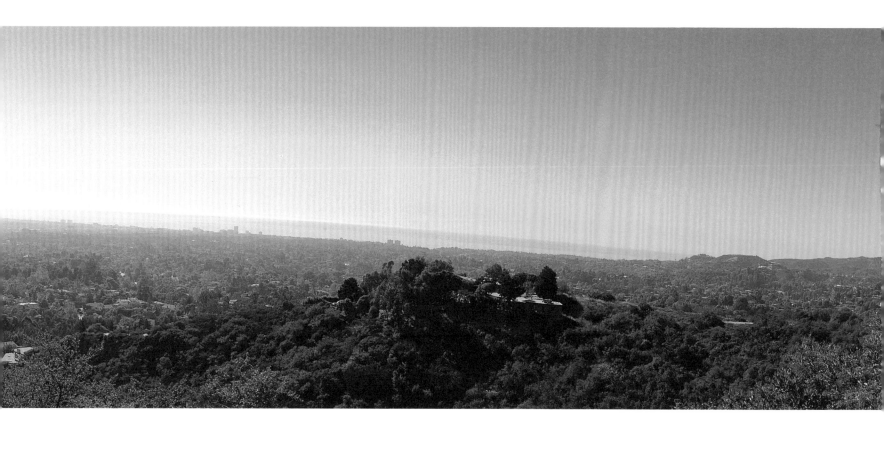

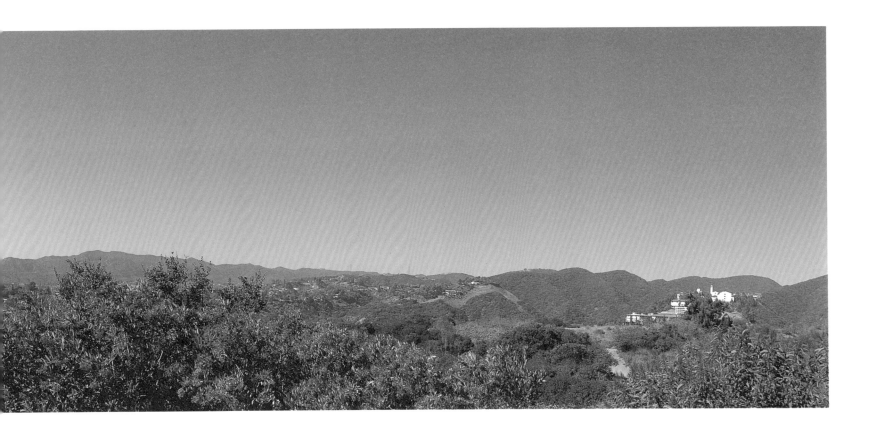

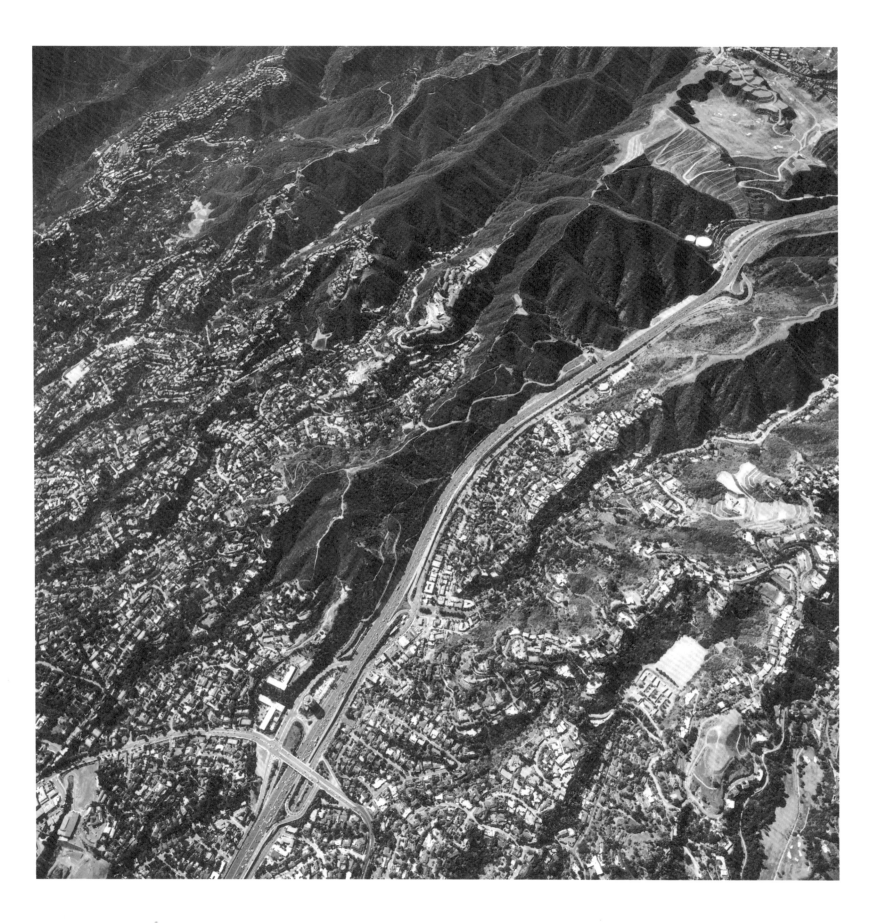

1987
Aerial views of site
View to east (Century City)

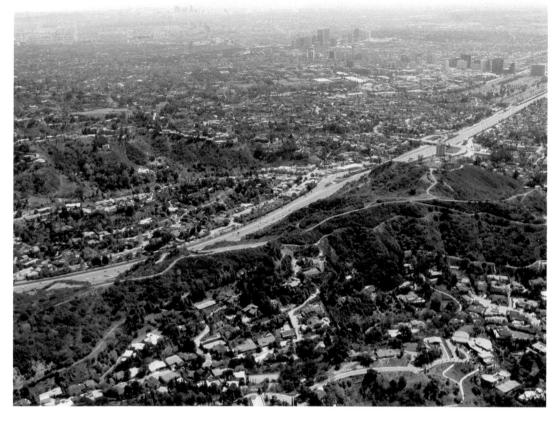

View to south

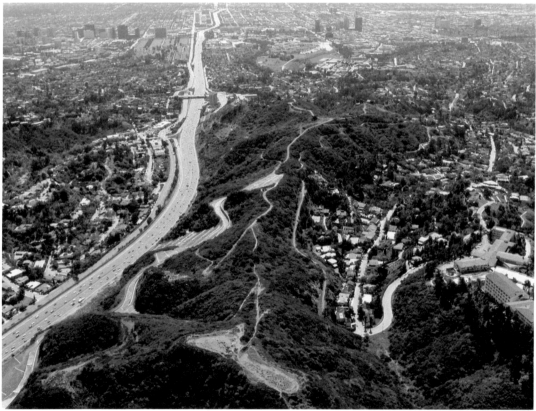

View to southwest

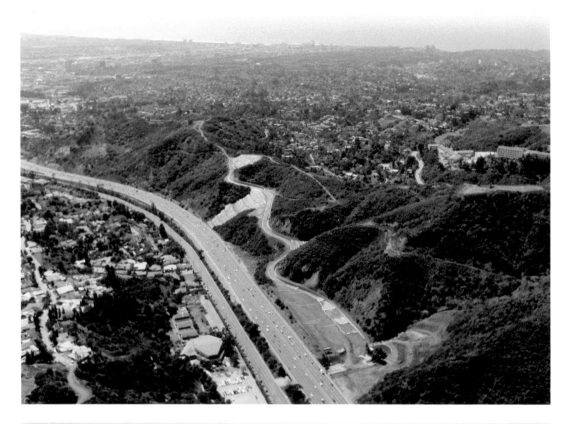

View to north

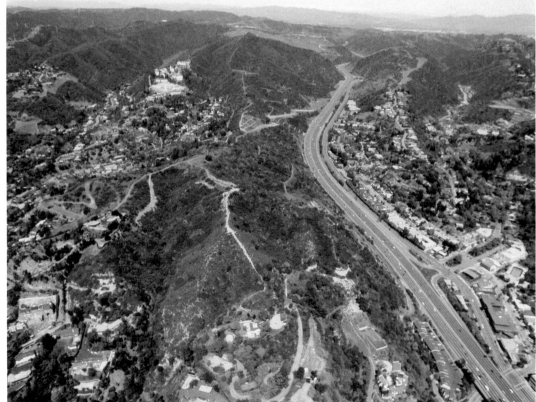

1985
Site
View to north (page 32)

View to east (page 33)

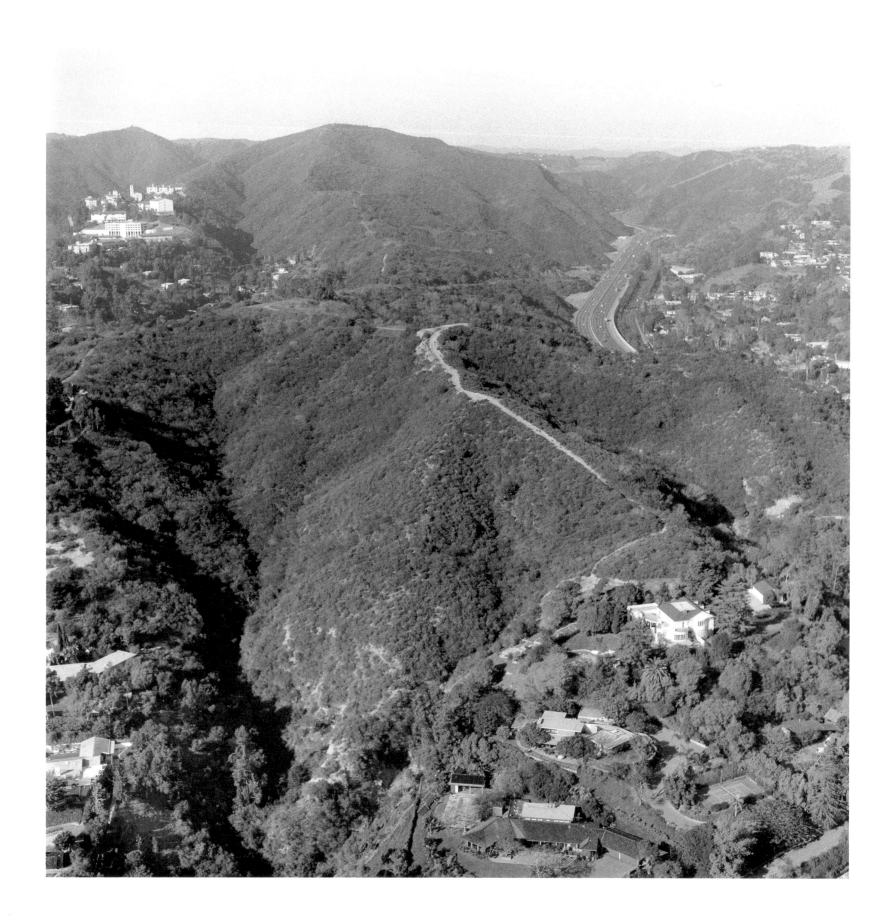

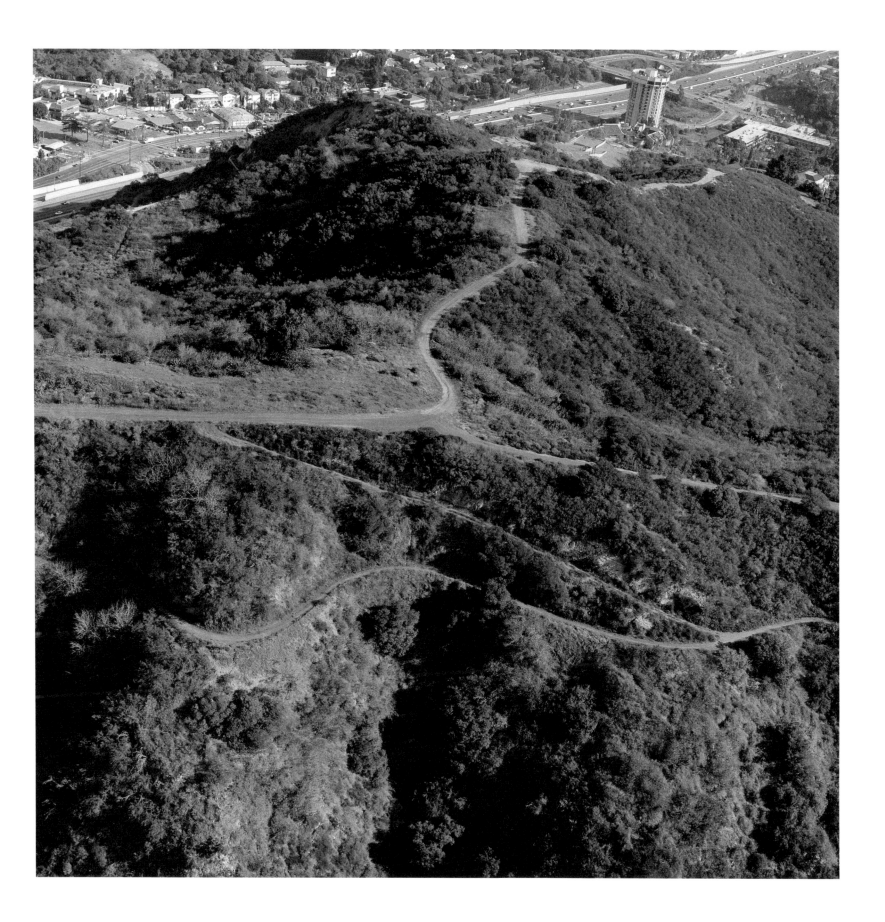

1984
Site
View to south

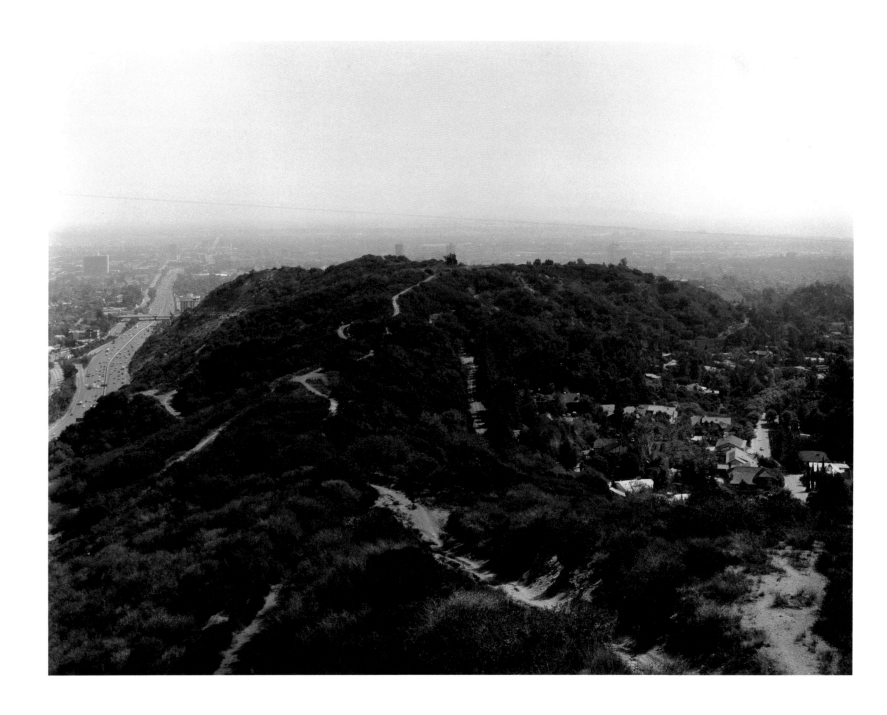

The site organization was generated by the city grid and a north–south axis that aligns with an existing ravine and bisects the site, providing the central focus for the complex. Many of the city's dominant features are visible from this elevated promontory.

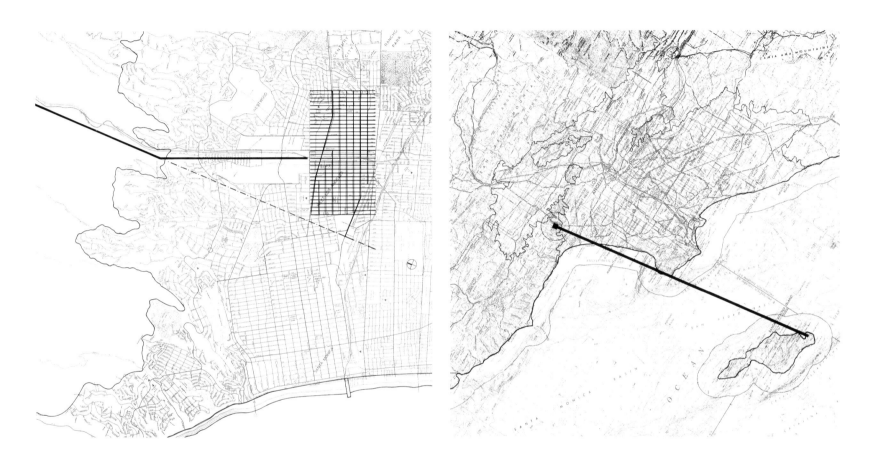

SEPTEMBER 1988
The building envelope is somewhat
limited in plan and elevation by
a Conditional Use Permit.

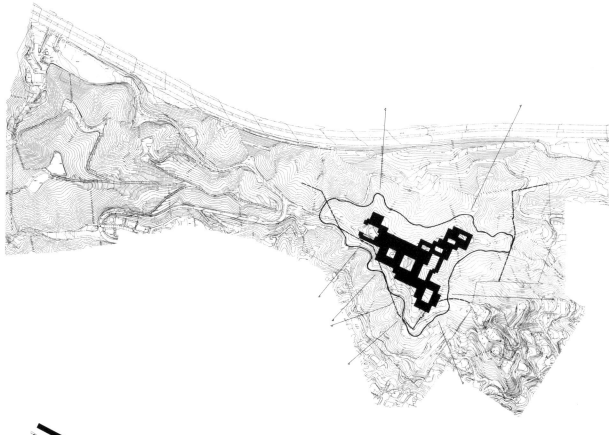

A dialogue has been established
between curvilinear forms — derived
from site contours — and building grids,
which relate to the city fabric
and freeway axis.

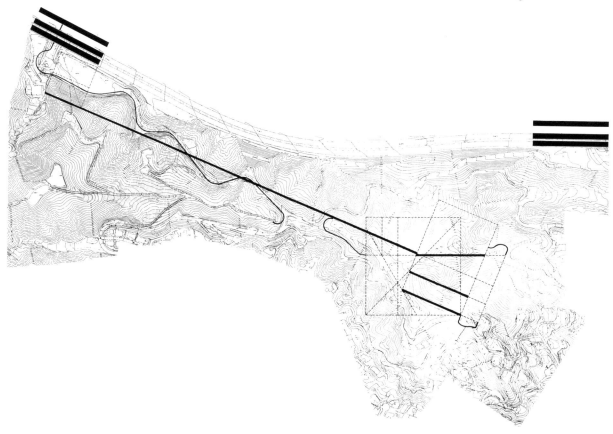

36

Geometric relationships have been articulated along ridges to establish the placement of building masses.

The garden extensions, which reach beyond the building envelope, register the composition with prominent site features.

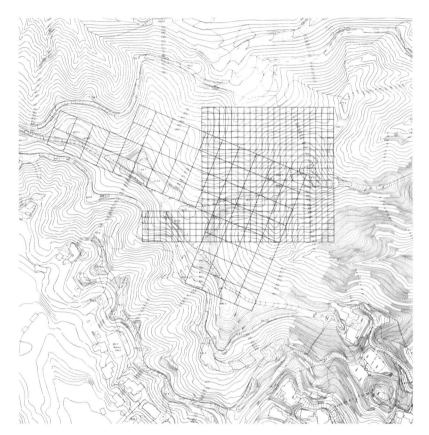
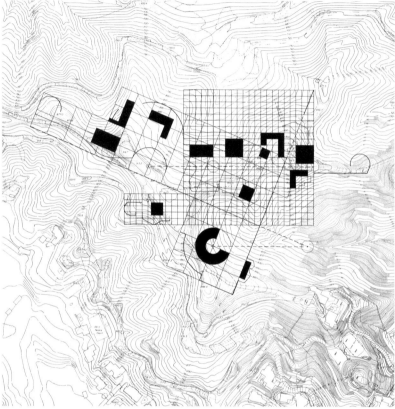

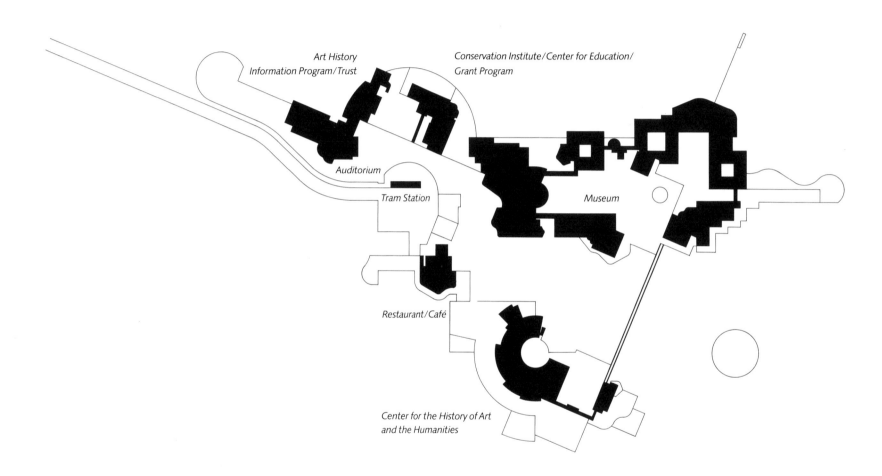

Art History
Information Program/Trust

Conservation Institute/Center for Education/
Grant Program

Auditorium

Tram Station

Museum

Restaurant/Café

Center for the History of Art
and the Humanities

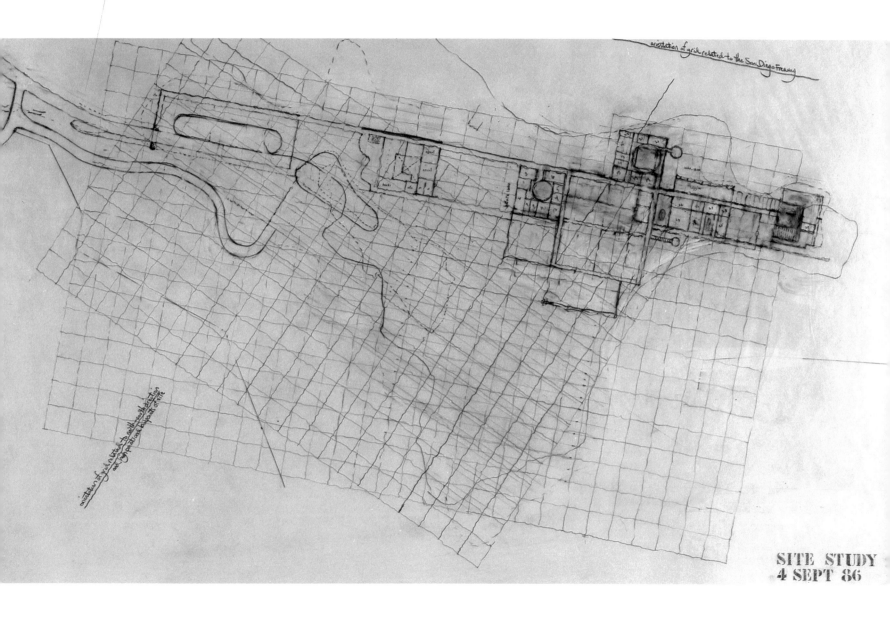

SITE STUDY
4 SEPT 86

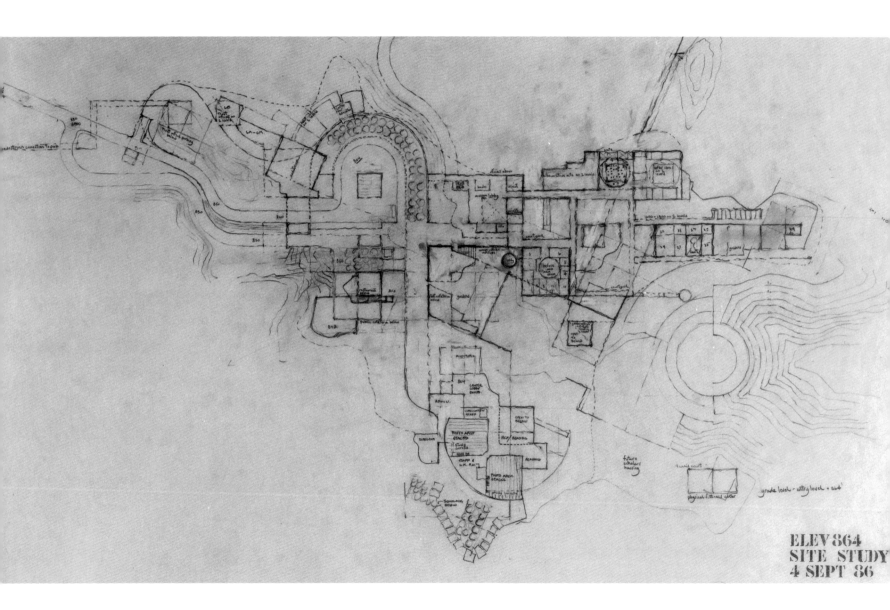

ELEV 864
SITE STUDY
4 SEPT 86

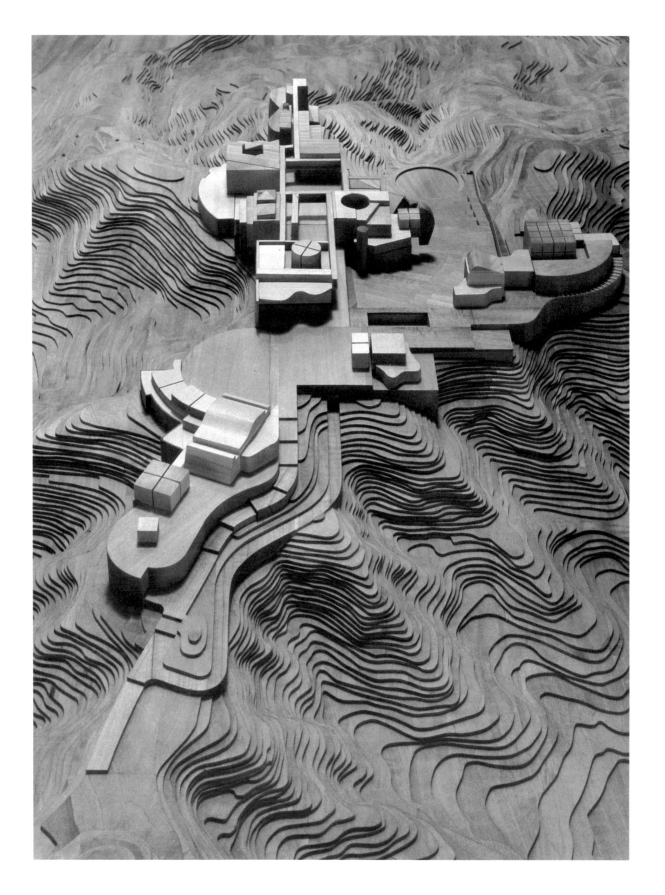

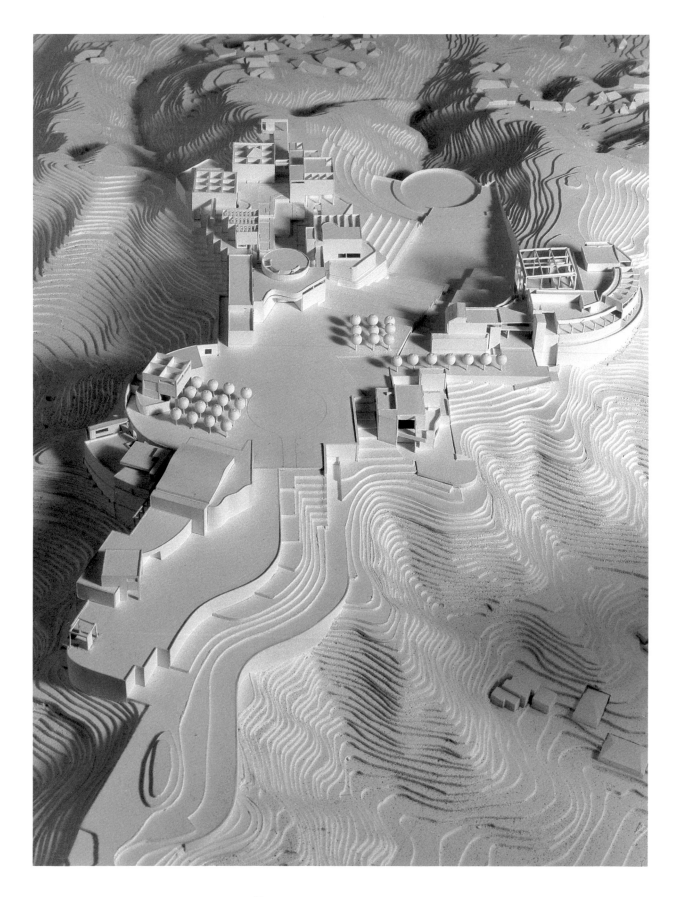

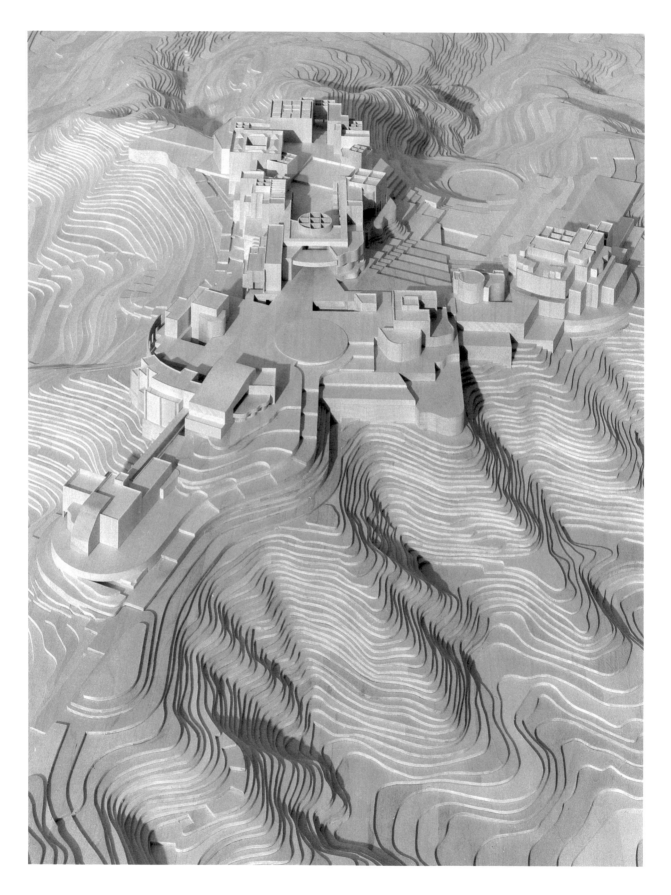

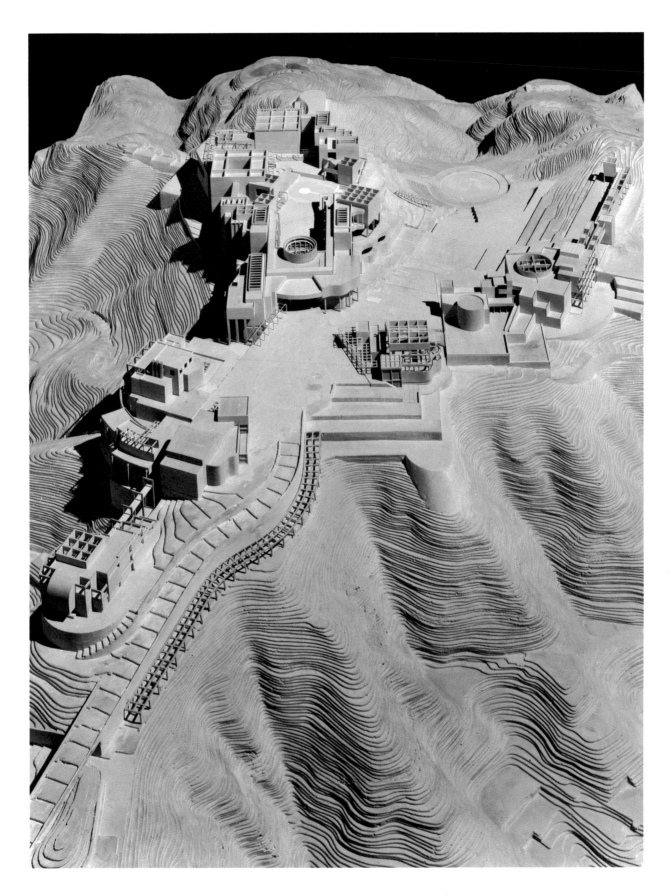

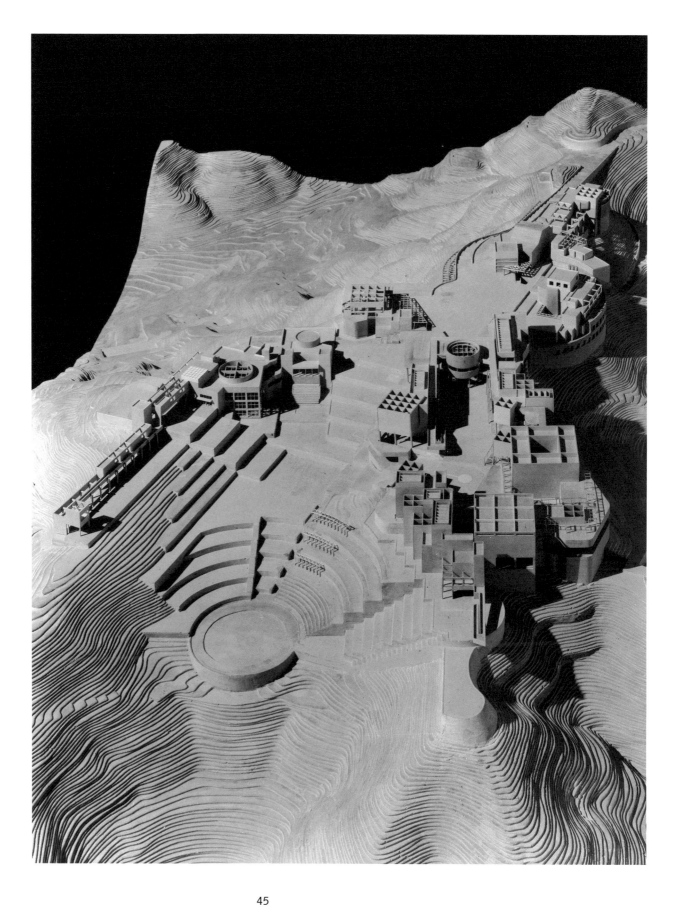

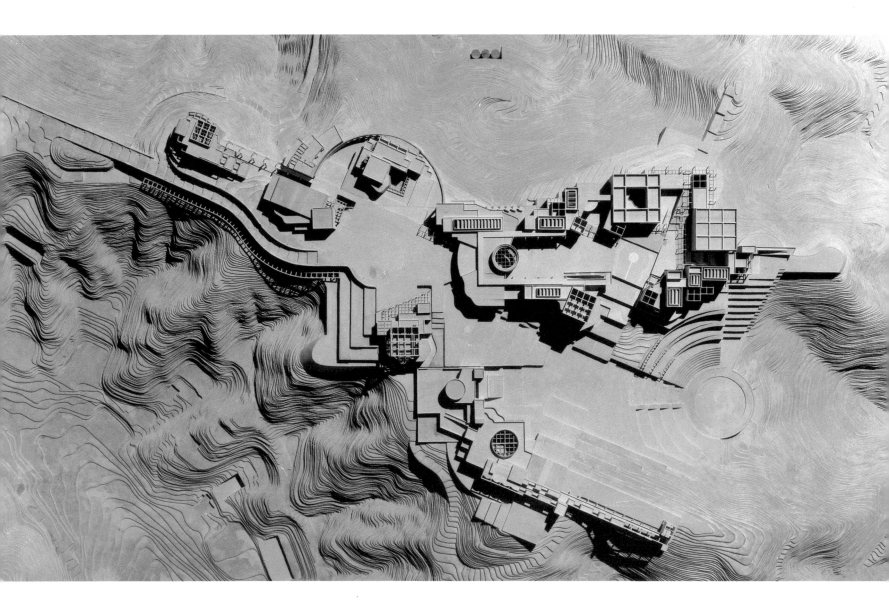

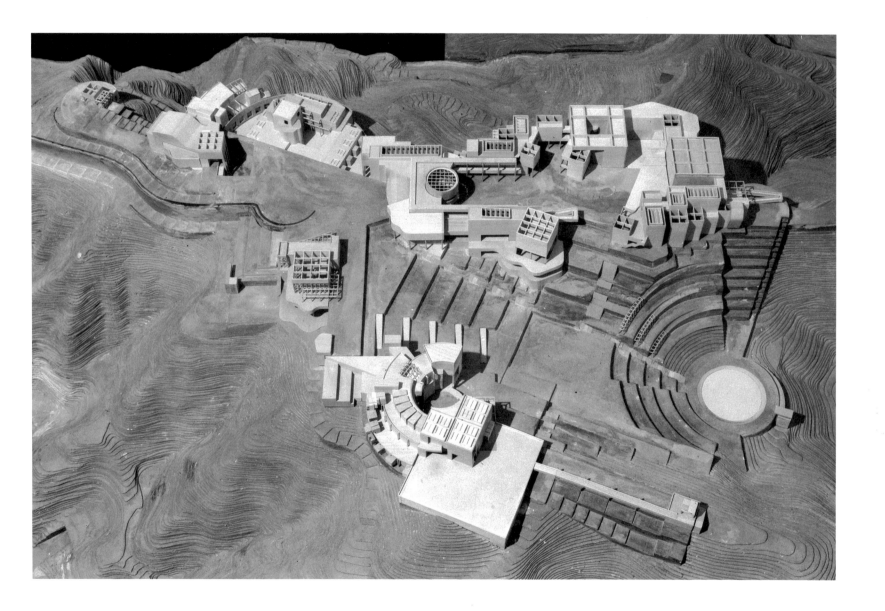

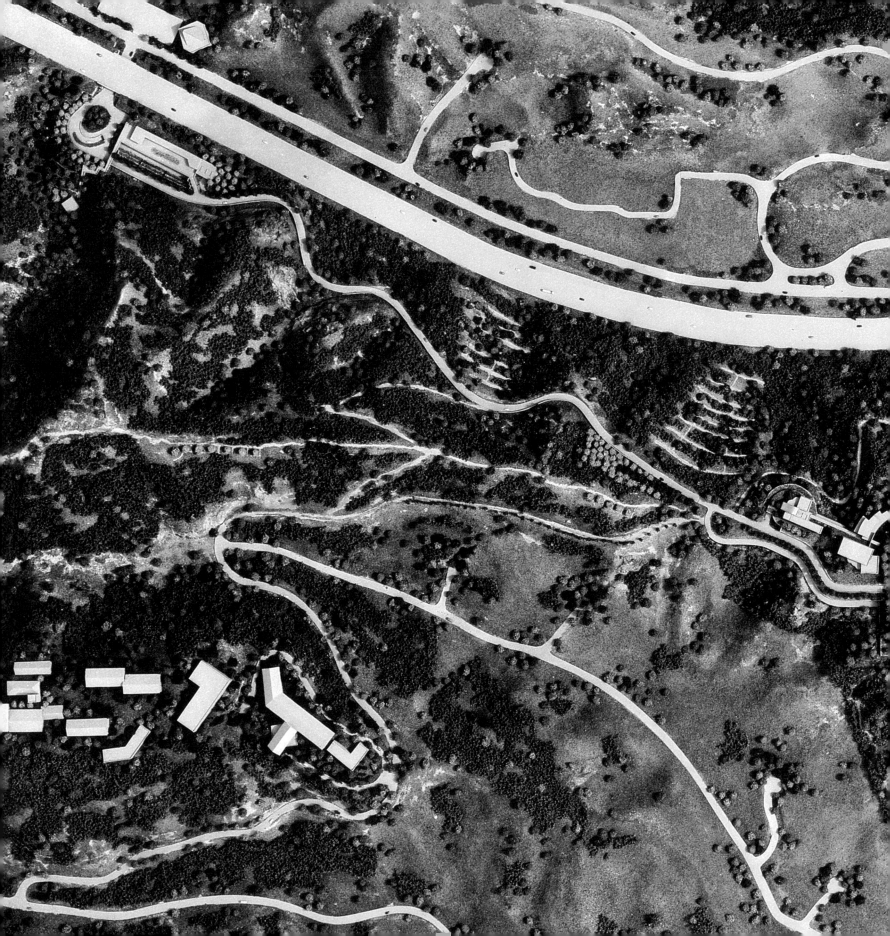

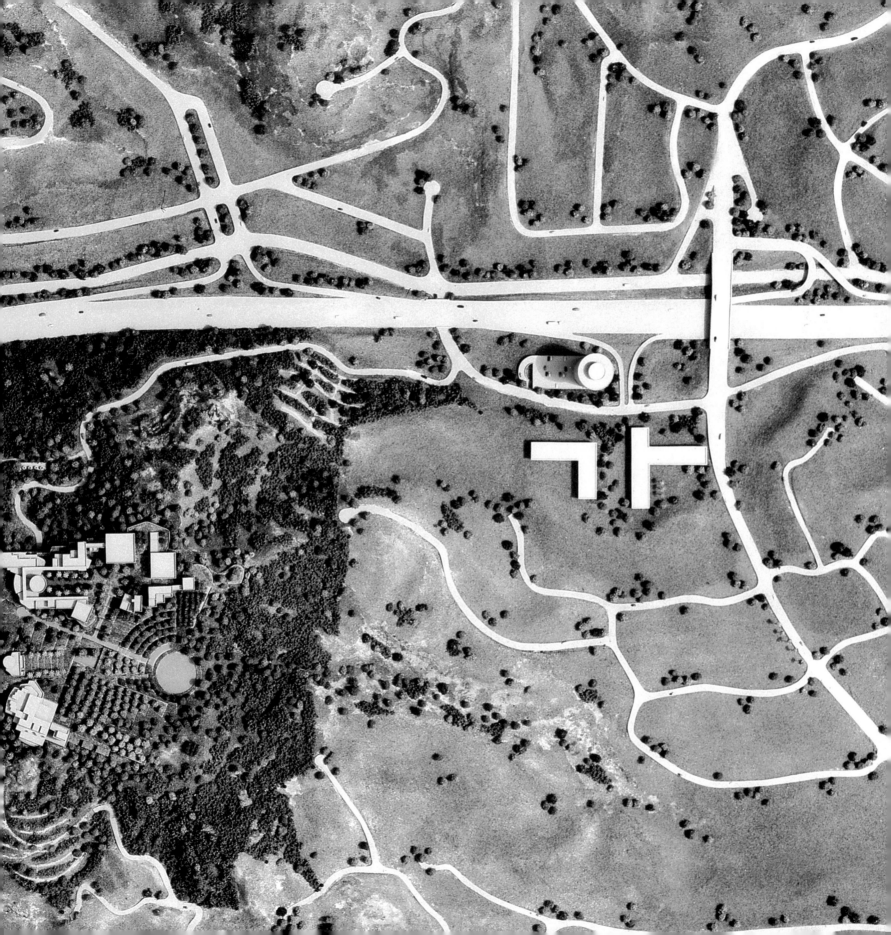

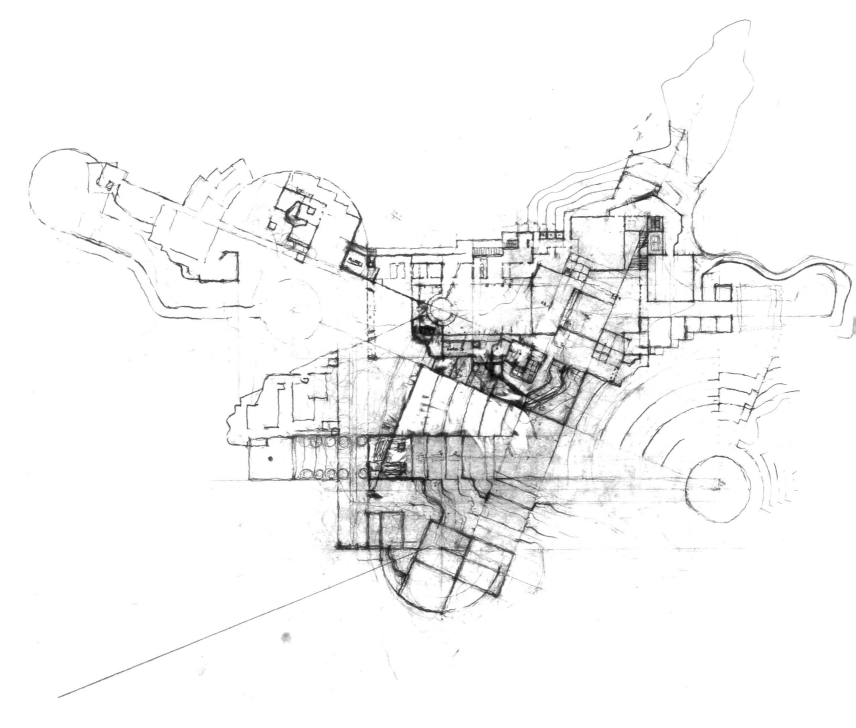

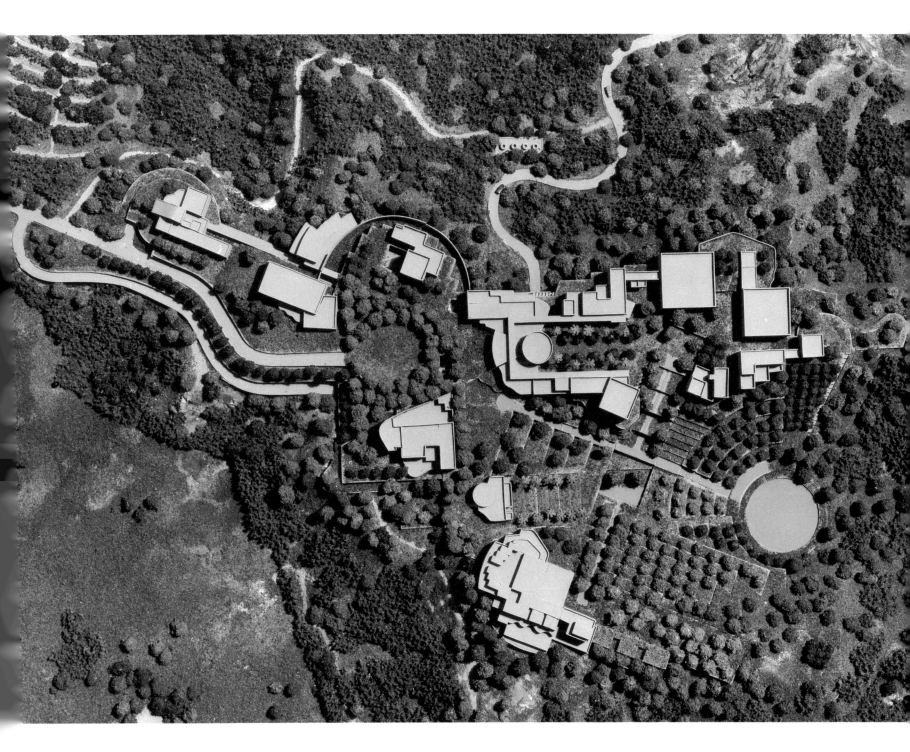

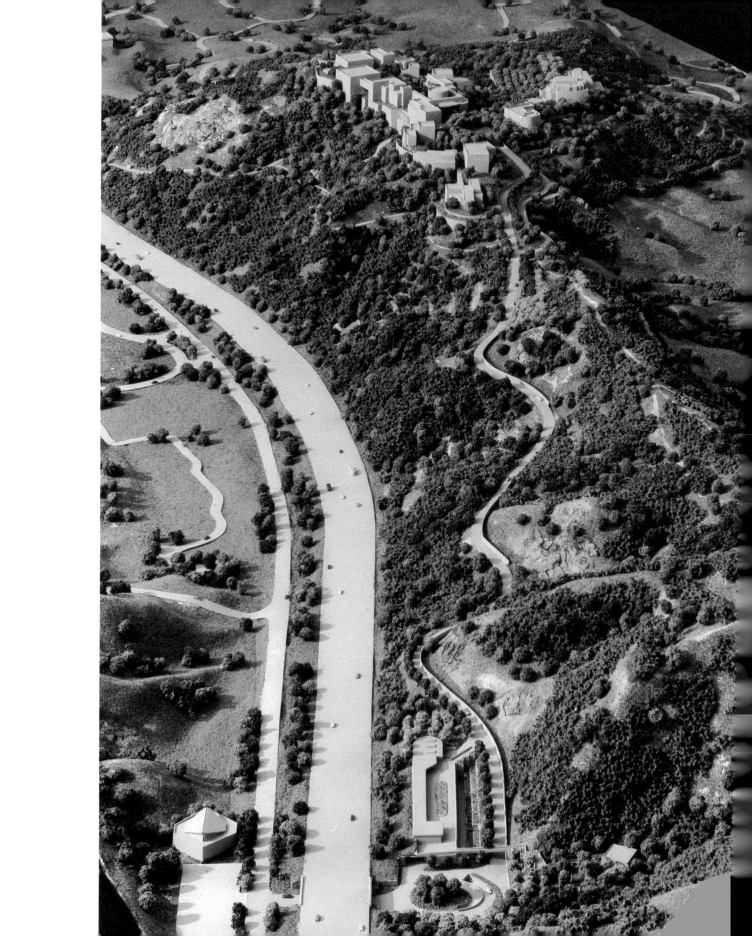

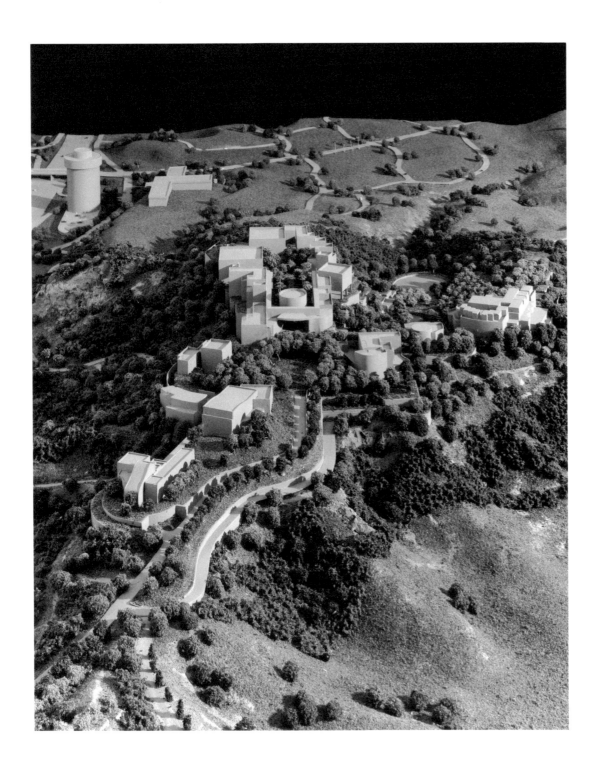

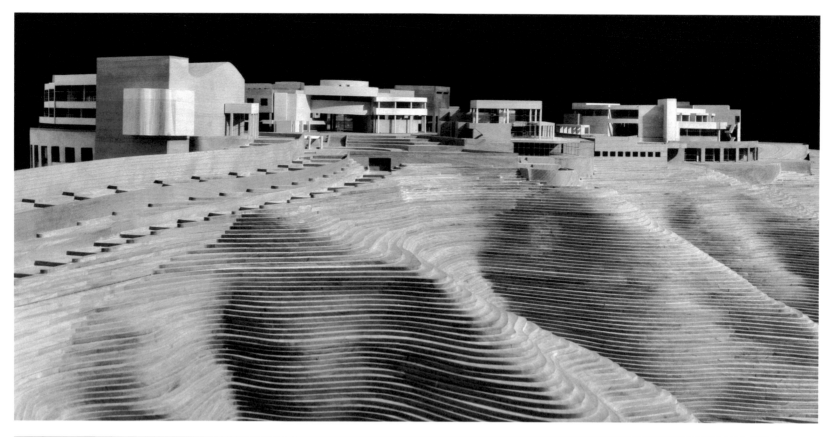
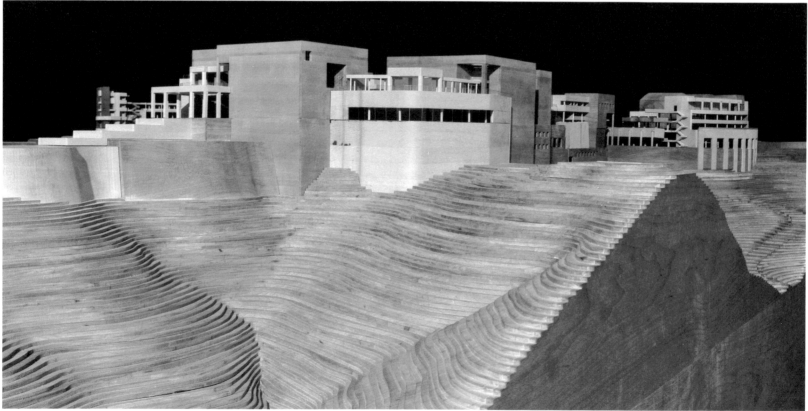

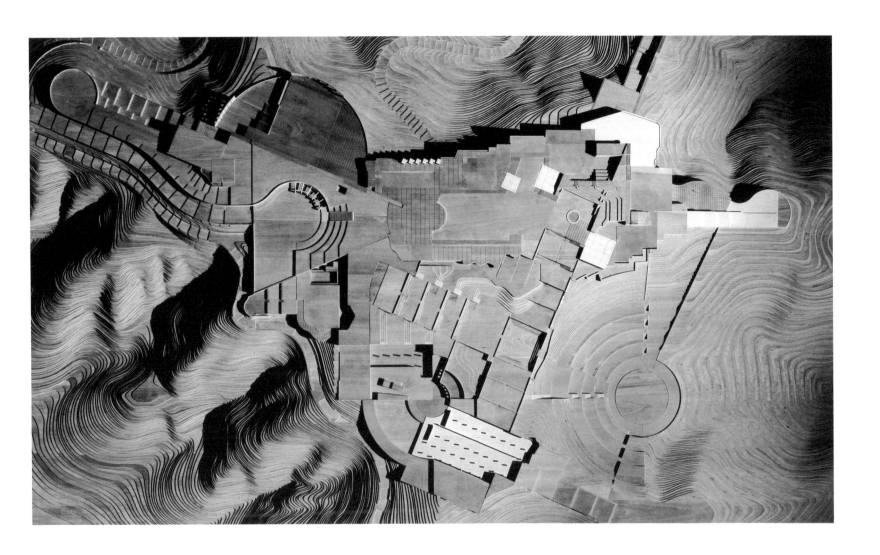

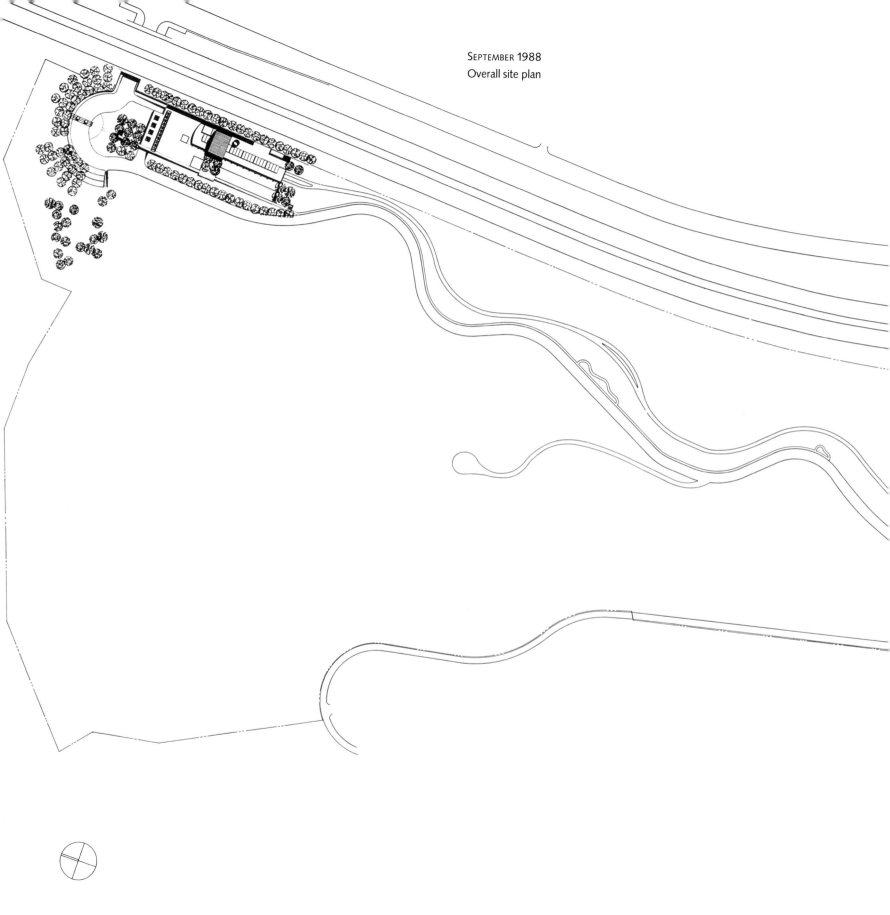

SEPTEMBER 1988
Overall site plan

56

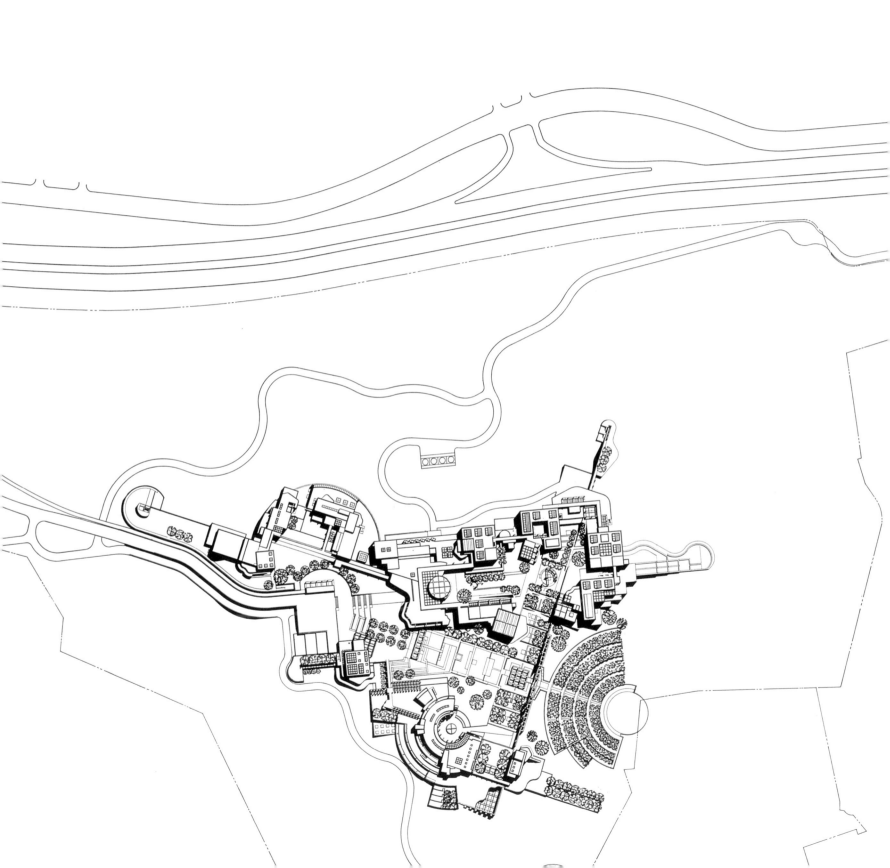

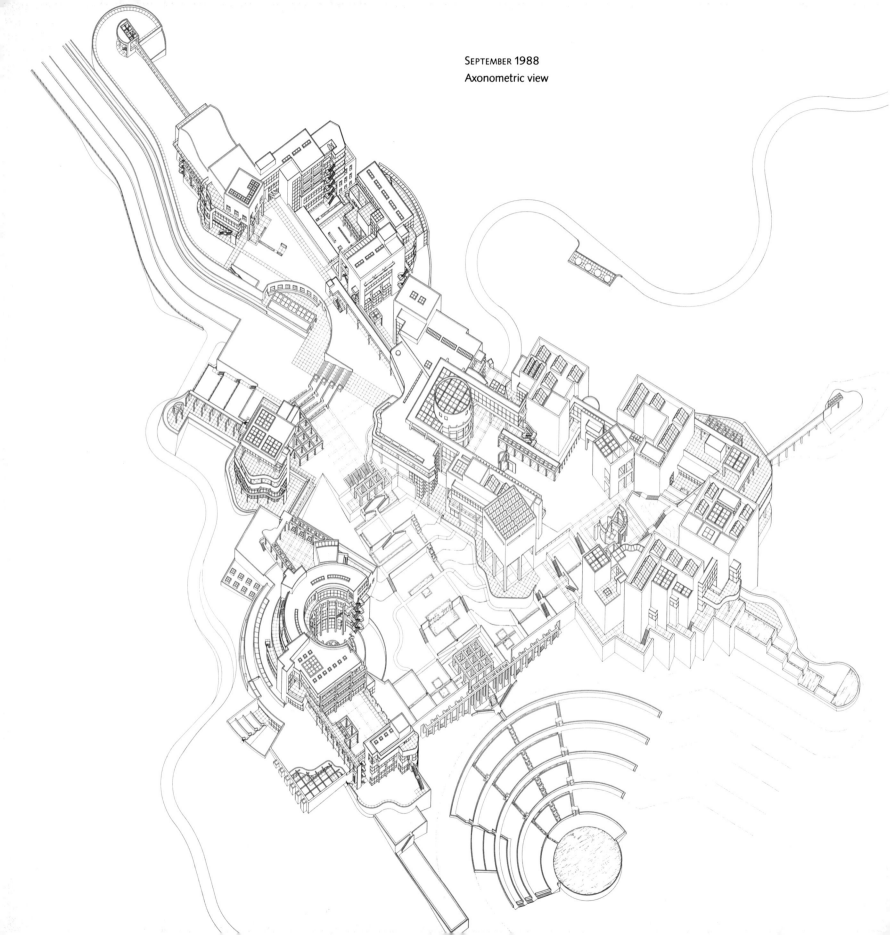

September 1988
Axonometric view

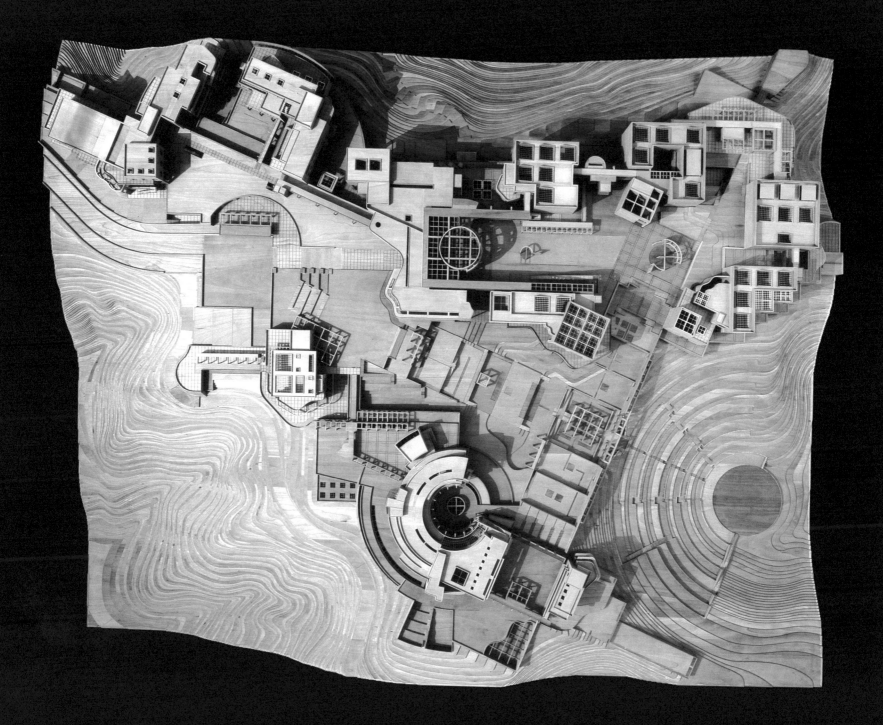

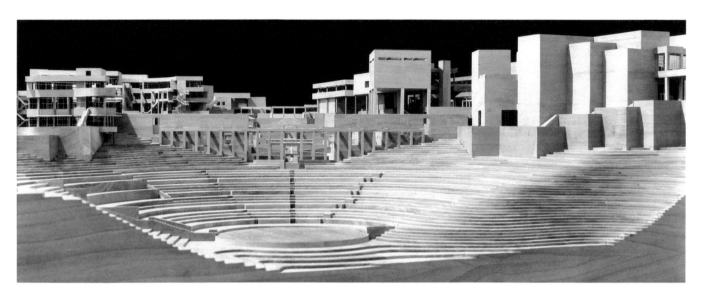

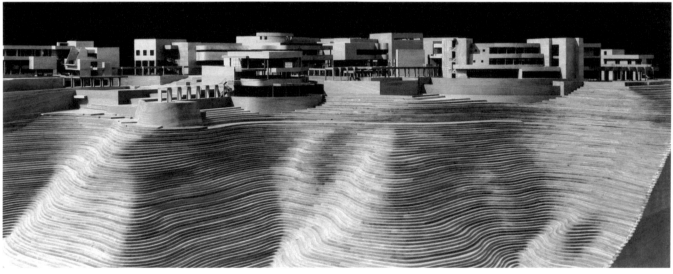

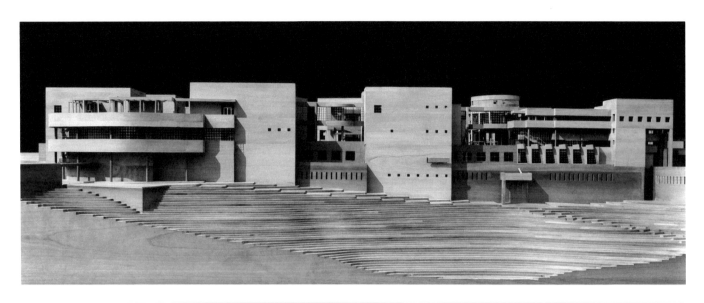

Entrance
View to south

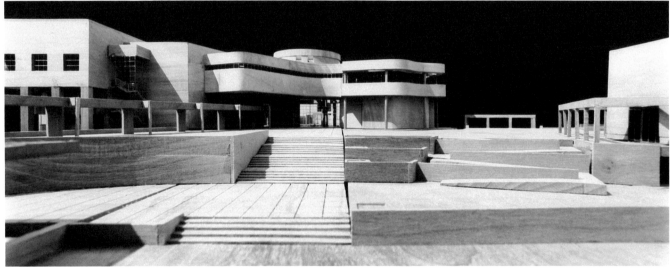

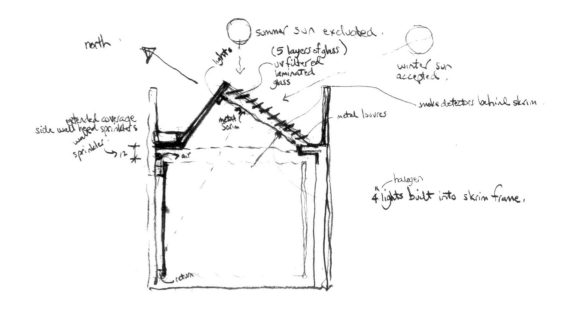

north

summer sun excluded.
(5 layers of glass)
uv filtered
laminated
glass

winter sun
accepted.

lights

smoke detectors behind skrim

metal
Scrim

metal louvres

extended coverage
side wall head sprinklers
water
sprinkler
→12

air

halogen
4 lights built into skrim frame.

return

Assemetrical prism skylight scheme

North skylight with movable louvres.
mechanically operated.
½" scale drawings
of sections both ways thru galleries

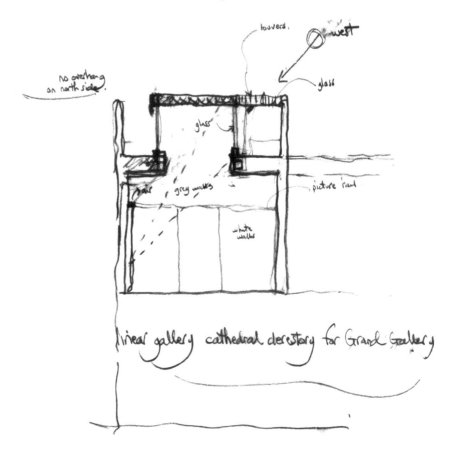

no overhang
on north side.

louvers.

west

glass

glass

air

grey walls

picture rail

white
walls

linear gallery cathedral clerestory for Grand Gallery

glass

artificial light.

small picture gallery
lantern top light

clear glass

fixed louvres

space frame
type structure

look at
quadrant scheme
with 16 quadrants

catwalk
above
adjustable louvres

Temporary
Gallery

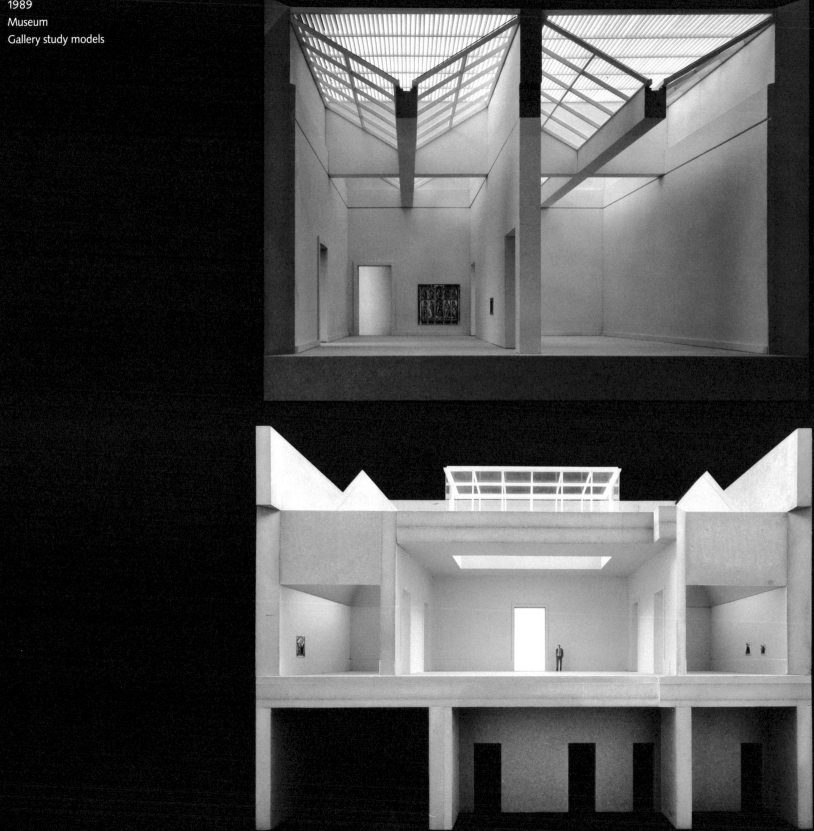

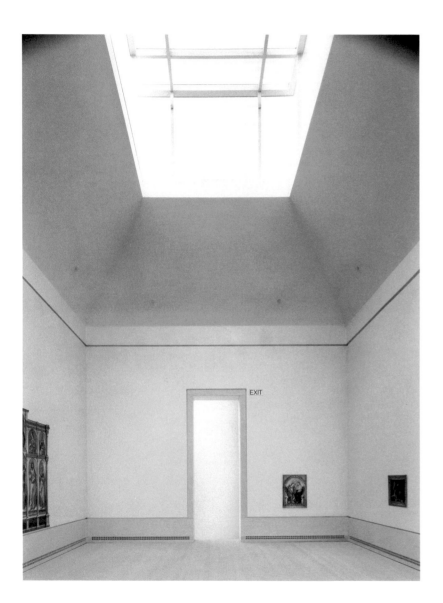

1987
Study sketches
Relationship between Museum and Entrance Plaza

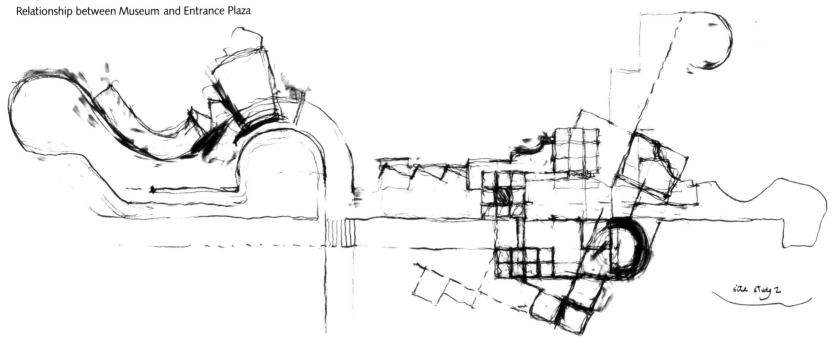

Relationship between Restaurant/Café
and Museum café

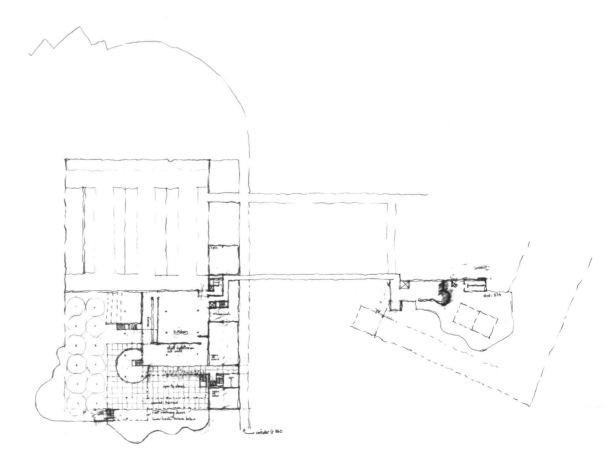

Museum; Central Gardens

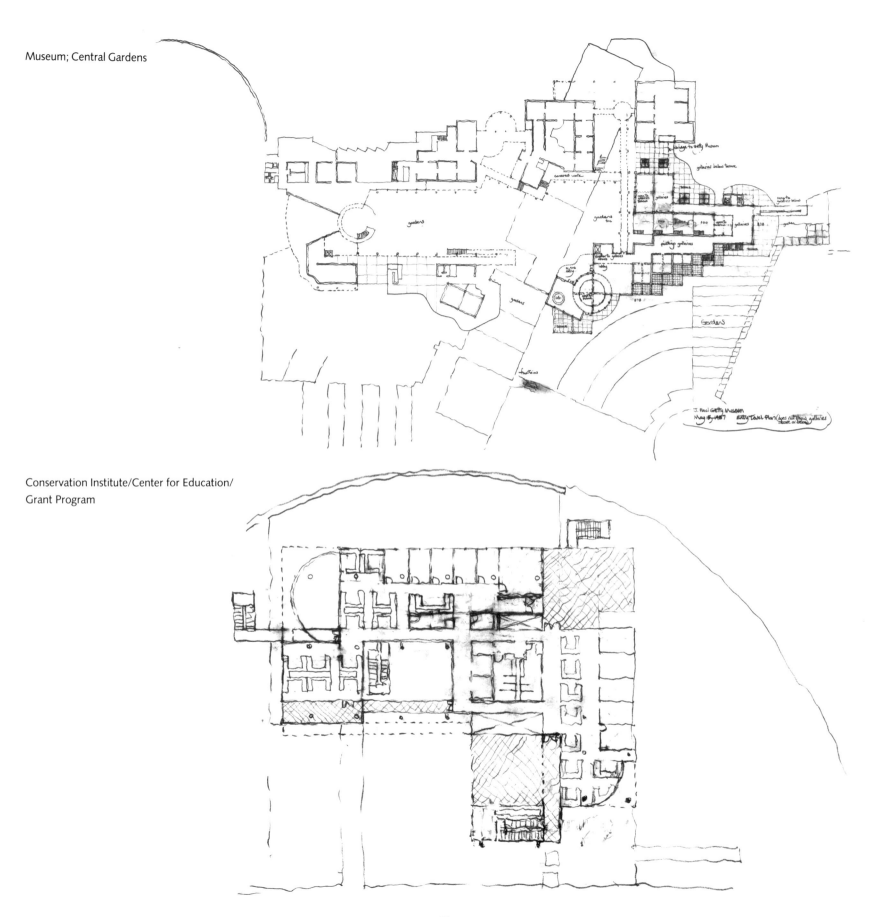

Conservation Institute/Center for Education/
Grant Program

FEBRUARY 1988
Center for the History of Art and the Humanities
Plan view

MAY 1991
View to south

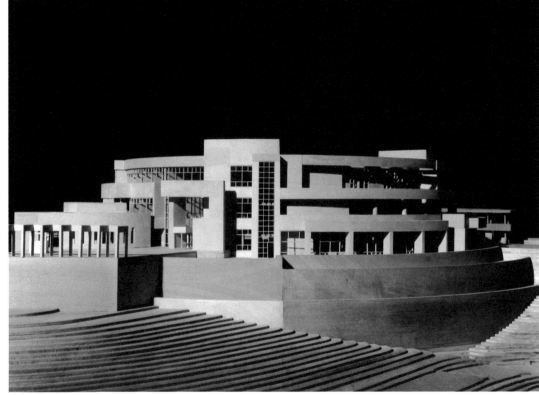

SEPTEMBER 1989
Center for the History
of Art and the Humanities
Courtyard

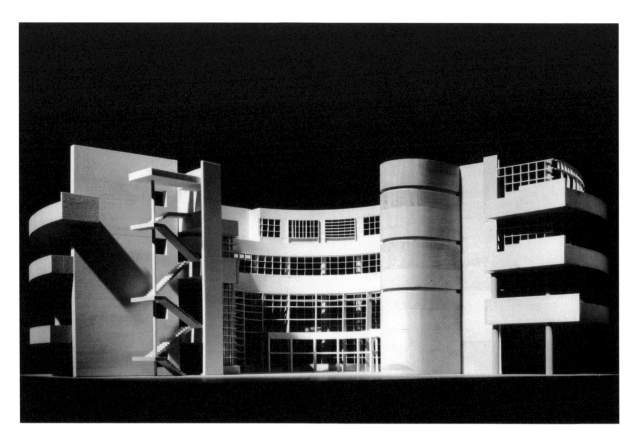

FEBRUARY 1990
Center for the History
of Art and the Humanities
Scholars' Wing

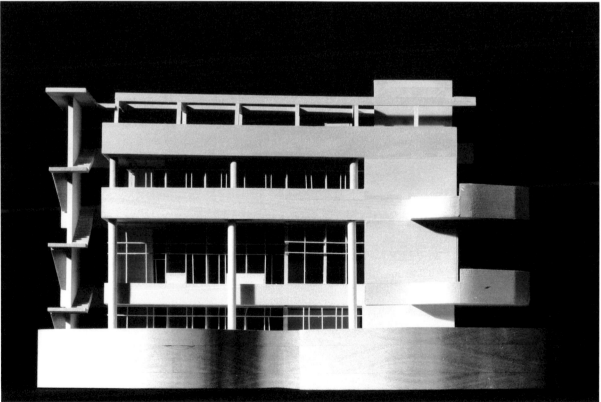

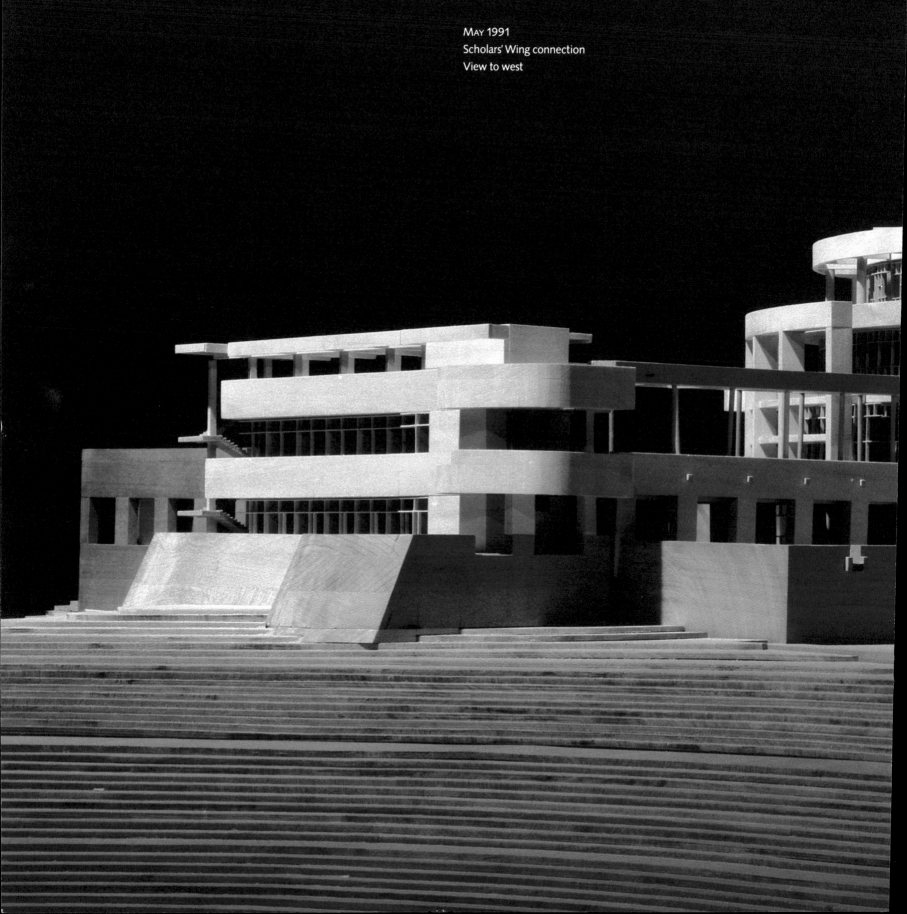

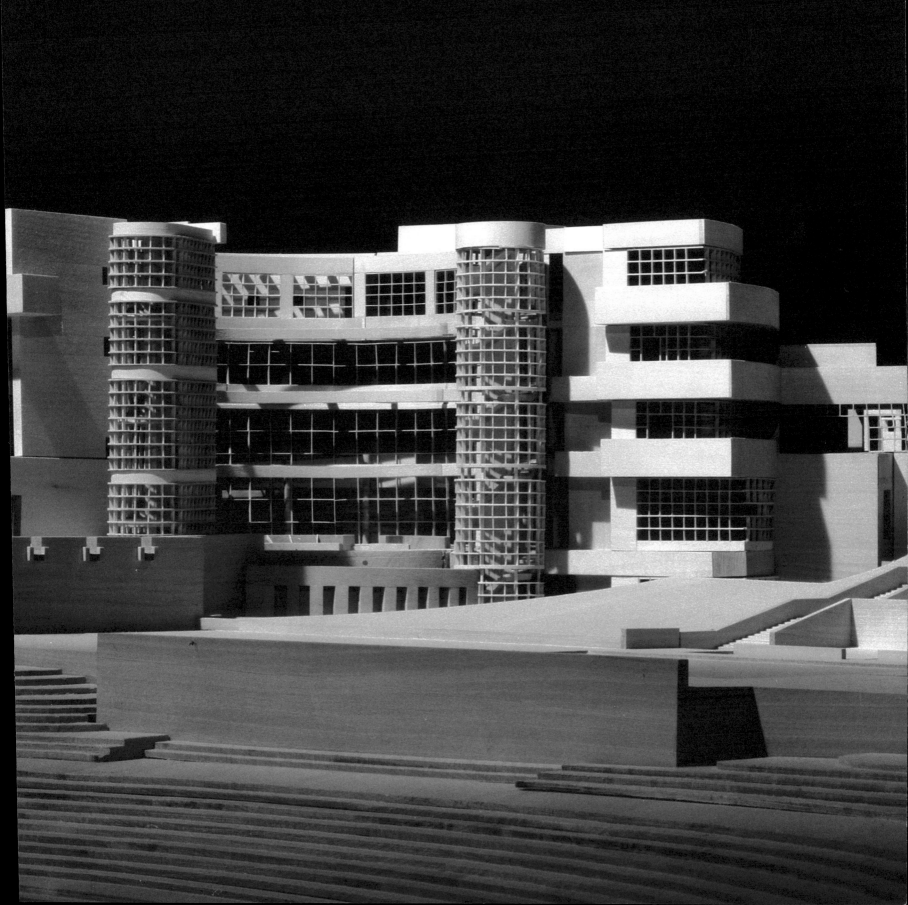

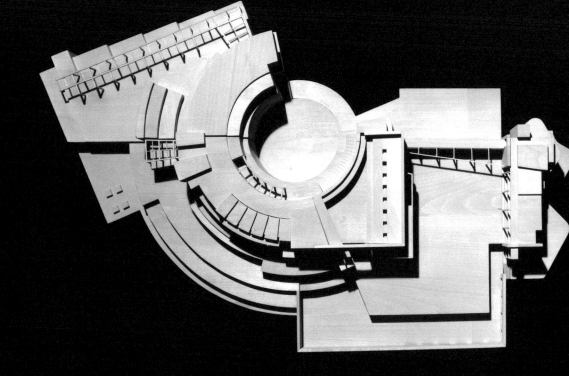

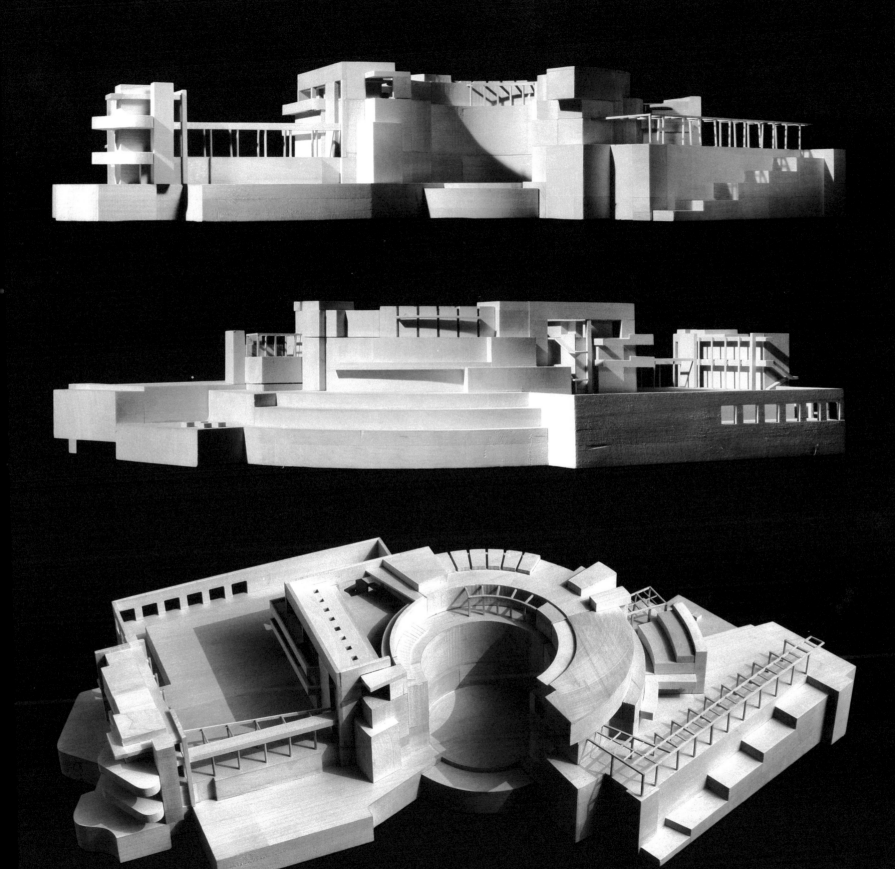

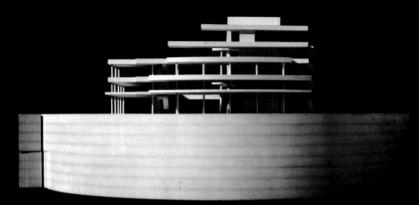

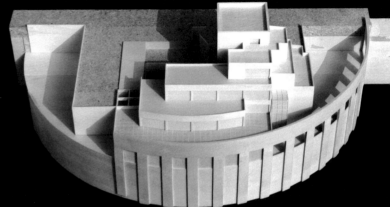

Museum
Decorative Arts galleries

Museum
Decorative Arts galleries

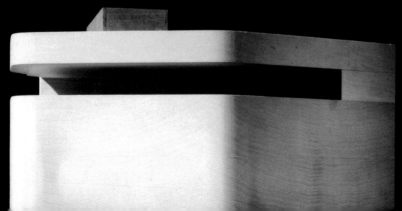

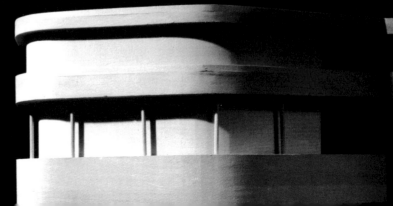

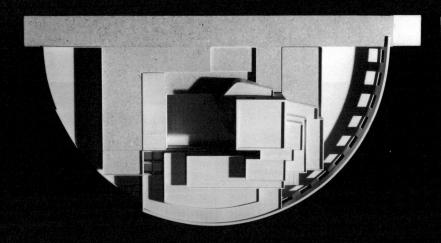

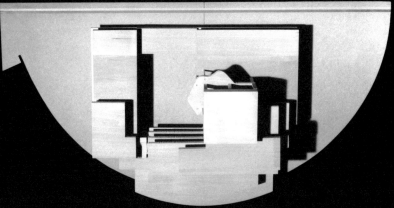

1989
Section through Auditorium

April 1989
Section through Museum orientation theaters and lecture hall

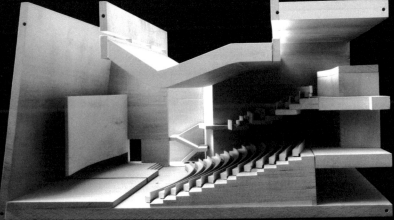

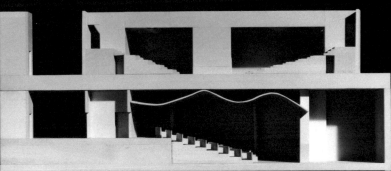

1988
North Entry tram station
View to south

Plan view

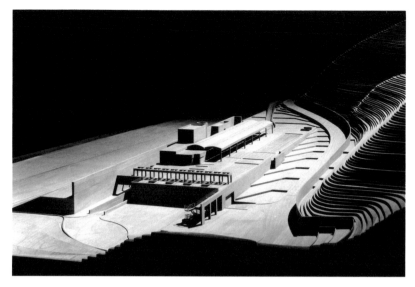

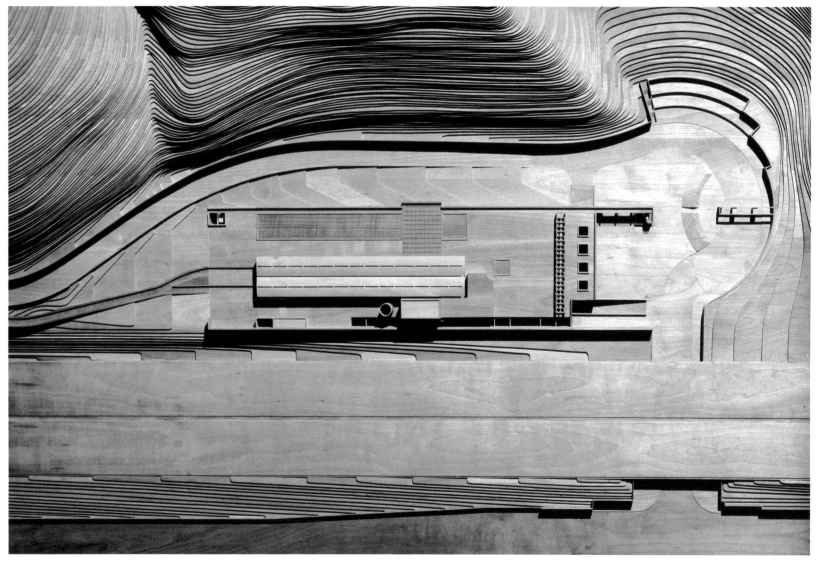

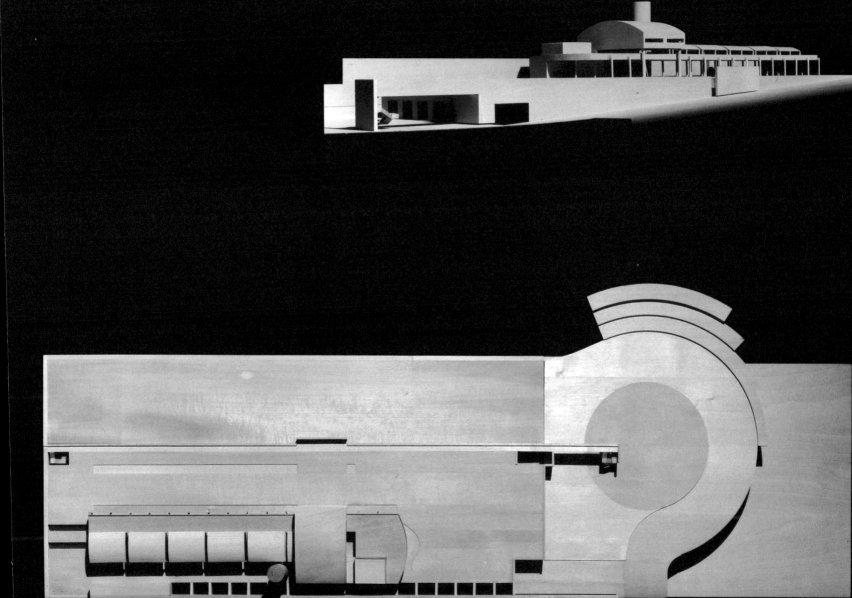

Key Section
Key Plan

Second upper level
First upper level
Entry level
First lower level
Second lower level

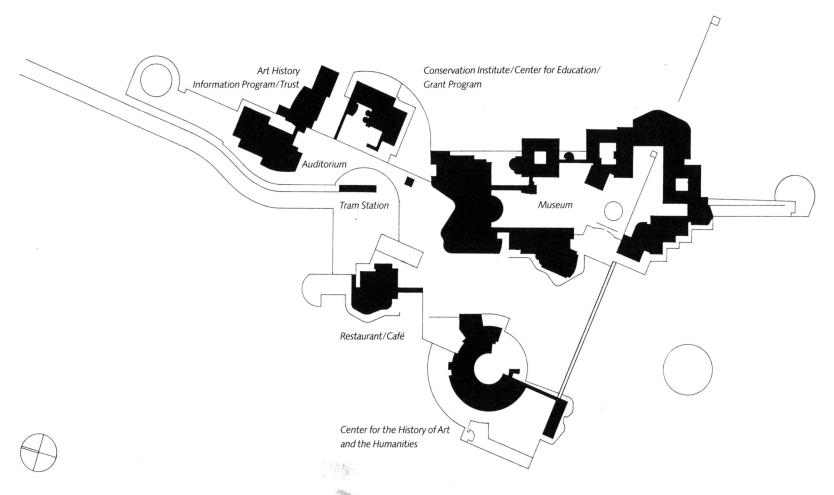

Art History
Information Program/Trust

Conservation Institute/Center for Education/
Grant Program

Auditorium

Tram Station

Museum

Restaurant/Café

Center for the History of Art
and the Humanities

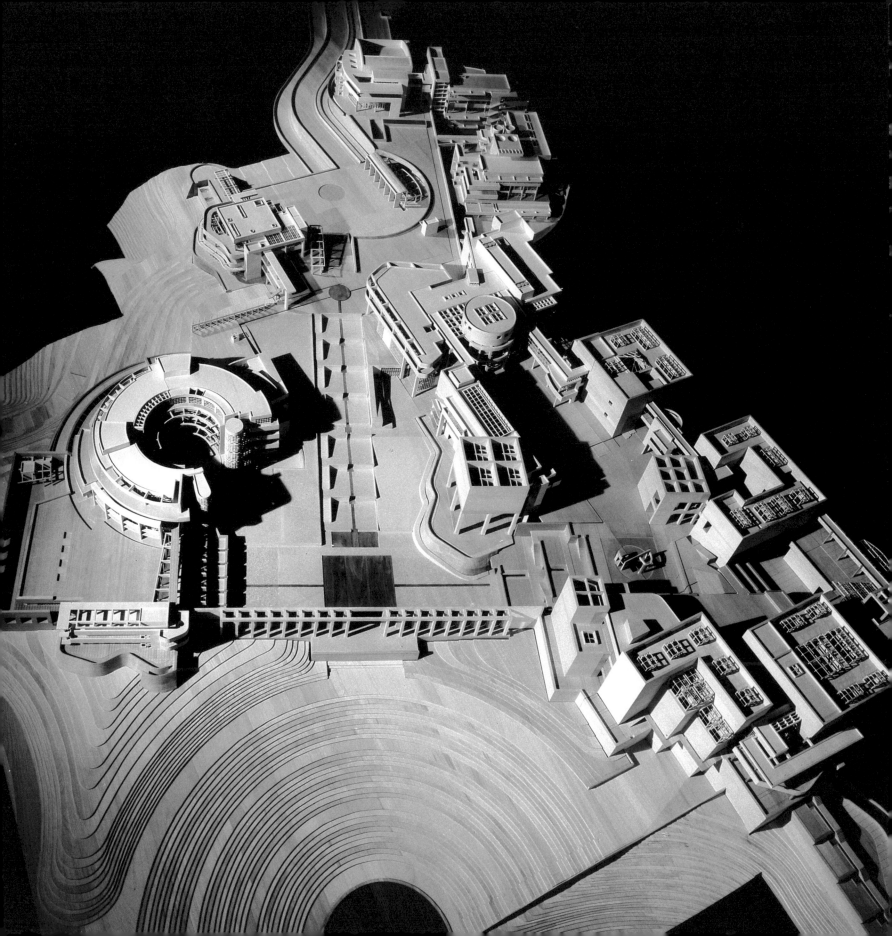

Site plan

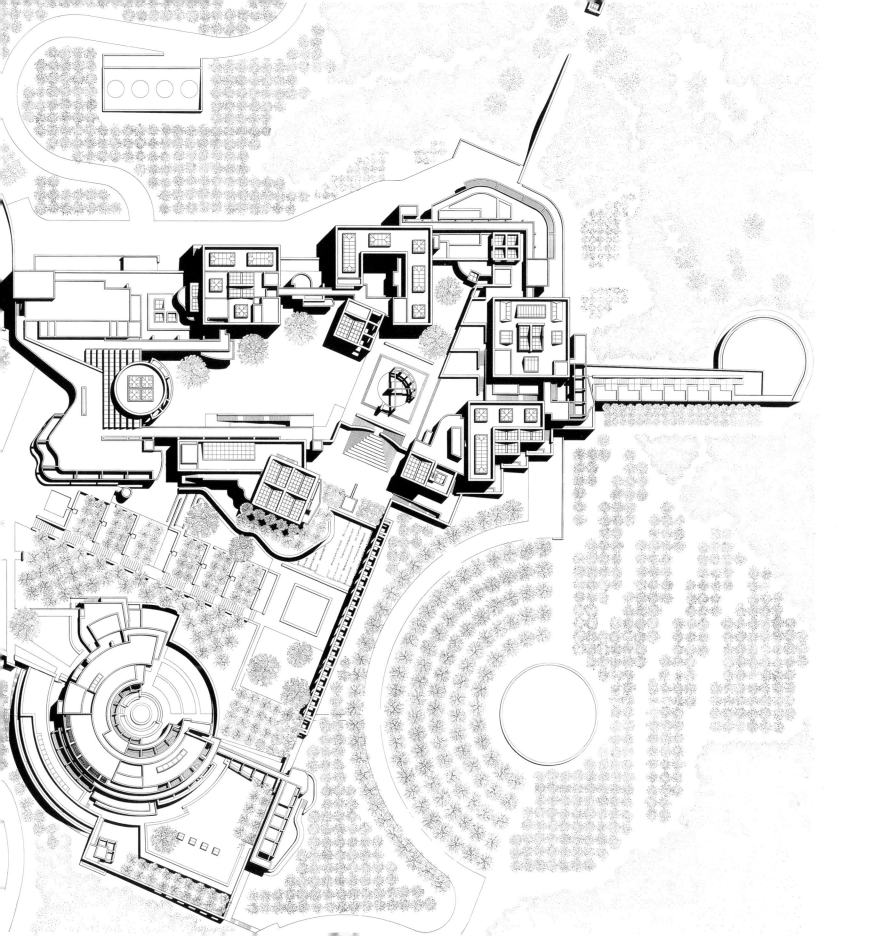

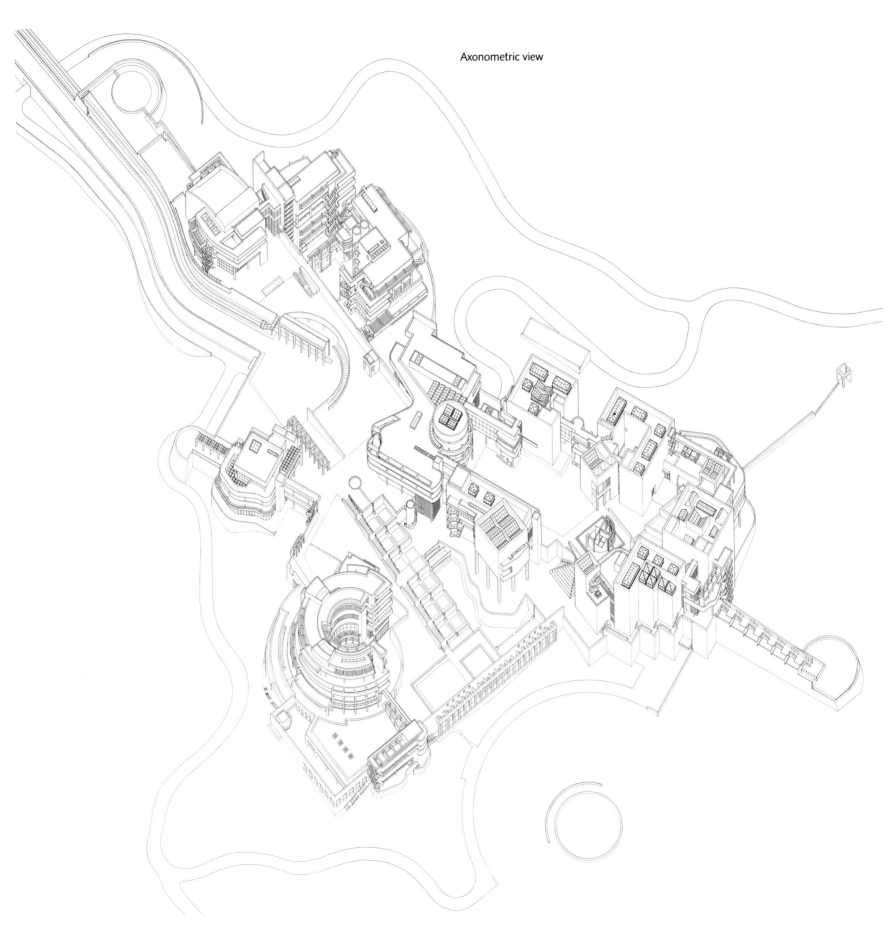

Axonometric view

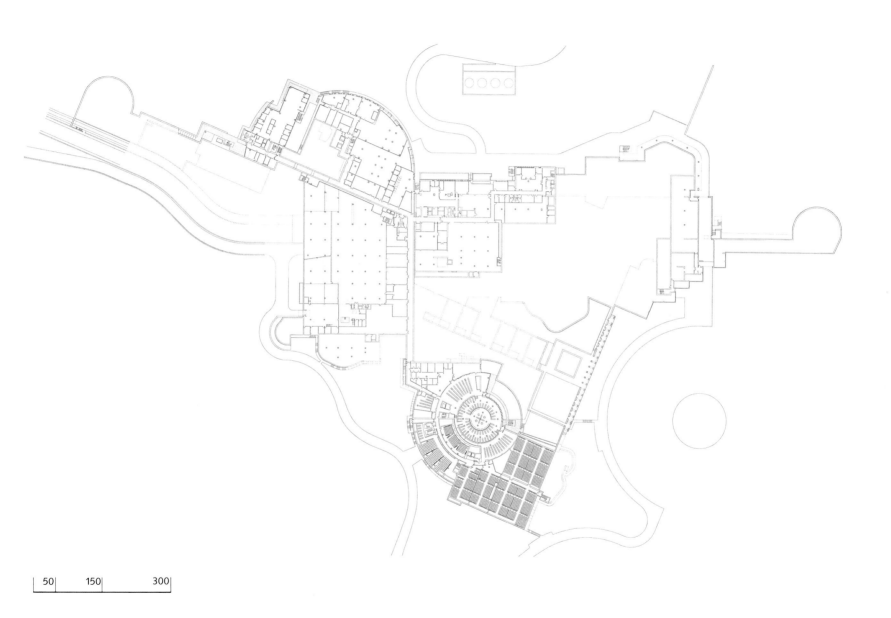

50 150 300

First lower level site plan

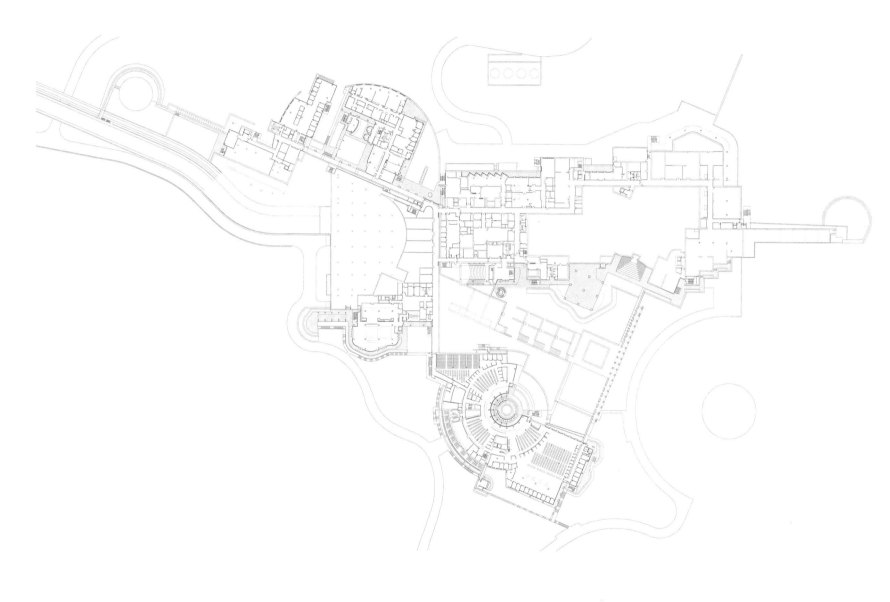

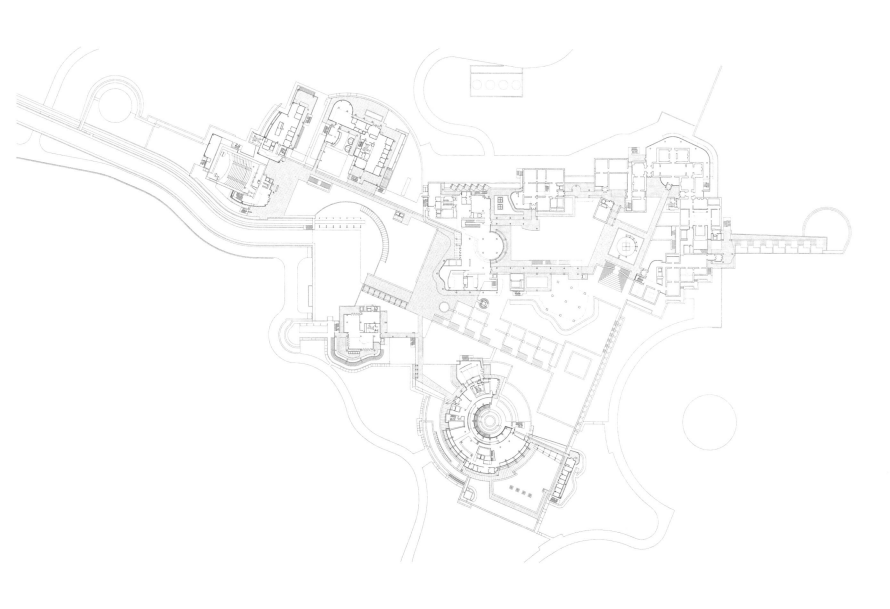

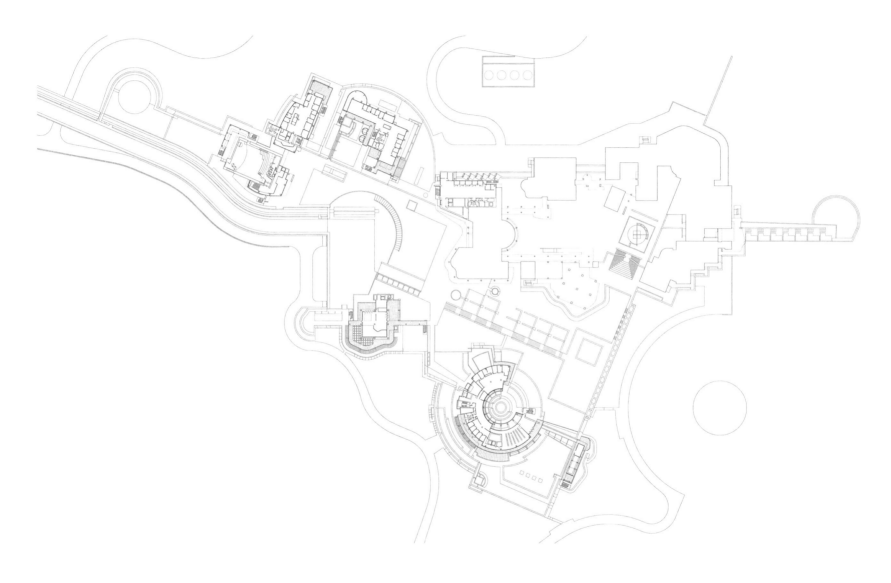

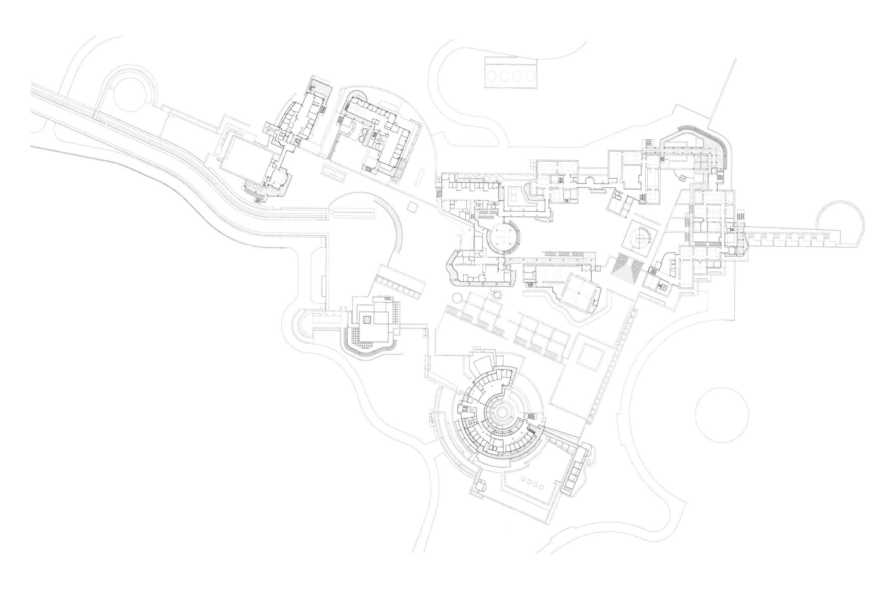

North elevation

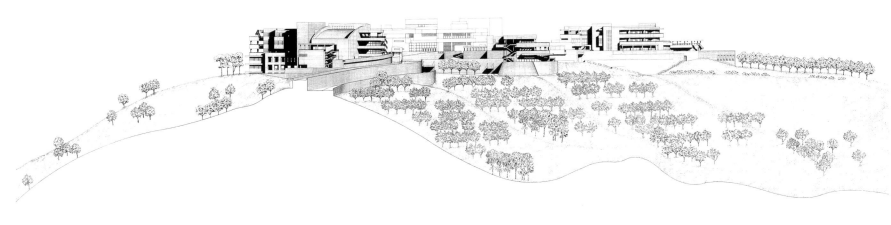

South elevation

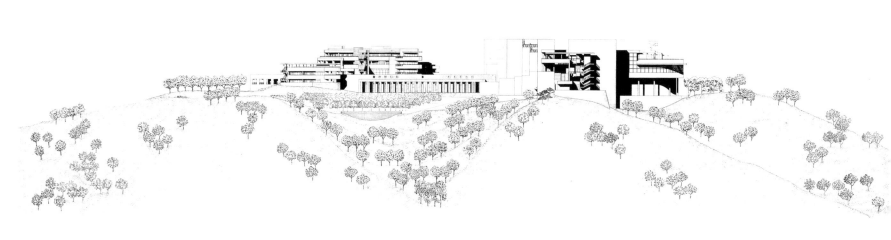

West elevation

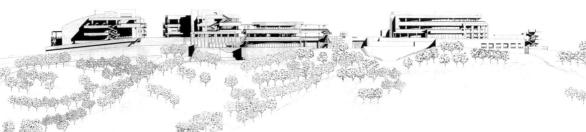

East elevation

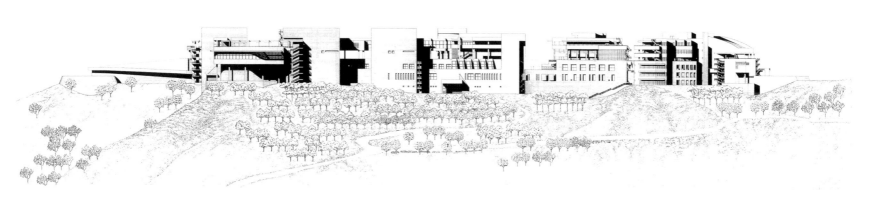

Cross sections
Facing Museum; Center for the History of Art and the Humanities

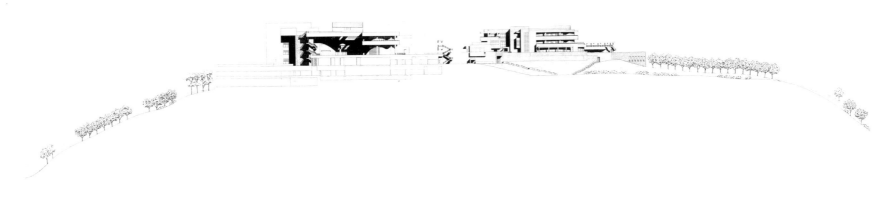

Through Museum courtyard, facing Auditorium;
Conservation Institute/Center for Education/Grant Program;
Museum

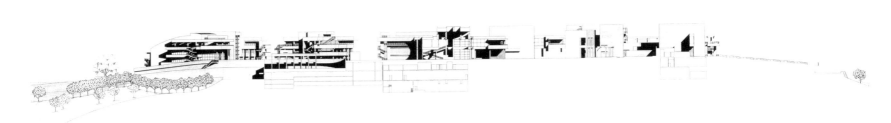

Through Central Gardens, facing Center for the History of Art
and the Humanities; Restaurant/Café

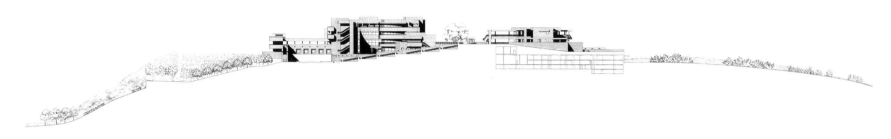

Through Center for the History of Art and the Humanities; Museum

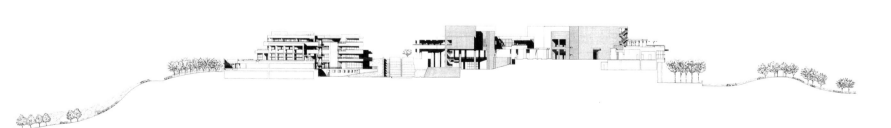

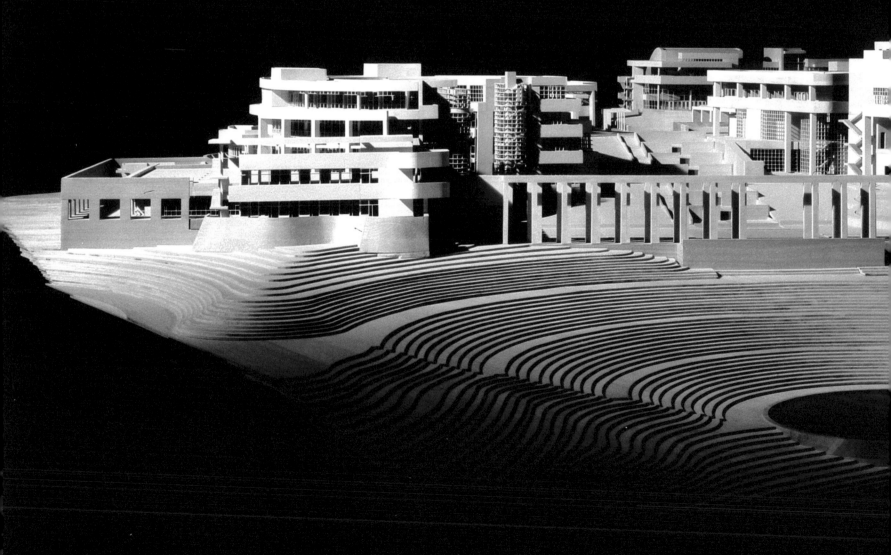

View to north

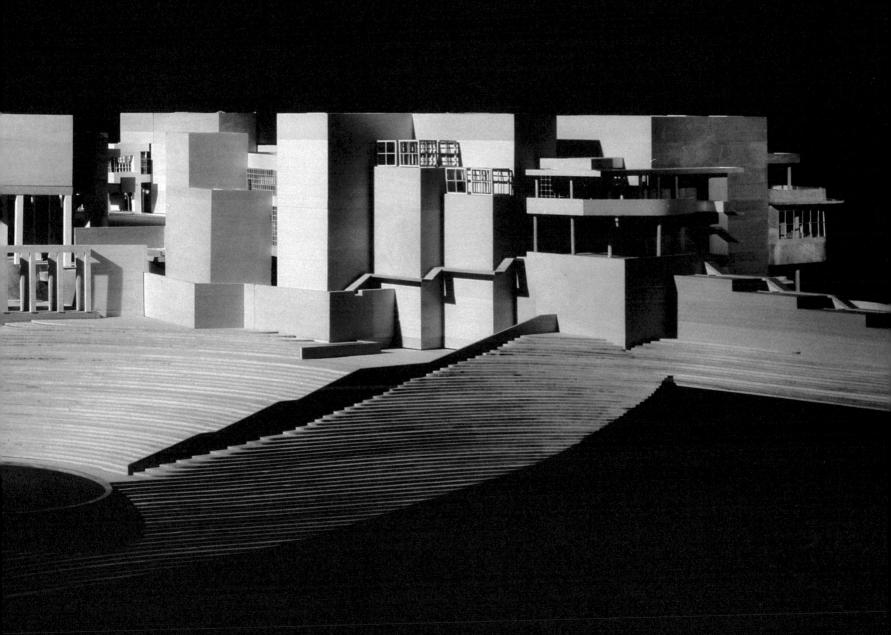

Museum
Entry level plan

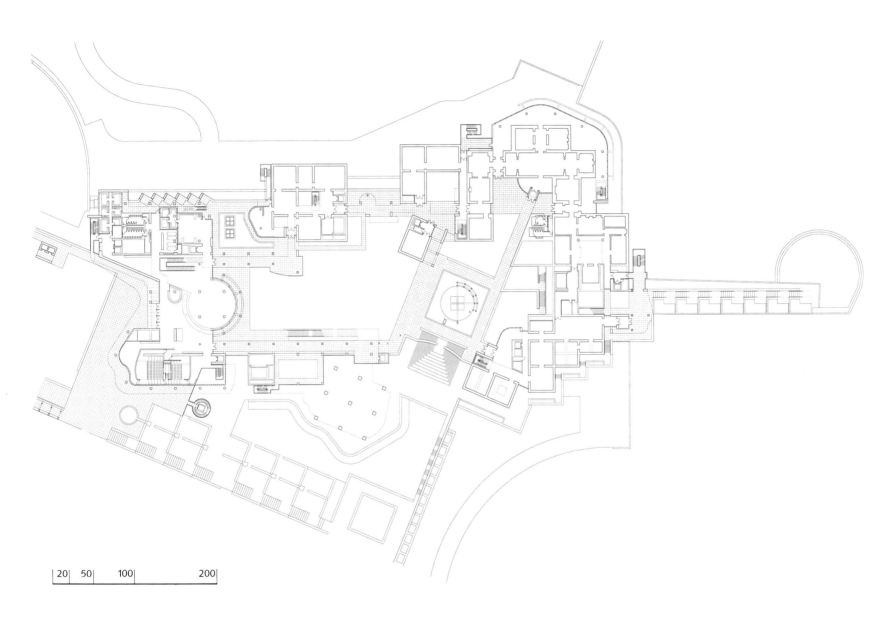

20| 50| 100| 200|

First upper level plan

Museum
Entrance
View to south (page 96)

Temporary Exhibitions Gallery
View to east (page 96)

Courtyard
View to north (page 97)

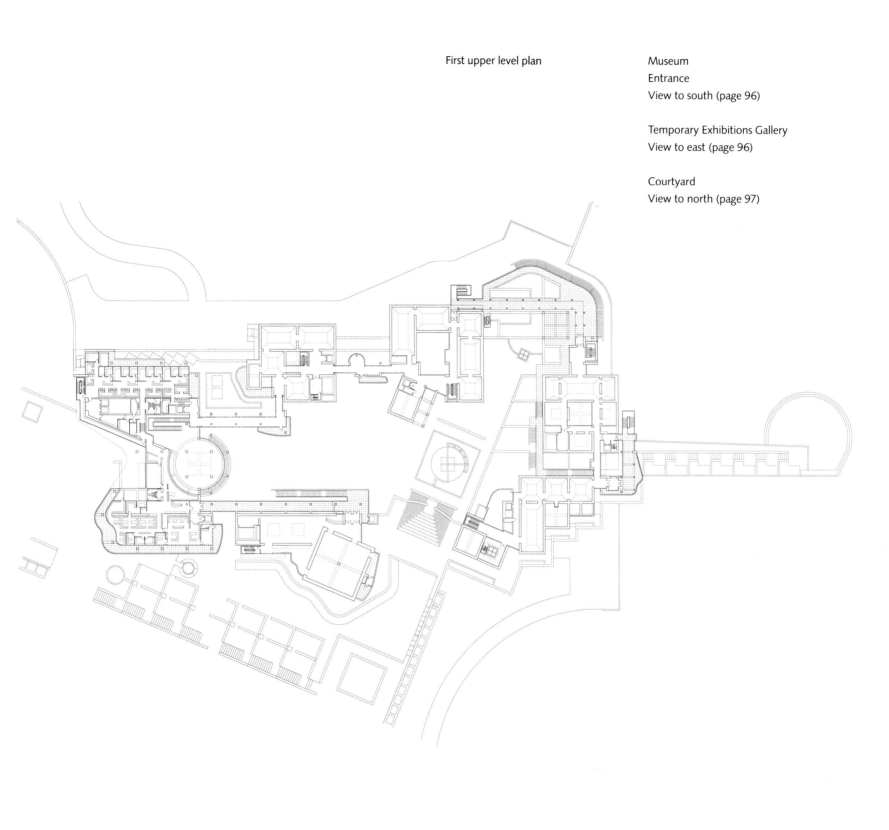

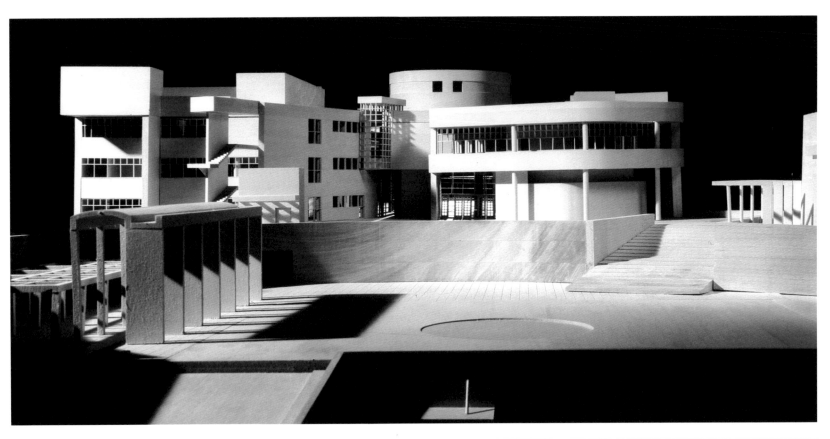
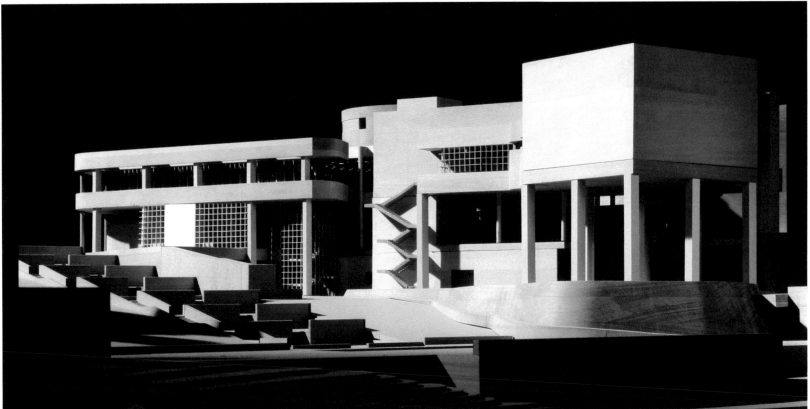

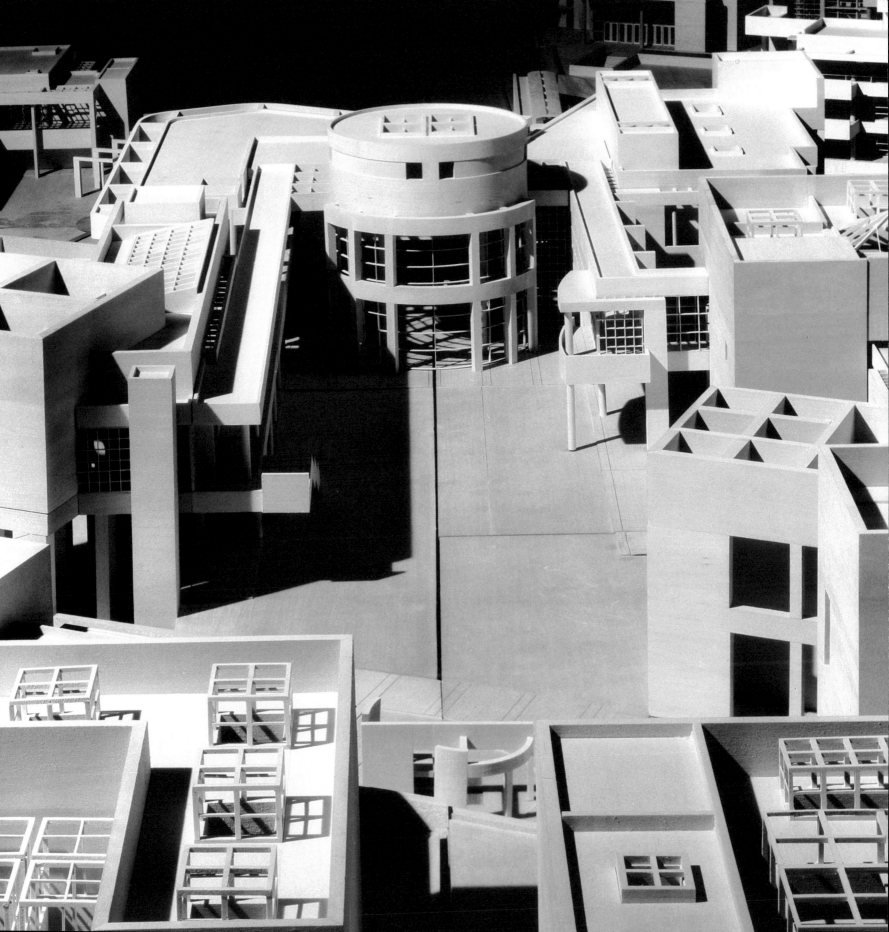

Museum
Fourth pavilion
View to east

Entrance
View to south

Courtyard
View to north

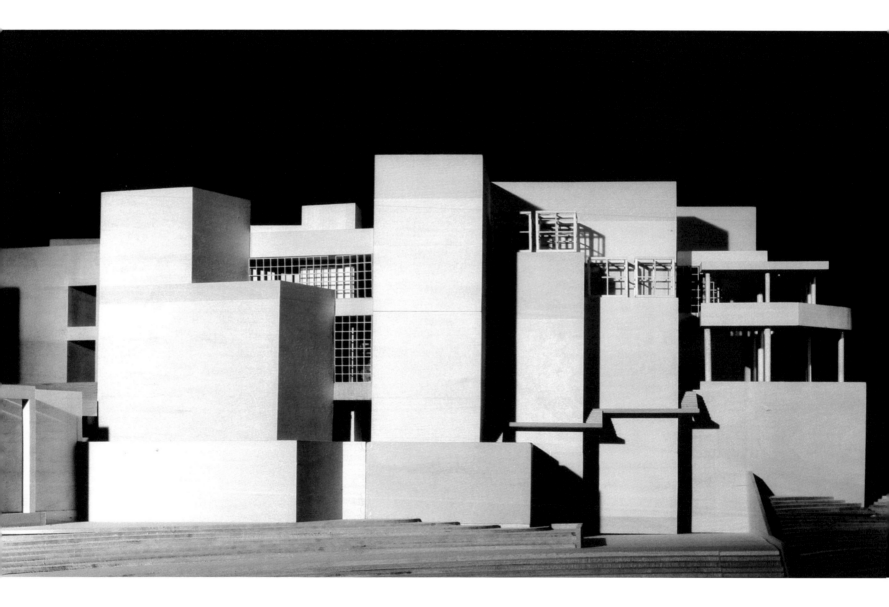

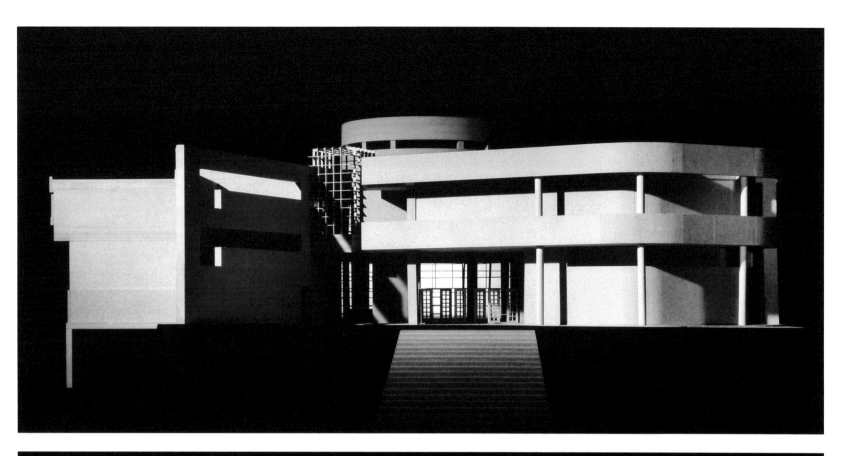

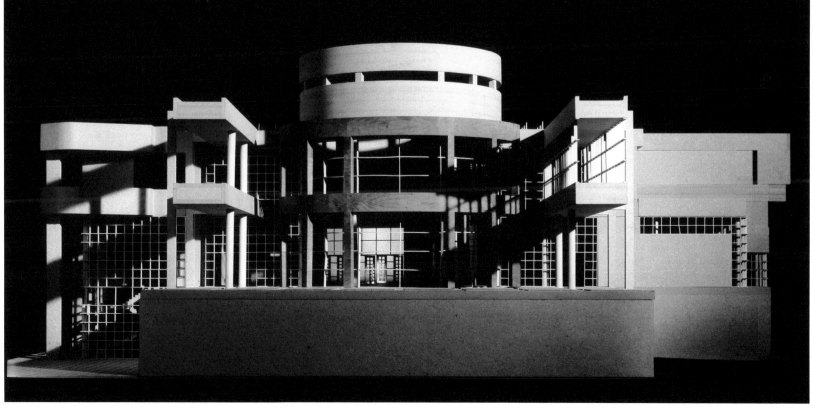

Museum

East elevation

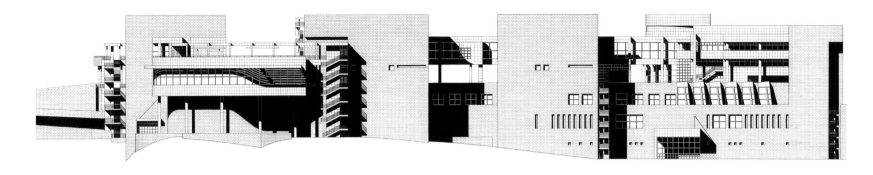

South elevation

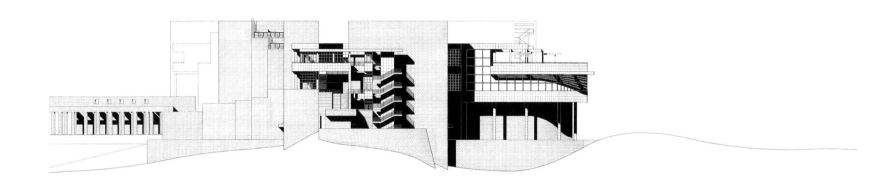

West elevation

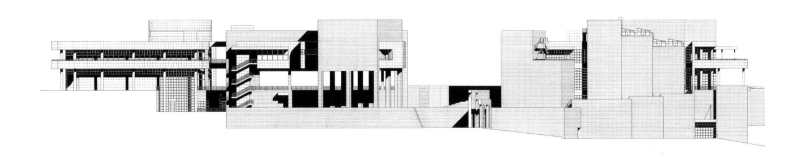

Sections through Museum courtyard
View to east

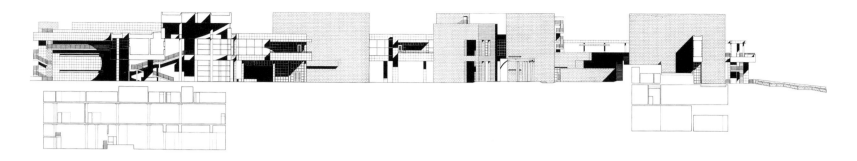

View to north

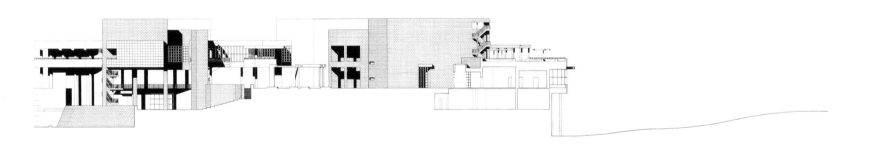

Section through Museum entrance
View to south

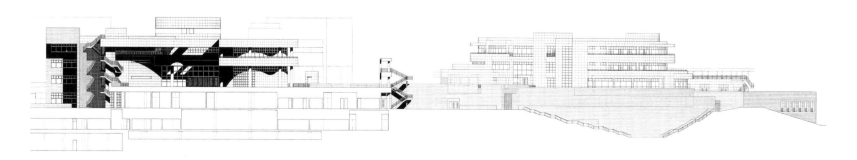

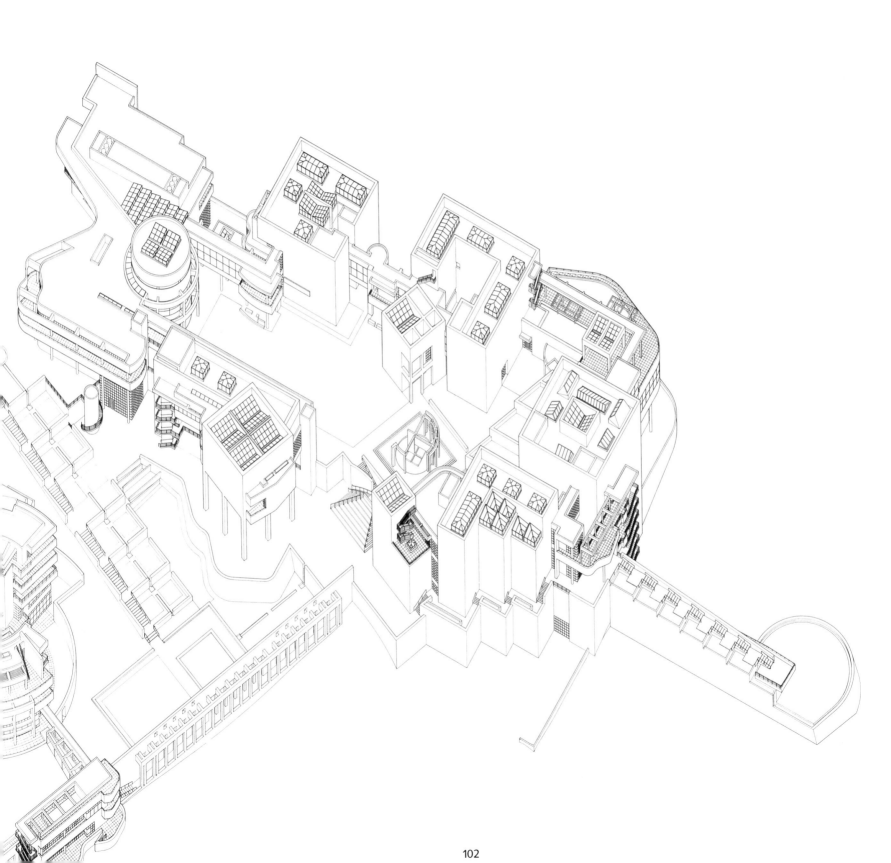

Lobby

First pavilion

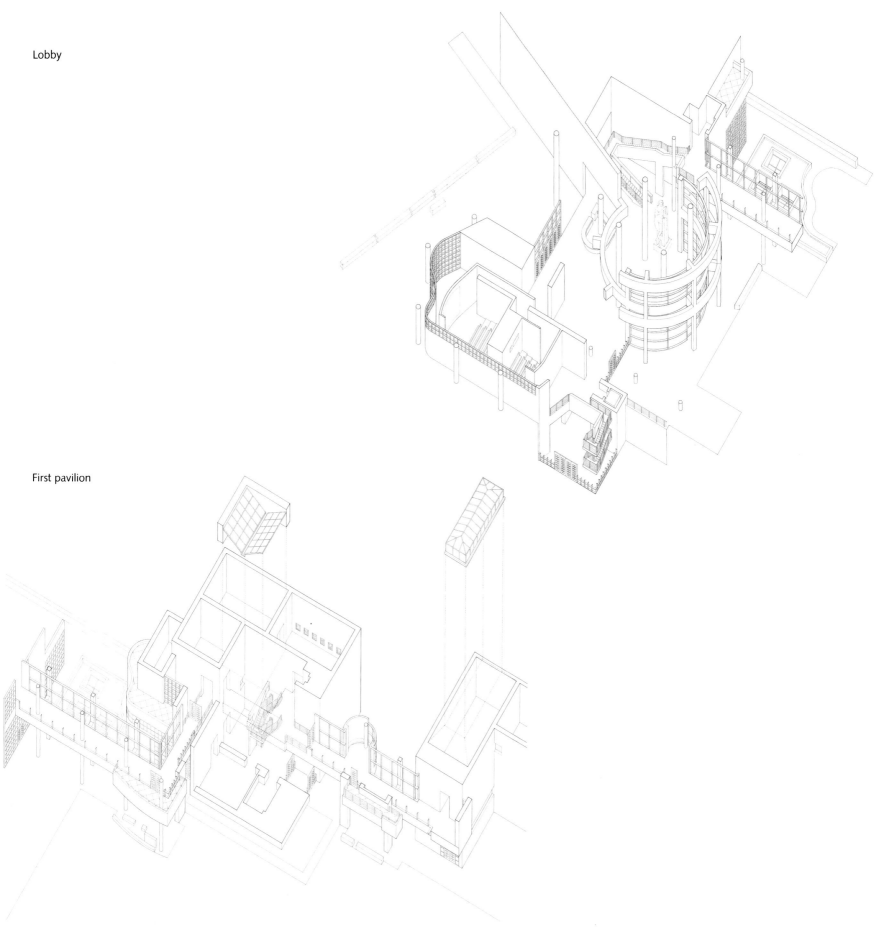

Museum
Second pavilion; Decorative Arts galleries

Third pavilion

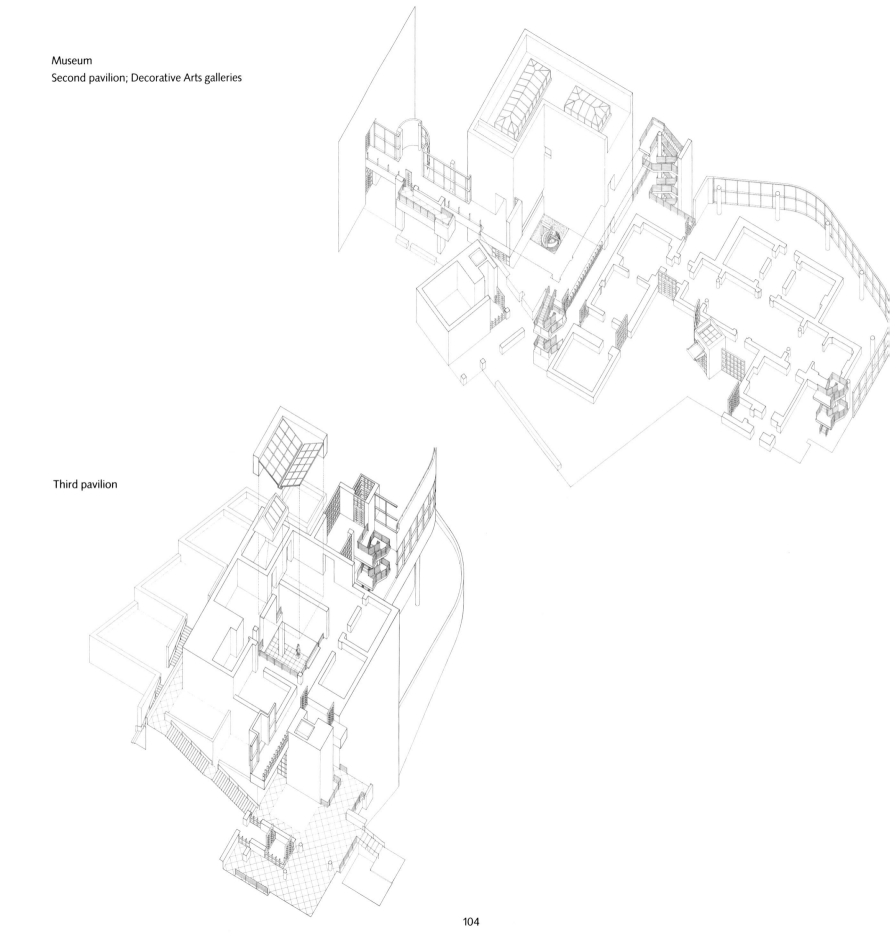

Fourth pavilion

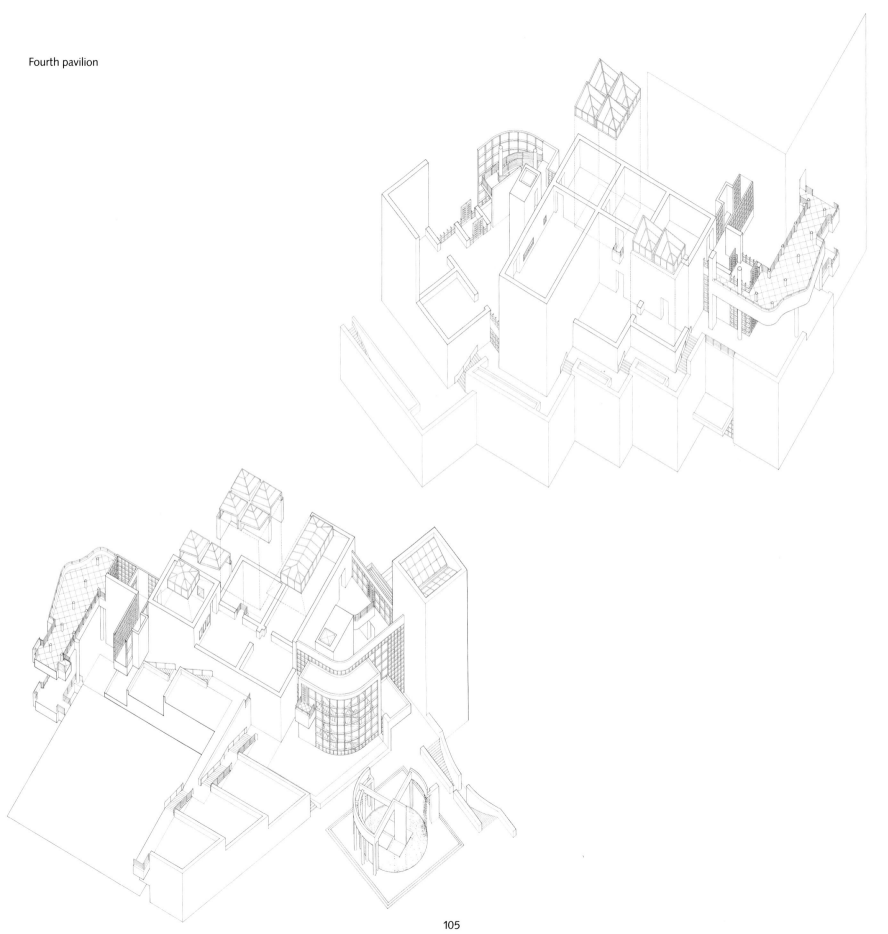

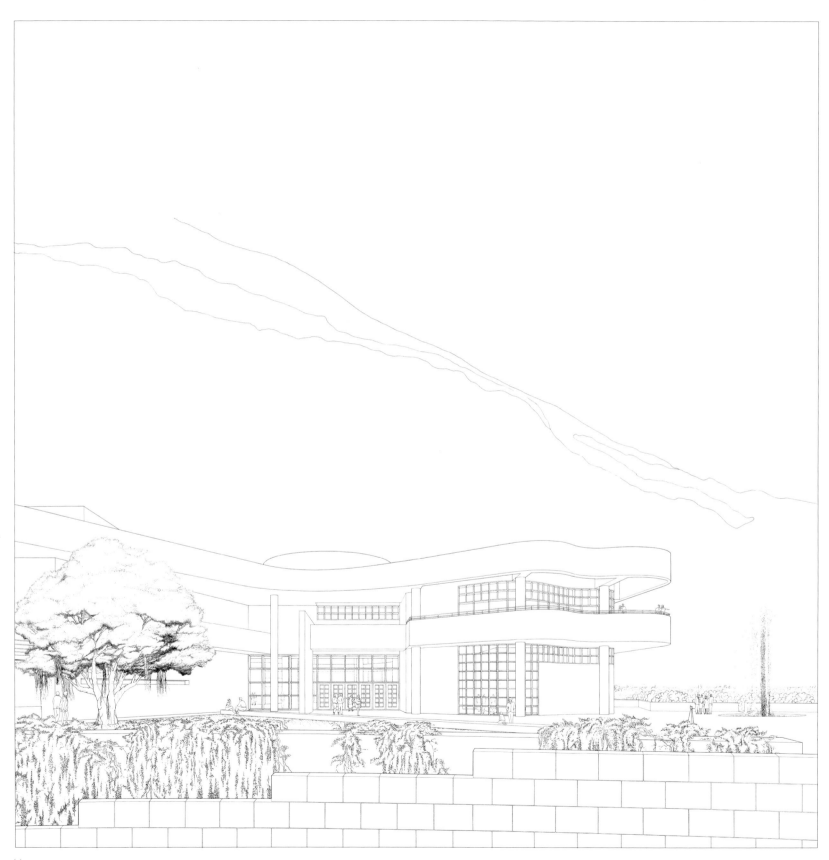

Museum
Entrance

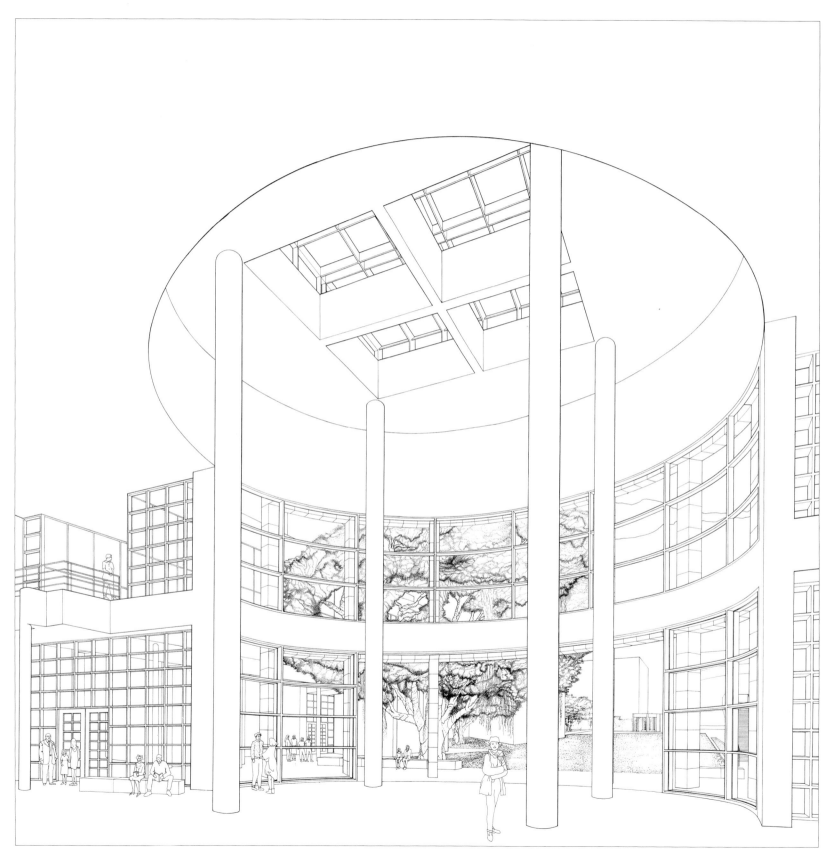

Lobby

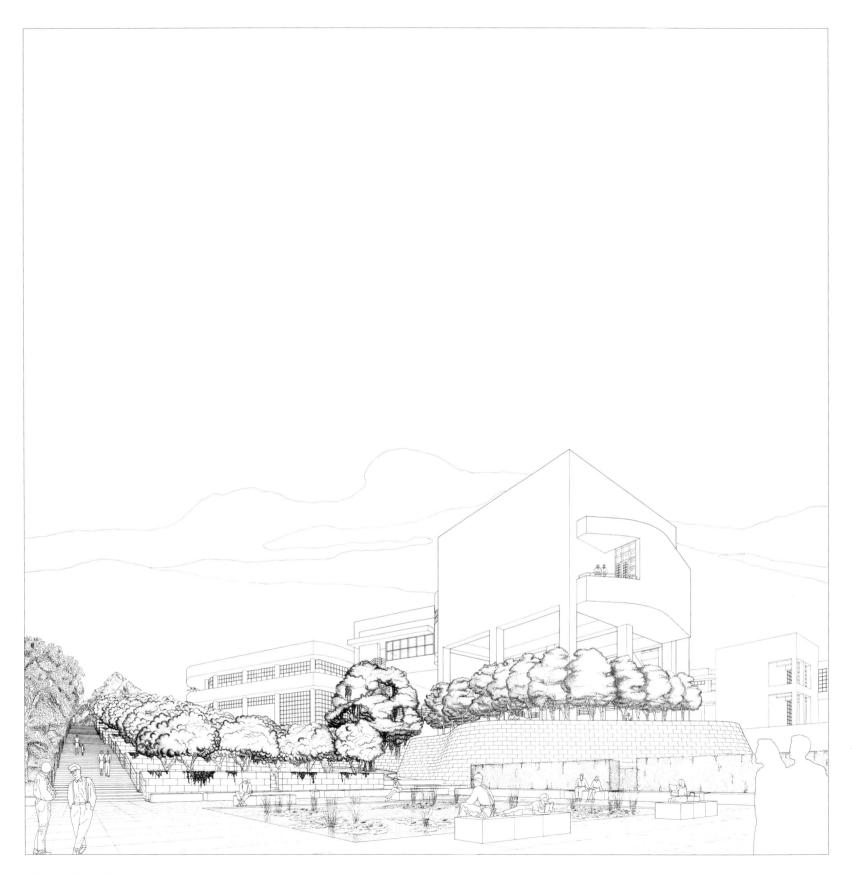

Museum; Central Gardens
View to north

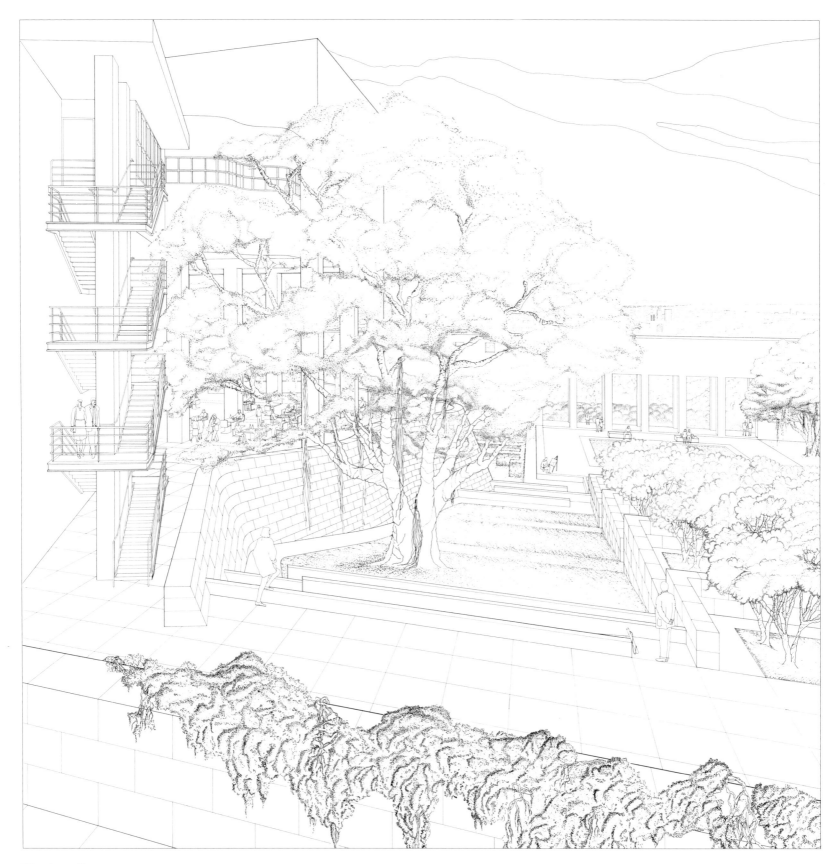

View to south

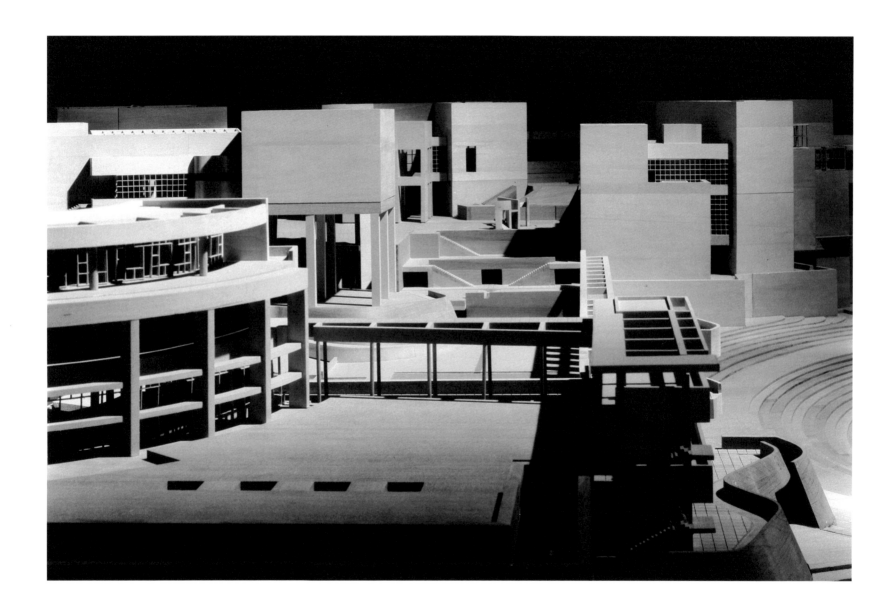

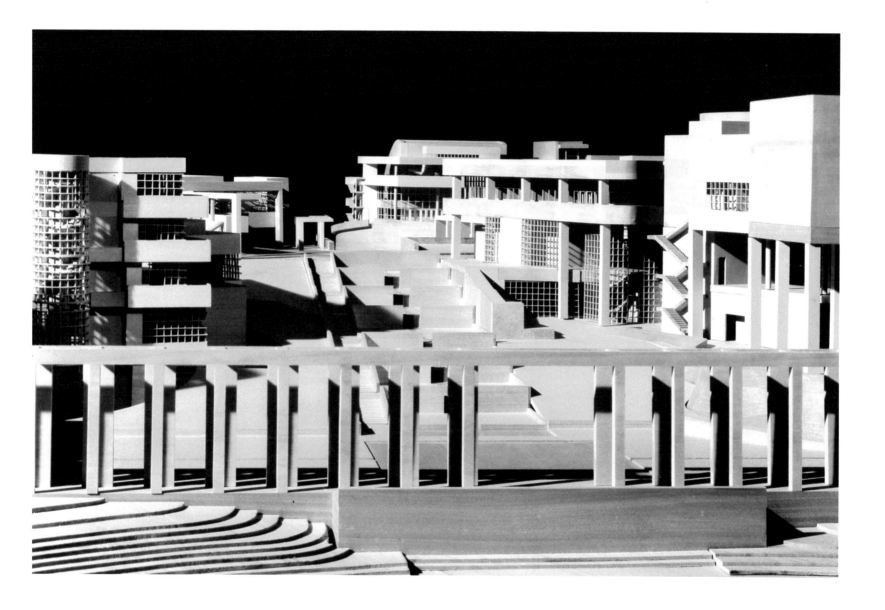

Center for the History of Art and the Humanities
First lower level plan

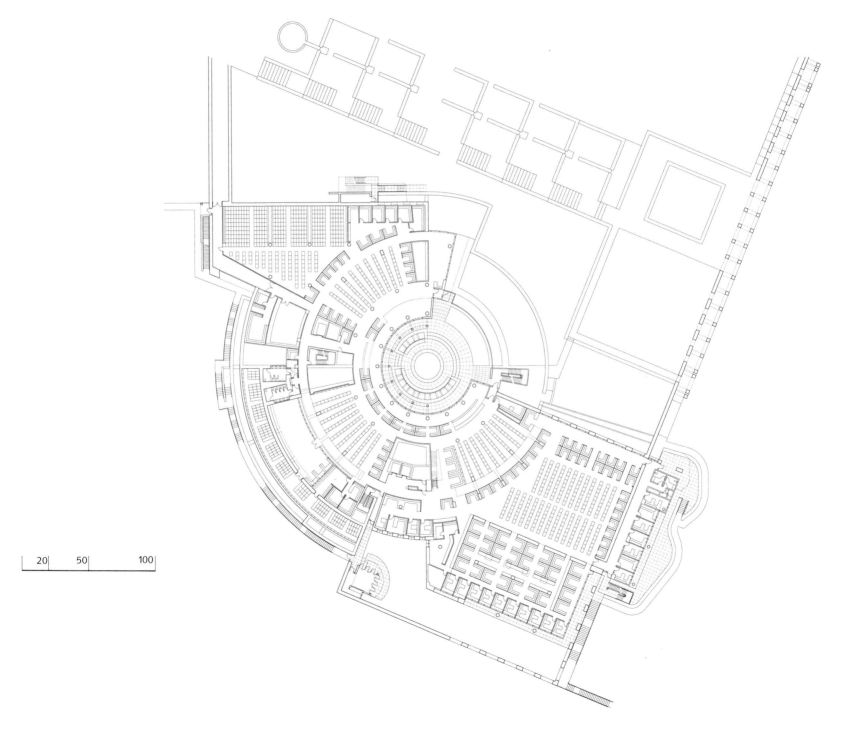

20 50 100

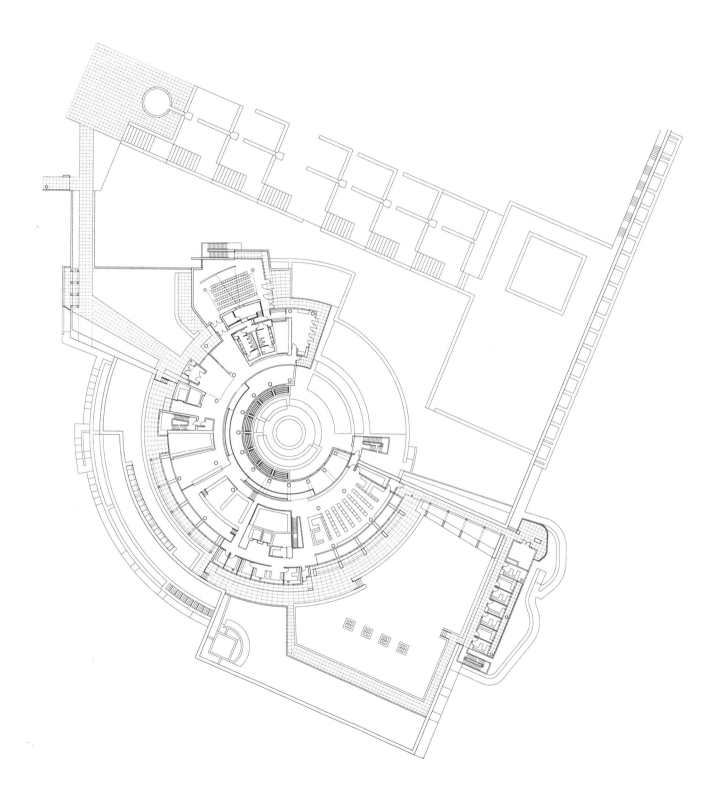

Section through Center for the History of Art and the Humanities
Views to west

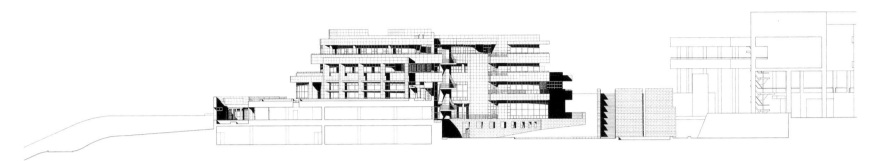

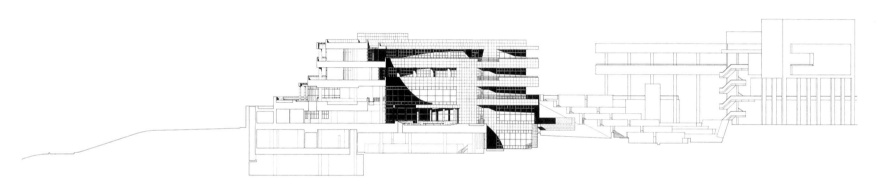

South elevation

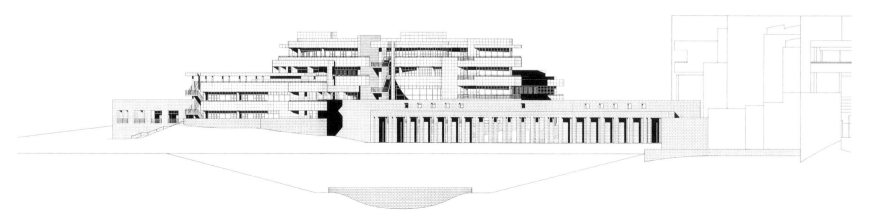

North elevations

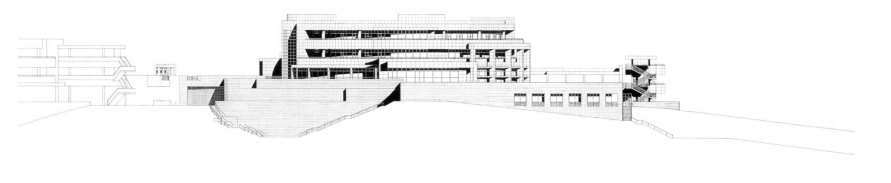

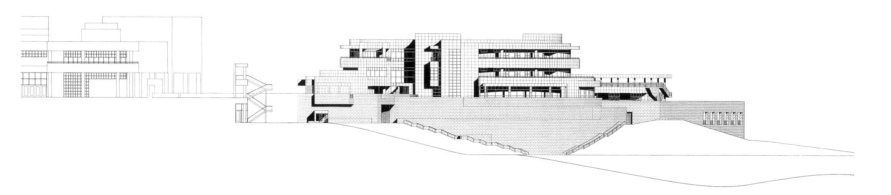

East elevation

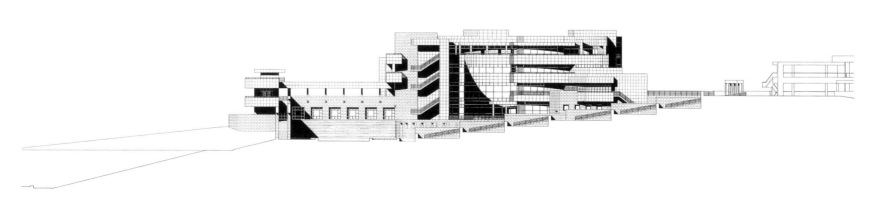

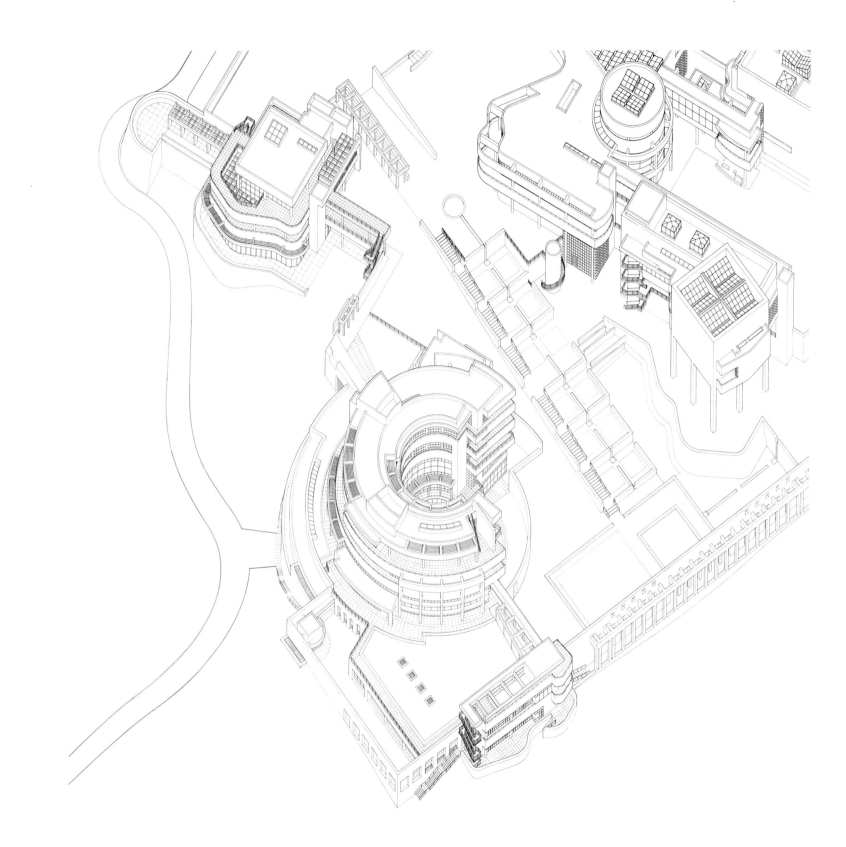

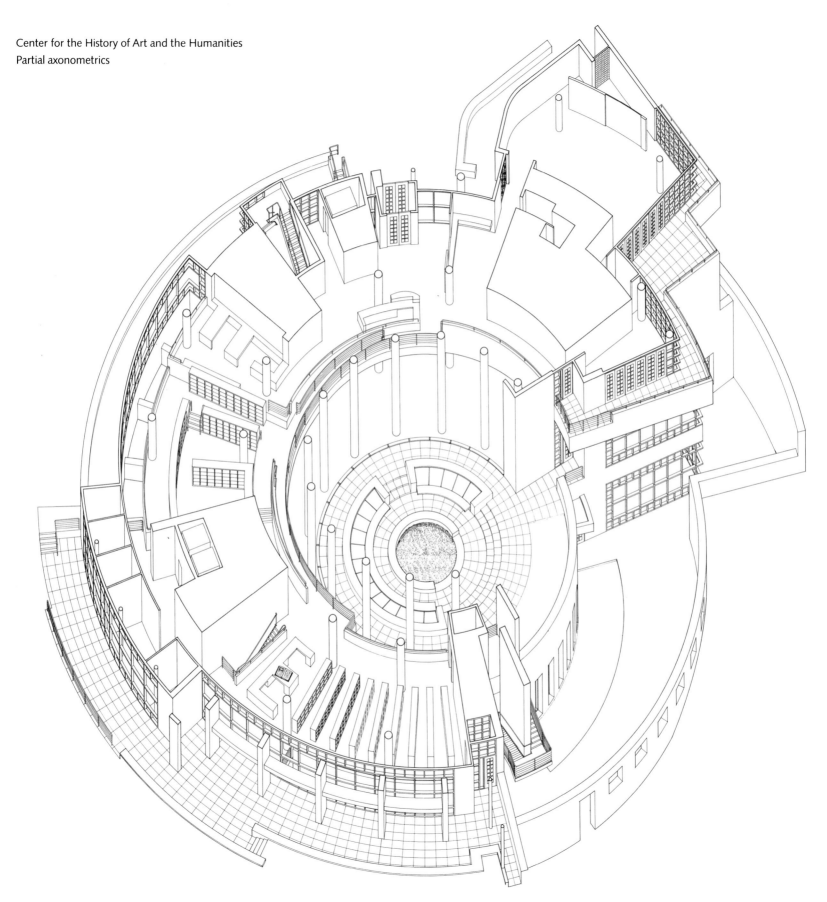

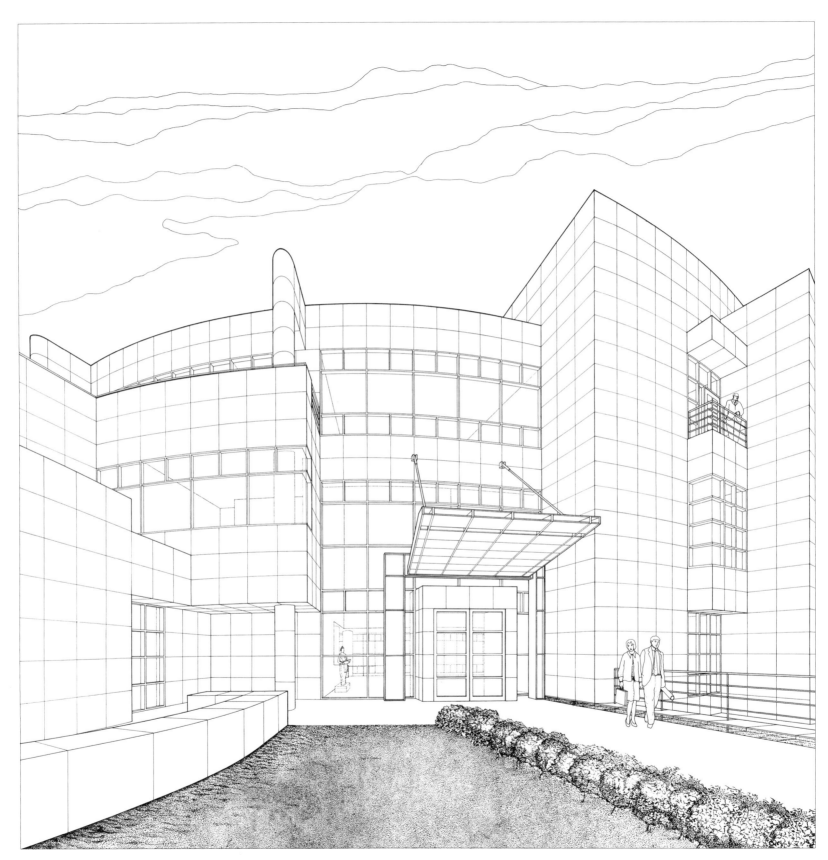

Center for the History of Art and the Humanities
Views of entrance; to west

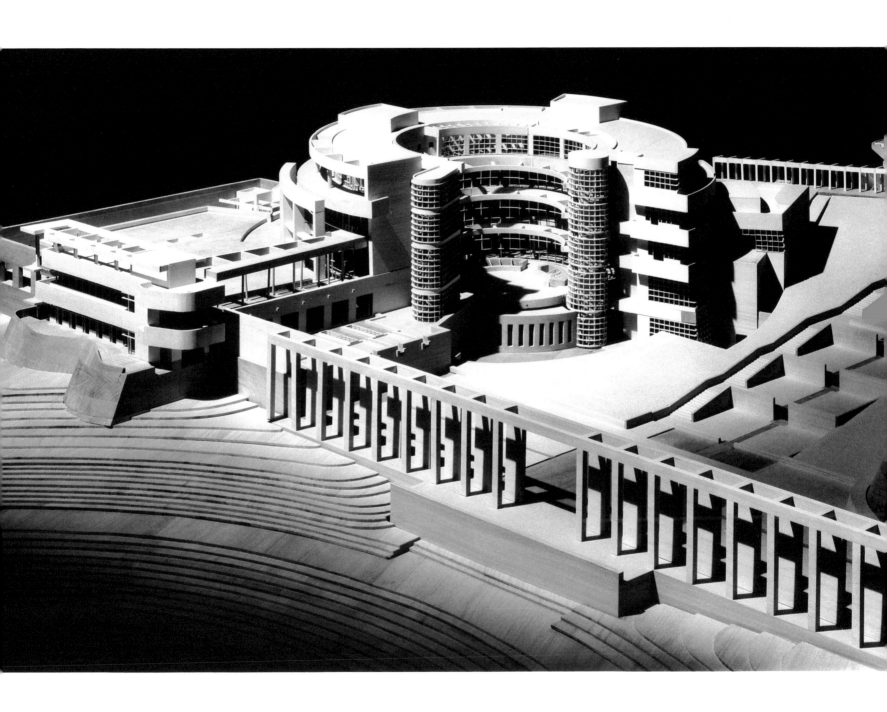

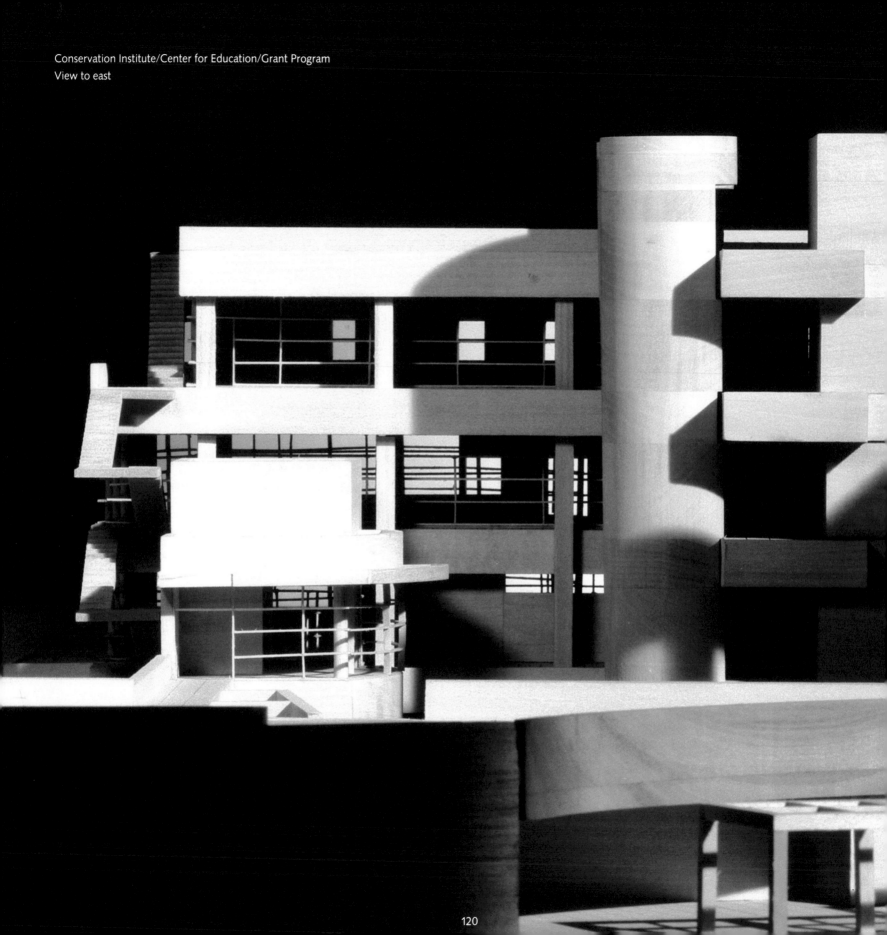

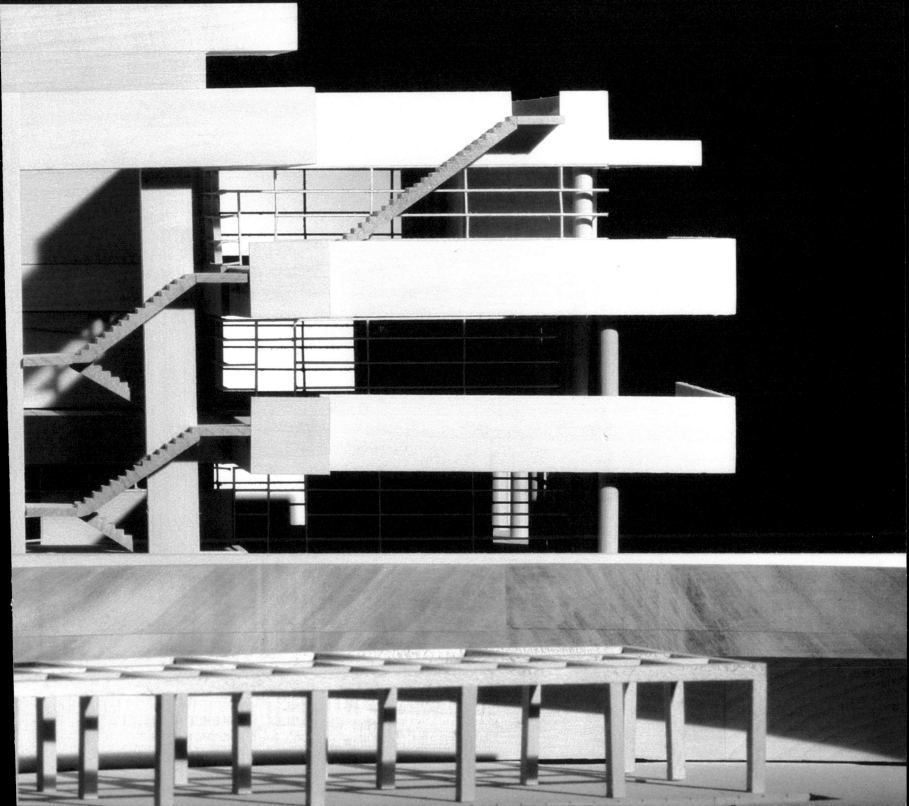

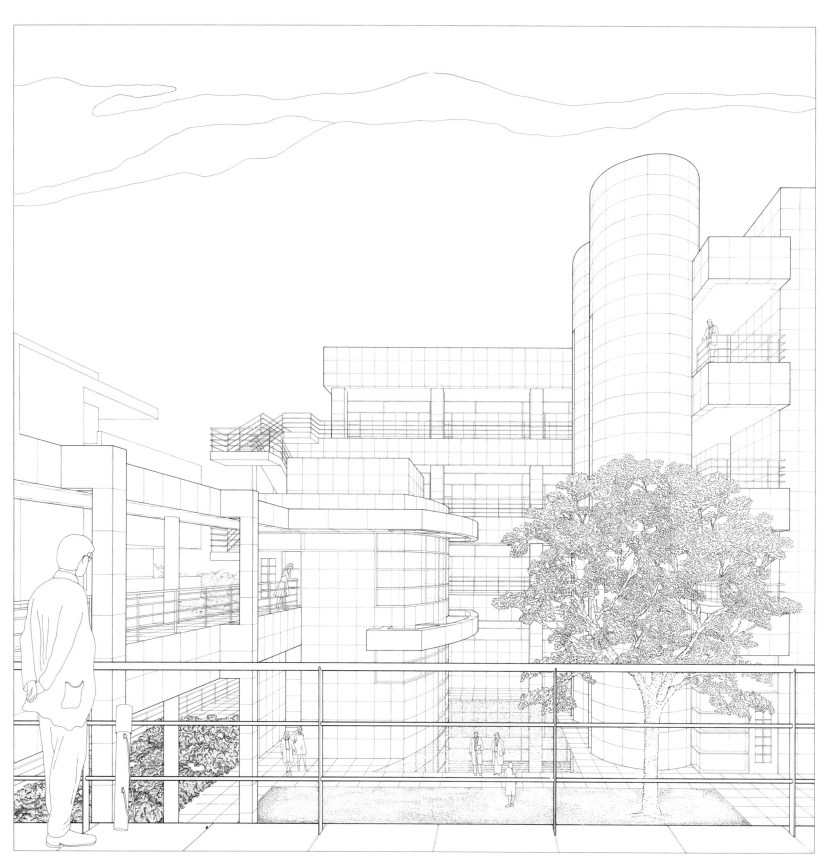

Conservation Institute/Center for Education/Grant Program
View to east

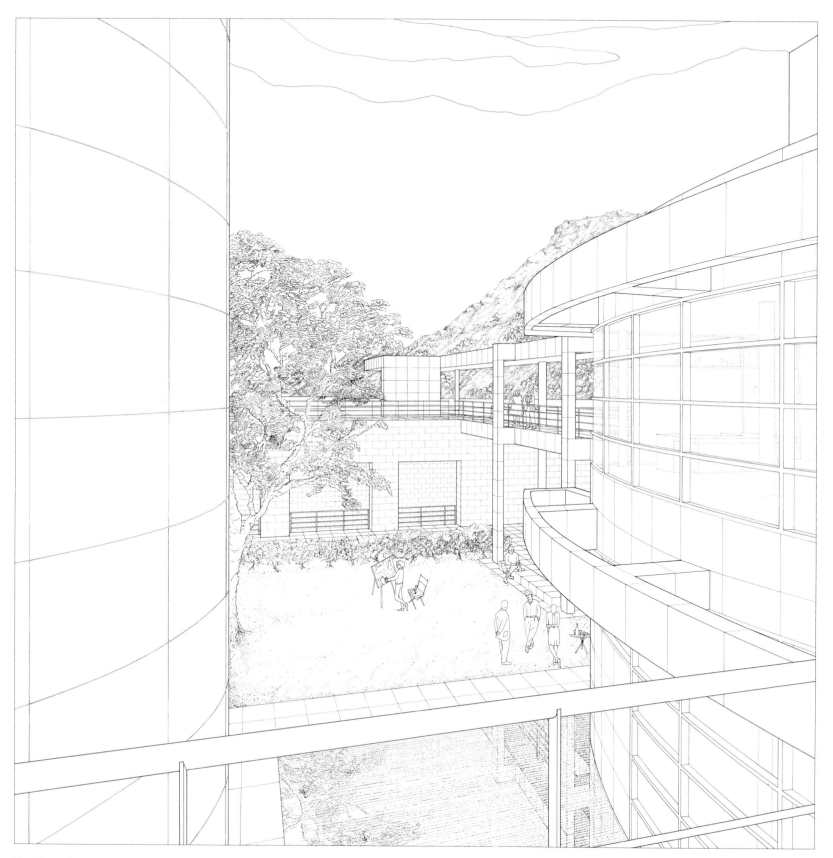

View to west

Conservation Institute/Center for Education/Grant Program;
Art History Information Program/Trust; Auditorium
Study models
MARCH 1989

JANUARY 1988

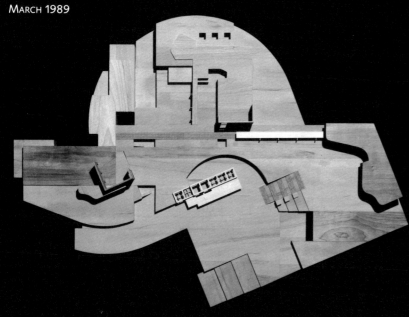

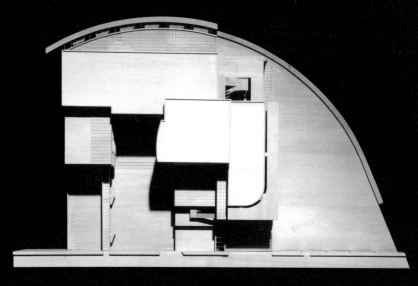

JANUARY 1988

MAY 1989

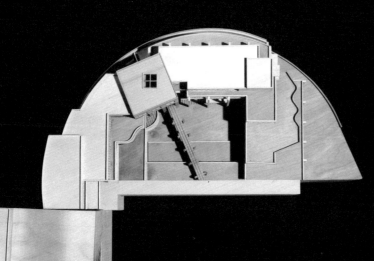

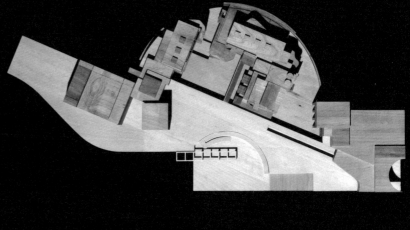

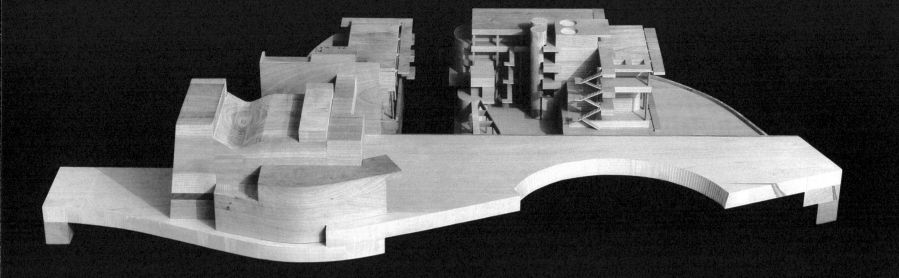

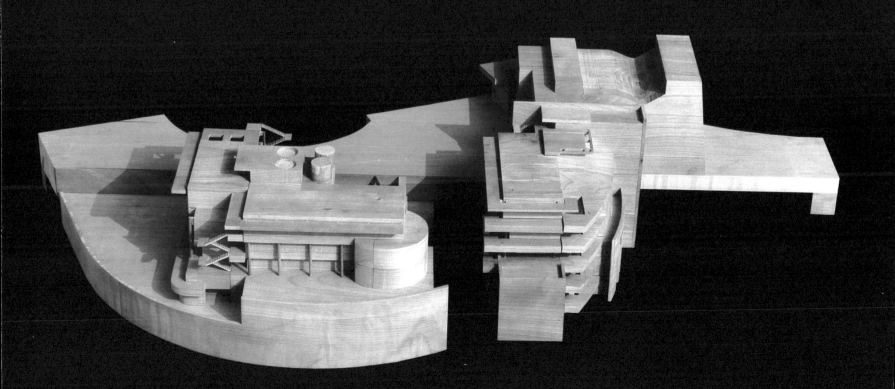

Conservation Institute/
Center for Education/Grant Program
Study models
Views to west
<small>OCTOBER 1987</small>

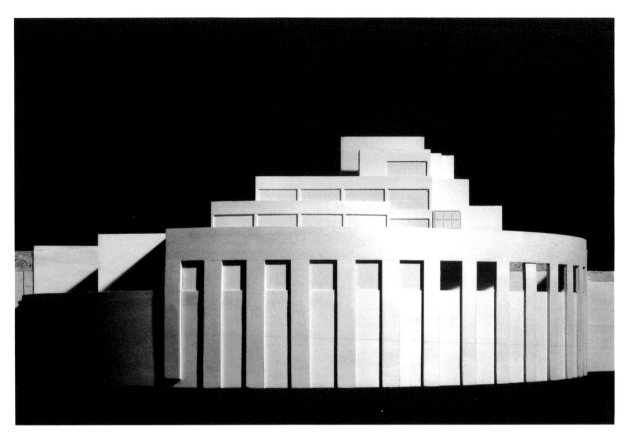

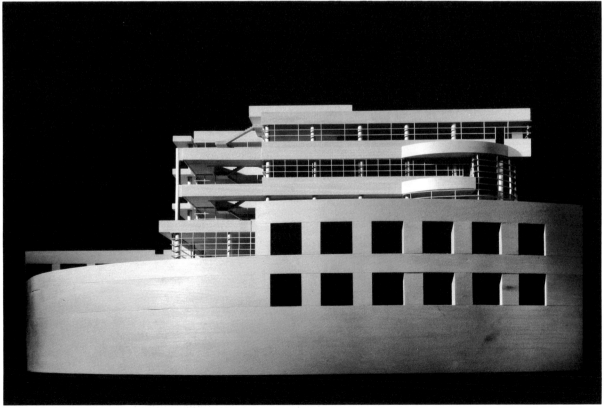

Views to north; to south
DECEMBER 1989

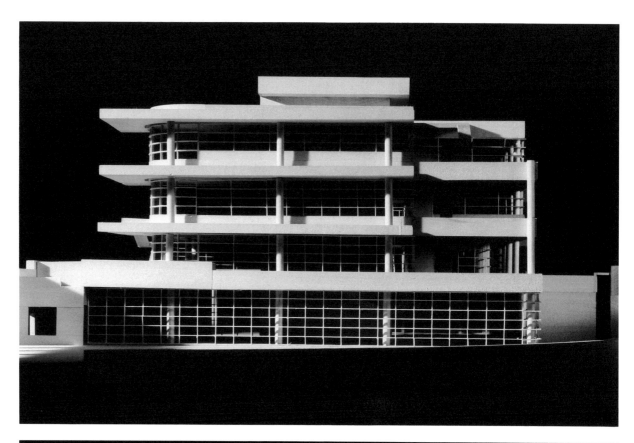

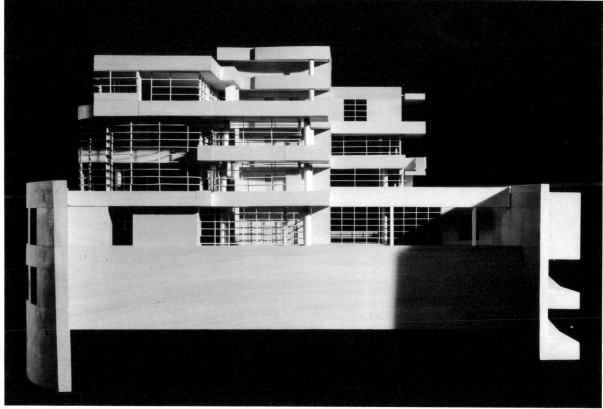

Auditorium; Conservation Institute/Center for Education/
Grant Program; Restaurant/Café
West elevation

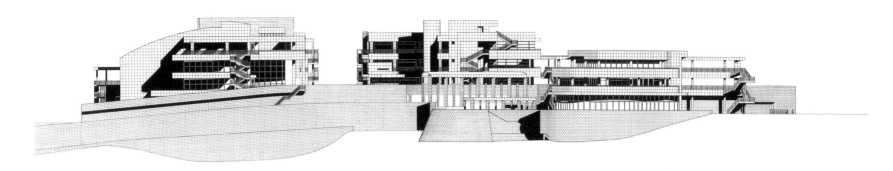

Art History Information Program/Trust; Auditorium;
Restaurant/Café
South elevation

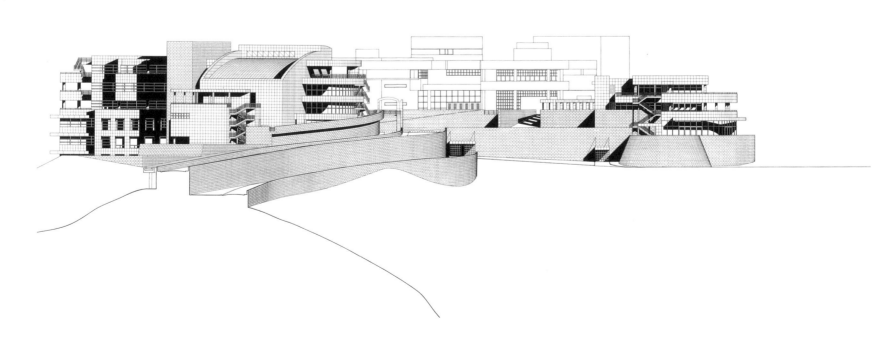

Auditorium; Conservation Institute/Center for Education/
Grant Program; Restaurant/Café
West elevation

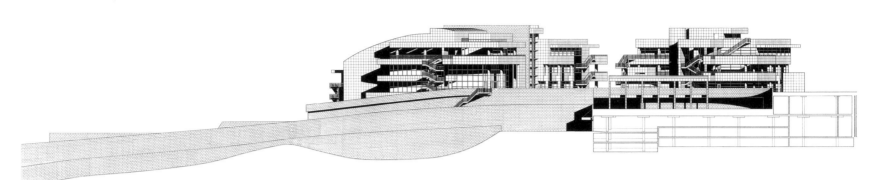

Conservation Institute/Center for Education/Grant Program;
Art History Information Program/Trust; Auditorium
West elevation

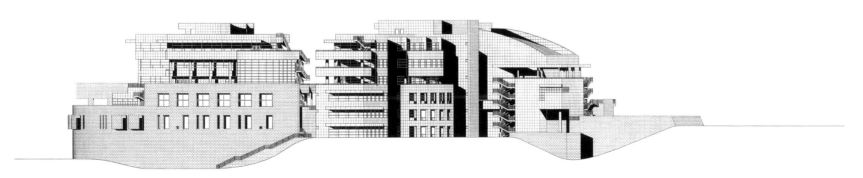

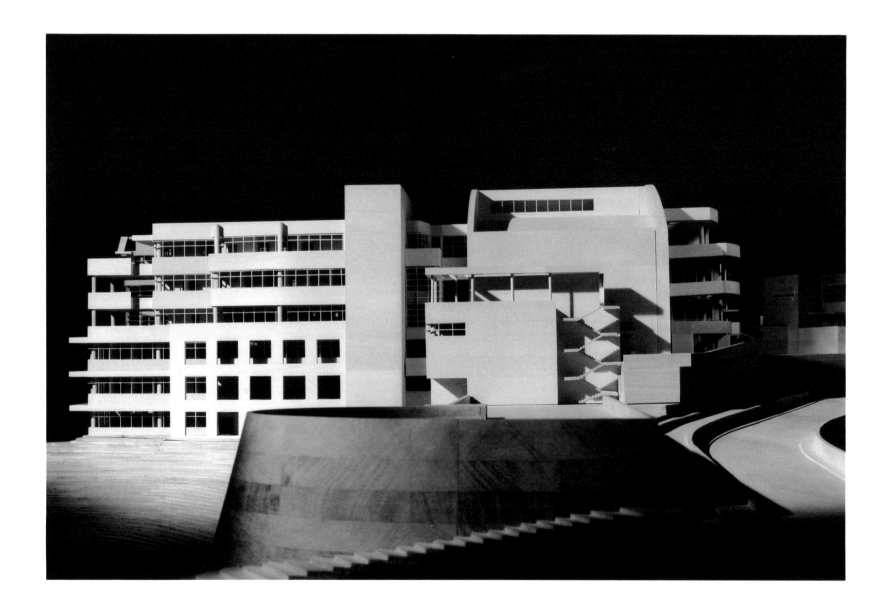

Auditorium
View to east

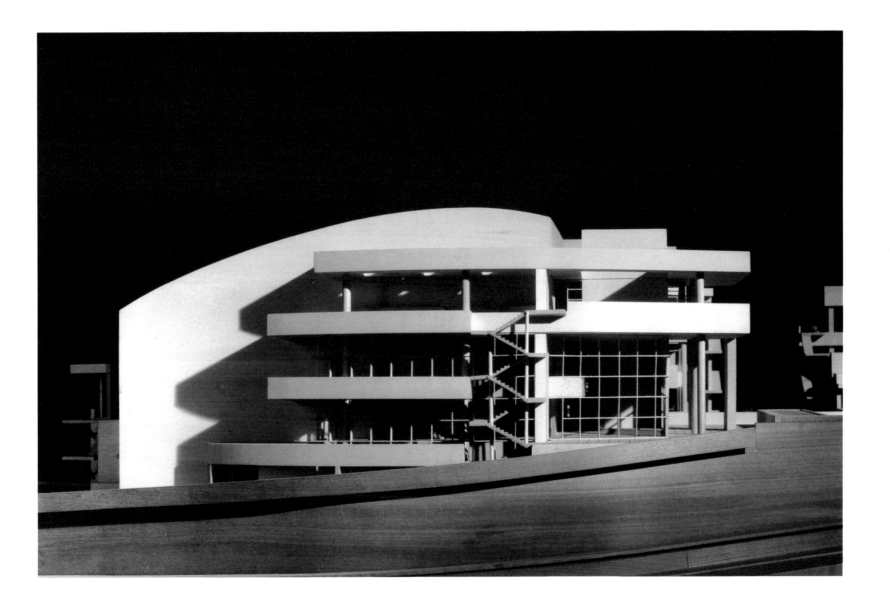

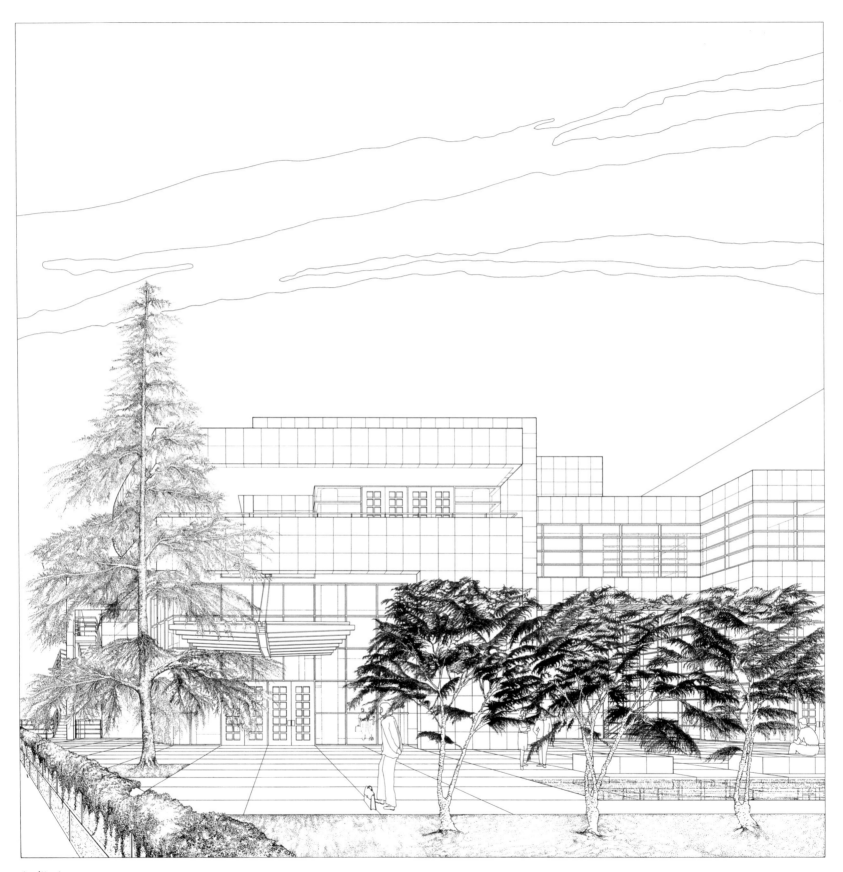

Auditorium
Entrance

Axonometric

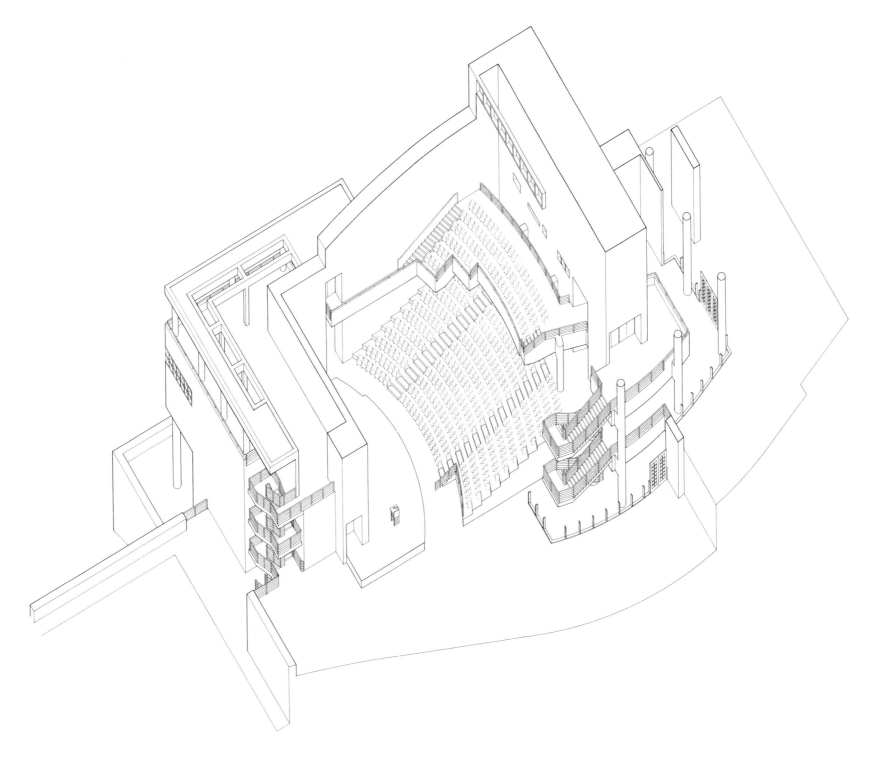

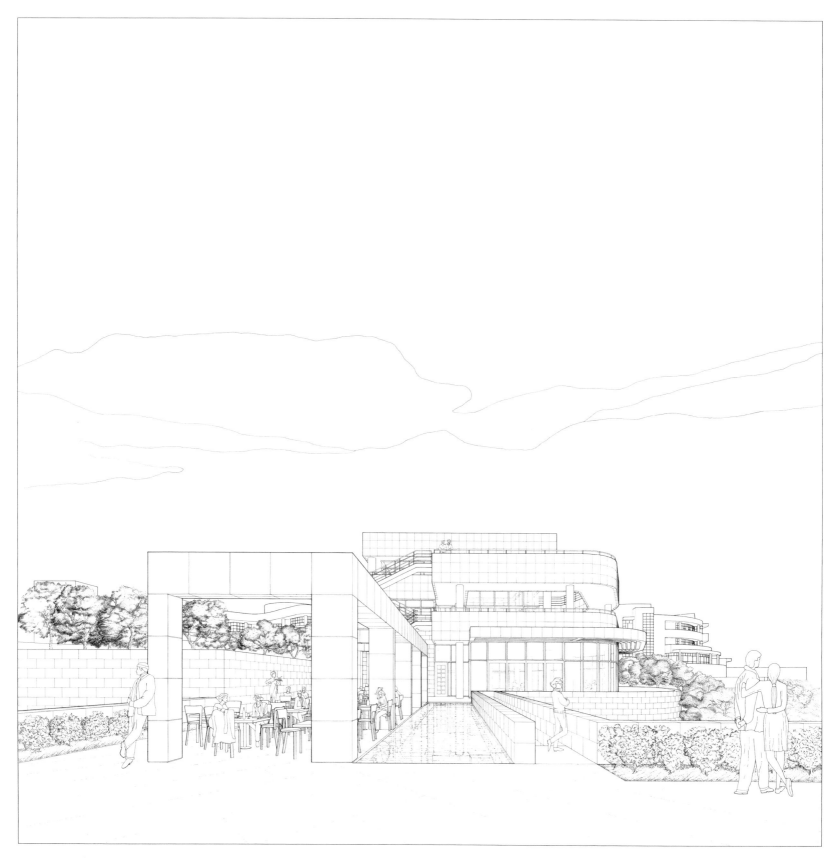

Restaurant/Café
Terrace

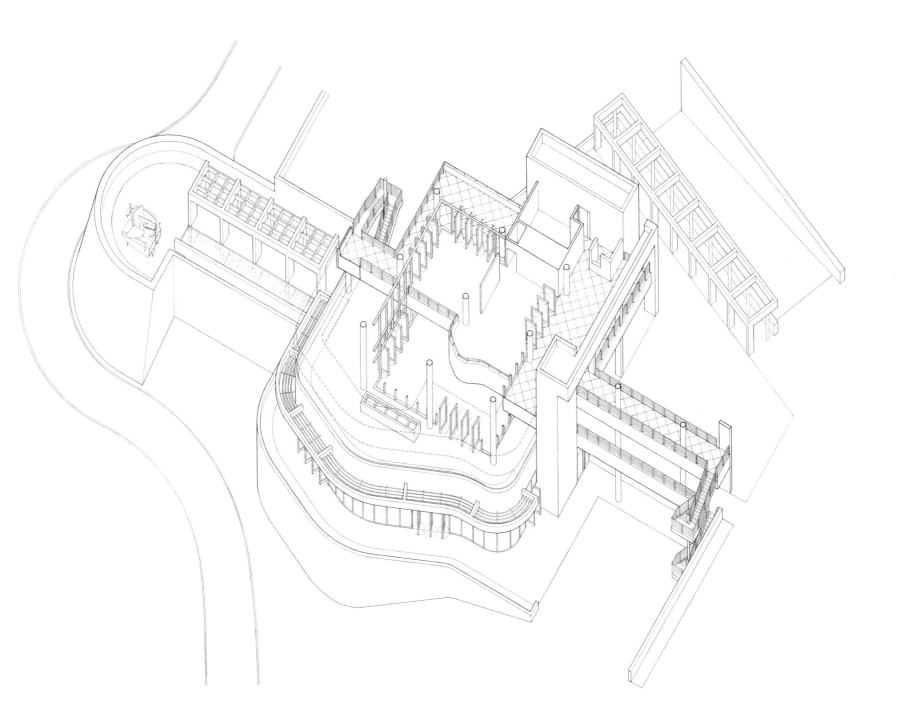

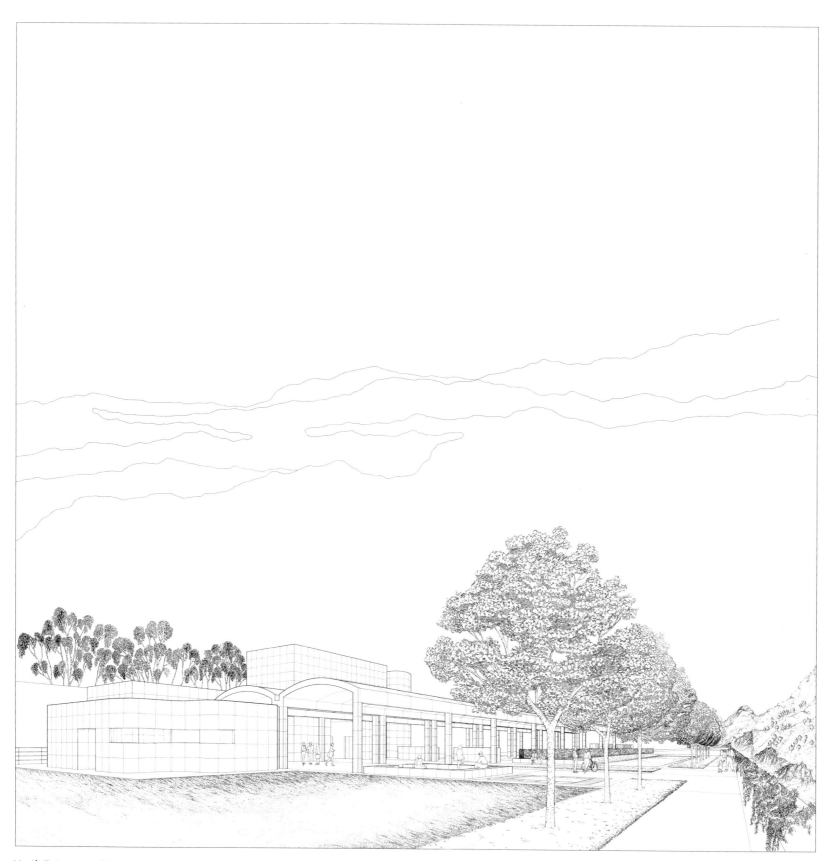

North Entry tram station

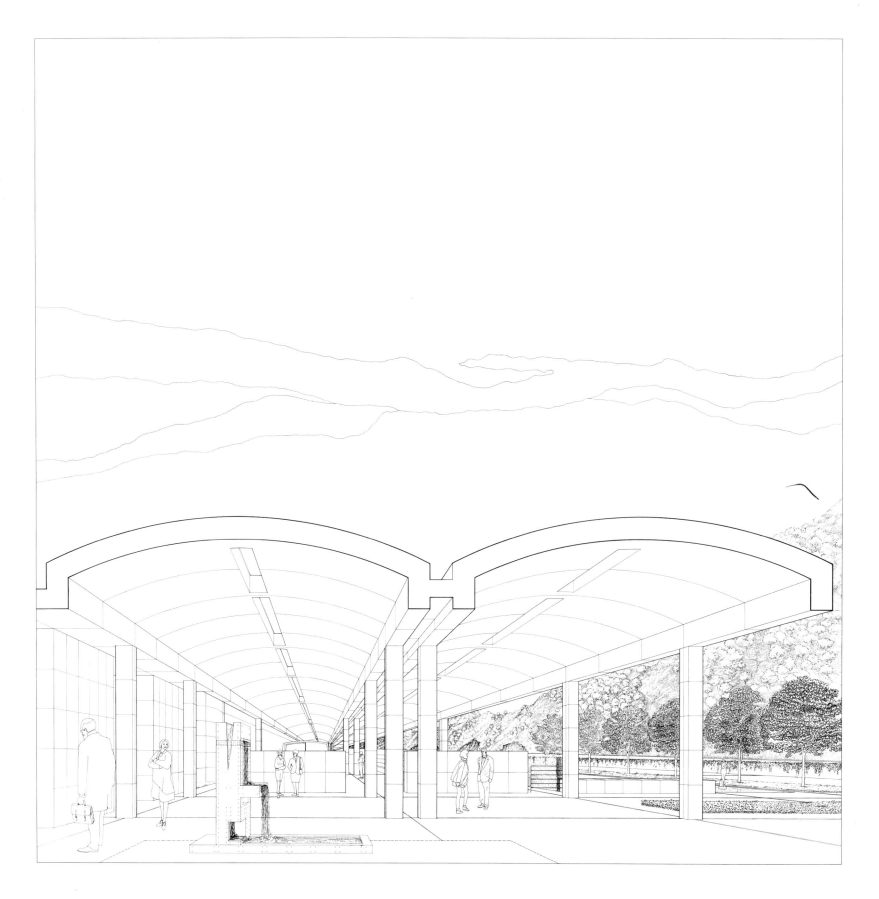

Construction mock-up of cleft travertine
Carlo Mariotti, Inc., Italy

Introduction

This report is intended to provide the reader with the initial and very basic building program planning requirements for the Getty Center facilities. It is not intended as a final, comprehensive, or definitive catalogue of our requirements. The architect will be developing a more specific program for space requirements in conjunction with an ongoing process of discussion and review with staff members at the various Trust programs. Furthermore this document should, in no way, be taken as representing operational or funding commitments for Trust programs or activities. Its purpose is solely related to the facilities planning process.

The complexity and relative immaturity of the Getty programs, the complexity of the project, site, and legal constraints, and the need for architectural advice and counsel require us to pursue an evolutionary design process. The Architectural Program is best read as a comprehensive introduction. It contains an overview and, for each major entity, a statement [reprinted here] of the mission, goals, and character of the program; descriptions of the functional components and primary activities, services, and programs; facts (or assumptions) about the general scale, scope, and characteristics of collections, activities, visitors, etc.; descriptions of basic physical requirements; descriptions of the interrelationships between the various entities; and some discussion of what we see as principal design or operational problems. In many respects this program is tentative. The process of more detailed examination of our requirements and professional architectural analysis will surely lead to significant refinements. The Conditional Use Permit granted by the City of Los Angeles may be obtained as an appendix to this document. It is a critical component of the basic requirements.

The report is organized to provide a brief overview of the complex of facilities and programs. Then it presents each major operating program separately and closes with requirements for operational support and facilities. Each section is organized in a layered fashion, moving from a broad statement of purpose through to increasingly more specific physical and operational problems and requirements. In most cases specific reference to square-footage needs have been omitted. These needs are being studied by the architect.

It is clear that the most challenging problem confronting us is the physical and operational integration of the several Getty programs. The program requirements as presented here tend to underscore the distinctive characteristics and diversity of the programs. It is, of course, essential that the

architectural solutions fit these specific requirements. But the necessity of examining the program in segments must not cause us to lose sight of the fact that the Getty Center is to be a multidimensional but highly integrated facility.

THE J. PAUL GETTY MUSEUM

The new Getty Museum will house a diverse collection of works of art and exhibit them for the delight and instruction of the public. Its program embodies the paradox of all museums. We must preserve the art entrusted to us for future generations yet risk its deterioration by putting it to use for today's public. The difficult task of both architect and client is to forge the best compromise, minimizing the hazard to works of art yet showing them to maximum effect.

The character of the new Getty Museum ought to be markedly different from that of a large general art museum. Its size and scale will be relatively modest. The collections will be specialized, the emphasis will be on the permanent collections rather than loan exhibitions, and the spirit will be contemplative rather than frenetic. The new Museum will be an elevated place, literally because it will sit on a hill above the surrounding city and figuratively because visitors will feel that they have withdrawn for a while from the anxieties of daily life. They should be put in a receptive frame of mind by the atmosphere of a beautiful, comfortable building. In the galleries they ought to be seduced by the beauty of individual works of art, a seduction that will be more complete if the works of art are not only especially fine but are seen in beautiful light and harmonious settings.

The Museum is to be a place where art is respected; where the public gets uncondescending guidance; and where integrity reigns. The seriousness of its purpose will be reinforced by the presence nearby of two other Getty institutions devoted to scholarship and conservation. Visitors will understand that the Museum is far more than a public showplace. Their receptivity should not be diminished by overcrowded galleries.

The primary goals of the new Getty Museum will be to:
A. House the collection. *Our principal mission will be to preserve and exhibit works of art, chiefly European, from the Middle Ages to 1900. The Getty collections are intentionally restricted in scope, not all-encompassing. Their characteristics will be concentration and excellence, not universality.*

European paintings, sculpture, and certain objects and furniture will be shown in galleries with daylight. Other European works of art will be shown nearby under different light

conditions. A large collection of French decorative arts and furniture, chiefly of the eighteenth century, will be shown separately without daylight. Works of art on paper (drawings, manuscripts, photographs) will be given rotating exhibitions in their own galleries without natural light; here the works in storage, which are far more numerous than those on exhibition, require study rooms. Some form of study-storage for all the collections will also be desirable.

The prime requisites for the preservation of the collection — our ultimate responsibility — are safe construction that can withstand natural disasters, reliable environmental control, and an effective security system.

B. Reflect the character of the collections. *The Museum's form and layout ought to express the special character of the Getty collections. The physical plan should organize the collections logically and provide the visitor with routes of travel which are rewarding in their variety, surprise, and beauty.*

The large general museum is typically housed in one or several large building masses whose interiors are subdivided for the various collections; these are presented synoptically, like chapters in a text on the history of art. The Getty collections, however, are less a text than an anthology, chosen somewhat arbitrarily and edited rigorously. We have elected to build subcollections of strength and depth, such as eighteenth-century French art and European paintings, and to sacrifice broad or uniform coverage of the history of art. As a result the various Getty collections may logically be housed, singly or in combinations, in discrete but connected pavilions.

If these pavilions were separated by walks, gardens, information centers, and other public spaces, we could achieve several other objectives as well: variety of scale and visual experience; distinctive ambiences for the different collections; dispersion of visitors, so that overcrowding in certain areas was avoided; lucidity of plan, so that visitors knew where they were; and encouragement of visitors to immerse themselves in what they were seeing at the moment and its specific context, rather than to feel obligated to move constantly onward in a prescribed sequence. Such a physical layout could offer many options for eventual future expansion in different areas of the Museum.

C. Give visitors a heightened aesthetic experience. *The main purpose of preserving the collections is to enrich the lives of visitors by giving them a memorable experience of works of art. The setting is of great importance to an optimal experience. For this we need a museum building that plays skillful accompanist to the collection. The building should subordi-*nate itself to the works of art in the galleries, assert itself with dignity and grace in the public spaces, and contribute logic as well as pleasure to the visitors' progress. We hope that the building can give modern form to the well-proven virtues, aesthetic and functional, of the great museums of the past. We require settings for the works of art that bear some relation to their original context, with lighting, scale, decor, and materials chosen to make works of art look at home — albeit in a home of the 1990s. Visual competition needs to be kept to a minimum. We need to provide many intervals for visual relief, rest and reflection, for it defeats our purpose to tax visitors' bodies and overload their senses. Looking at art should be an intense experience. After a while recovery is necessary, for which we need to provide appropriate spaces.

D. Be sure visitors learn all they can. *A pleasurable encounter with a work of art can stimulate curiosity. Curiosity, fed with useful information, can produce the intellectual excitement and enrichment that comes with a closer familiarity with a work of art and its context. In the new Museum we have a remarkable chance to deepen the visitor's experience by a variety of means, including a lucid organization of the collections, helpful labeling, and educational adjuncts in the vicinity of the collections that provide information and interpretation. From the moment visitors enter the Getty property, in fact, their experience should be viewed as potentially educational.*

E. Benefit from the proximity of other Getty organizations. *The Museum will have a good deal of practical business with the other related Getty institutions. The curators and educators need the library and photograph archives of the Center for the History of Art and the Humanities practically every day, and they require work space to which they can retreat from their Museum offices. They will want to participate in Center activities as much as is appropriate. We also expect Center staff and scholars to enjoy a privileged status in the Museum. All this suggests that the Center must be no farther than a short walk away and ideally reached by a protected passage.*

The Conservation Institute will provide the Museum with certain essential services, especially technical analysis and advice, which will require the transport of works of art between the two. The Institute's activities will be of constant interest to the Museum's conservators. We expect the treatment of the Museum's collection, in turn, to be of interest to the scientific and training staffs of the Institute. In no other area of this project is there a greater need to facilitate contact, official and casual, between staffs.

The Museum's staff and collections serve as resources for the Center for Education. We expect regular contact and collaboration, especially concerning the Institute for Educators. The Center for Education need not be adjacent to the Museum, but it would be convenient to have it within a short walk.

John Walsh

THE GETTY CENTER FOR THE HISTORY OF ART AND THE HUMANITIES

The Getty Center for the History of Art and the Humanities is an advanced research institute. Every part of it can be compared to some other institution, but taken as a whole the Center amounts to a unique creation. Such a unity of resource collections, research initiatives, publications, and distinguished scholars embraces everything a university possesses except students and pedagogical routine.

Tied to the Getty Trust and its mission in its broadest scope, the Center is nonetheless a highly distinctive entity. As the research arm of the Trust, it provides the resource collections and the highest caliber of scholarship in those fields of knowledge which are immediately pertinent to the study of art. The Center will be able to accomplish its mission provided a number of conditions are met for its growth over a long period of time. Its resource collections must aim to become as comprehensive and variegated as possible; it will need to chart a responsible course of its own as the understanding of art in the culture at large changes; and it will by necessity gradually create a community of scholars, both visiting and resident.

A further word on each of these aspects. Within the fields of Western art, the Center should obtain everything required for the conduct of research over the next few years while preparing for the gradual expansion of its scope in non-Western areas. This constitutes a daunting task, largely thankless for those who take it on but most rewarding for the future. The overriding importance of the future *in such an endeavor* demands long-term support, precise planning, and major acquisitions. The policy guiding our acquisitions must combine quick tactical moves with an unwavering sense of goals that are still remote. Such policy is all the more decisive as the study and significance of art do not remain constant but

instead fluctuate as part of the whole development of thinking. A rigid policy could well lead to narrow collections; a constantly wavering policy would disperse resources over too wide a field. Since the new art created at any time plays as powerful a role for the study of art in general as does historical thought, it is absolutely indispensable that modern and contemporary art be considered as integral to the scope of our resource collections as the art of the past.

The true intellectual life of the Center will depend largely, if not exclusively, on its community of scholars. In order to gather scholars who share a keen sense of purpose in their work and who may have affinities in their interpretative goals, the Center attracts small groups of researchers rather than an arbitrary number of individuals. Research conferences and seminars will periodically quicken the life of our scholarly community without disrupting the peace and constancy of work for those who wish to labor on their own.

The Center will have many lives and facets as an institution. To the insider and the resident scholar, it will be the foyer of their work; to the occasional visitor and to the academic community at large, it will come to represent an approach and a commitment to the field that are of great potential consequence. To acquire wide resonance and impact, the Center needs to project its work far beyond its own walls. It can do so by a variety of means: research seminars and conferences, publications, systematic collaboration with other Getty Trust entities, and, of course, the renown of its scholarly community. Internally, we want to create an atmosphere of highly focused work and liberal exchange, a kind of academy in which imagination balances rigor, where a spirit of exploration and scrutiny pervades every aspect. Externally, we can offer opportunities for scholars to partake of that spirit, to acquaint themselves with new paths of research and multidisciplinary endeavors. Publications and research conferences will be the essential means of the Center's external mission.

With regard to the academic community — from among which most of the Getty Scholars and visitors will be drawn — the Center may come to play yet another significant role. It may help to pioneer approaches, create research resources, and coordinate efforts that would otherwise lag behind or falter altogether, and it may offer alternative or even corrective opportunities where academic institutions tend to stagnate. Many academic departments in the humanities — especially those in the history of art and literature — have narrowly subdivided and specialized expertise,

often avoiding altogether the presence of more than one scholar in the same or closely related fields. While this may have arguments for coverage and economy on its side, it has undoubtedly led to artificial isolation and an acute lack of challenge, scholarly scrutiny, and imaginative practice. Here the Center may be in a position to influence long-term academic policy by the quality and result of its own closely integrated programs.

The Center aspires to a more than academic presence in Los Angeles. We want to add to this city and its many promises yet another one, that of an eminent national and international institution for the study of art, as only a metropolis could command.

In conclusion it may be useful to bring the salient qualities we seek for the Center once more into high relief.

Ideally, the Getty Center for the History of Art and the Humanities ought to be a place of reflection and critical examination. While thought requires a protected and secluded setting, scrutiny and debate occur in a public arena. The cloistered scholar and the crowded auditorium in combination make for a productive tension.

In order to protect Center programs from aggressive intrusions on the part of a vast community of individuals and institutions, it is vitally important that we hold fast to the basic idea of creating a center for advanced research and avoid the appearance of a service institution where everyone seeks to promote their own special interests. The ultimate impact of the Center will be greater and more lasting for its high level and selectivity. Any visitor to the Center should be reminded of its large purpose and deep vision.

The special importance of the library to the Center as a whole and to the entire complex of Getty institutions would suggest a forceful architectural manifestation inside and out. The reading room deserves to be singled out as a significant arena. If one were to diagram the character of the Center, one might place at its core the potentially vast resources of the library and Archives of the History of Art and extend to its periphery the different itineraries of use along which scholars and visitors do their work. From this core one would move toward more and more specialized areas before turning back toward more communal places.

With regard to the design of Center facilities, it is essential to keep these characteristics constantly in mind. More important than a concept of mere functional efficiency is the notion of the place and its atmosphere. Scholars and visitors

should find themselves in a different setting when they enter the Center, different from office as well as public library, different from busy university corridor or bustling museum lobby. The atmosphere we have in mind might be compared to that of a secular monastery in which a sense of calm and historic purpose replace the tension and bustle prevailing outside.

That the Center for the History of Art and the Humanities houses so many different activities and resources will be readily manifest to the visitor only in certain places and in partial form. These partial manifestations are, however, of great importance for the institution as a whole. Because of the highly distinct character of its collections and programs, the Center should resemble a prism rather than a monolith. Its activities and purposes are refracted throughout rather than being solidly and simply present in any given place. The Center's composite nature requires subdivision and specialization of spaces and sites, but it also suggests the need for frequent reminders of its unifying purpose.

What emerges from this basic conceptual model, then, is a physical organization in composite form along clear itineraries. The chosen site happily reinforces this concept.

Kurt W. Forster

THE GETTY CONSERVATION INSTITUTE

The conservation of the world's cultural heritage, numbering millions of art objects, archaeological and anthropological artifacts, and monuments and sites, is threatened today more than ever before. Demographic growth, industrial expansion, the pollution of the environment, the combined effects of natural and man-made disasters, and the looting of archaeological sites are some of the factors that endanger the transmission of these very important testimonies of our cultural identity to future generations. Each society has a vital need to conserve the material evidence of its origins and its past achievements in order to build its future.

The Institute has been established to improve the quality of conservation both in the United States and internationally. As the best conservation practices are interdisciplinary, the Institute's programs attempt to bring together the collective knowledge and judgment of the curator, scientist, and conservator. Within the new Getty Center complex, the Institute will be a meeting point and a focus for communication among conservators, scientists, and art historians. Because

of the scarcity of resources available elsewhere, the Institute can make a significant contribution in three main areas: scientific research, training, and documentation.

The Scientific Research Program is concerned with research into conservation materials and methods, the provision of analytical services to the Museum, and research involving the application of advanced technologies to conservation. Research will be undertaken both in house and by other institutions on contract. Priority will be given to research projects that address urgent conservation problems that are of international scope and interest and that do not duplicate research conducted elsewhere.

Based on the Institute's goal of developing an interdisciplinary approach to conservation, the Training Program will consist of activities in three major areas: advanced theoretical and practical training, professional exchanges, and the development of training opportunities and curricula in collaboration with other institutions. Training activities will deal with all types of cultural property: fine arts, archaeological and ethnographic material, and architecture and sites. Training related to conservation science, documentation, and conservation management will also be handled by this program.

The Documentation Program will be aimed at enhancing the possibilities for information exchange between individual specialists and institutions. It will develop an international online data base containing a critical mass of information which can support conservation practice around the world by networking existing data bases as well as those that may be developed in the future. Information generated by the Scientific Research and Training programs will be included in this data base, which will form the basis for the dissemination of printed products such as Art and Archaeology Technical Abstracts.

Luis Monreal

THE ART HISTORY INFORMATION PROGRAM

Documentary evidence, previous research, and art objects themselves constitute the basic building blocks of art historical research. Yet the vast amount of information essential to the study of art is geographically dispersed and extremely difficult to integrate. Collections, bibliographies, catalogues, archives, and publications are often unique to the institutions housing them, and these institutions are scattered worldwide. The Art History Information Program was created in response to the recognition of the importance of using the computer to create and link major research data bases.

The Program's activities and projects are based on the concept that computers can dramatically enhance progress in the field of art history research. Computers can make available a variety and breadth of information which would be inconceivable through any other means. They permit the researcher to filter selectively a volume of data by retrieving only a given subset of information. Moreover they allow art historians to better use and integrate this information. Data-processing tools facilitate comparisons, allow for faster and better production of publications, and improve communication between researchers.

While concerned with the increased effectiveness and productivity of scholarly activity, the Art History Information Program acknowledges that its real challenges involve the collaboration of humanists and computer technicians to develop scholarly workstations and a far-reaching scholarly community.

Computer data bases and research tools for art history are the Program's desired goals, but the process of getting there also carries significant benefits. Through its activities, the Program is forming cooperative links among international research institutes, libraries, universities, museums, and constituent groups of art historians. The exercises of exploring standards, grappling with multilingual information, and establishing common authority sources can only promote greater clarity and mutual assistance.

Michael Ester

THE CENTER FOR EDUCATION IN THE ARTS

The goal of the Getty Center for Education in the Arts is to raise the status and improve the quality of arts education in elementary and secondary grades in the nation's schools. Conceived as a locus for widespread program activities, the Center acts as catalyst, leader, and manager for a variety of programs and research projects in arts education. Our work will be accomplished by a modest staff, contractors, and grantees.

The Center is guided by three fundamental principles. First, art education is essential to the educational development of all children, because the visual arts provide knowledge and experiences that contribute to an understanding that is unique and different from that gained through verbal and written language. Second, art education instruction should integrate content and skills from four subject disciplines that contribute to understanding art: art history, art criticism, art production, and aesthetics. This

approach to art instruction is referred to as "discipline-based art education." Third, regular, direct experience in looking at art objects is indispensable to a fuller understanding of art.

The Center has chosen to spend its initial years researching and developing several different programs focused on the visual arts in order to best determine how it can expect to exert leadership, leverage change, and ultimately achieve more substantive and rigorous arts education in the nation's schools. As its activities progress, the Center will determine which programs will receive continued resources in terms of staff time and budget. Because the Center's programs are not fixed, and probably will not be for several more years, a certain amount of flexibility in terms of space needs should be considered.

Leilani Lattin Duke

THE J. PAUL GETTY TRUST OFFICES

The J. Paul Getty Trust provides overall policy direction and fiscal control for all of the operating programs. Although each of the programs has an independent identity and appropriate leadership, they are under the stewardship of the Trust and its chief executive officer assisted by senior staff. The space provided for the Trust at the new site should appropriately reflect that relationship. The Trust not only guides the programs but assures that their vitality, relevance, and flexibility are maintained through an ongoing process of critical assessment. The Grant Program managed by the Trust contributes to this by providing a flow of information at the same time as it contributes to the field as a whole. Activities centralized at the Trust include the investment program and all financial activity, all legal matters, public affairs, and the general administration and central operations for the Getty Center. The Trust will also coordinate facilities management and certain operational services at the Museum in Malibu and at other sites.

Although it is visualized that the Trust space will be distinct from that of the programs, at the same time its siting should neither inhibit interaction between the Trust staff and program staff nor create a sense of isolation from the programs. The space should be characterized by understated distinction. While these are offices and should feel that way, they should also reflect an institution dedicated to the visual arts.

Stephen D. Rountree

PROJECT CREDITS